ALBINUS ON ANATOMY

ALBINUS ON ANATOMY

BY ROBERT BEVERLY HALE
Curator Emeritus, The Metropolitan Museum of Art
Instructor of Drawing and Lecturer on Anatomy, The Art Students League of New York
Lecturer on Anatomy, The Pennsylvania Academy of Fine Arts

AND TERENCE COYLE
Instructor of Drawing and Anatomy, The Art Students League of New York
Lecturer on Anatomy, National Academy School of Fine Arts and New York University

WATSON-GUPTILL PUBLICATIONS/NEW YORK
PITMAN PUBLISHING/LONDON

First published 1979 in the United States and Canada by Watson-Guptill Publications,
a division of Billboard Publications, Inc.,
1515 Broadway, New York, N.Y. 10036

Library of Congress Cataloging in Publication Data
Albinus, Bernard Siegfried, 1697–1770.
　Albinus on anatomy.
　1. Anatomy, Human—Early works to 1800.　2. Anatomy,
Artistic—Early works to 1800.　I. Hale, Robert
Beverly, 1901–　II. Coyle, Terence.
III. Title.
QM21.A28　　1979　　611　　79-15406
ISBN 0-8230-0221-7

Published in Great Britain by Pitman Publishing Ltd.,
39 Parker Street, London WC2B 5PB
ISBN　0-273-01444-7

Manufactured in U.S.A.

First Printing, 1979

Edited by Bonnie Silverstein
Designed by Bob Fillie
Production by Hector Campbell
Set in 12-point Baskerville

We wish to thank the New York Academy of Medicine for the generous use of their material and facilities, and especially Mrs. Alice D. Weaver, head of the Malloch Rare Book and History Room, for her gracious assistance. We also were fortunate in obtaining the fine photographic expertise of Lee Boltin, which was of essential importance to the quality of the finished book.

We are indebted to Don Holden, Editorial Director of Watson-Guptill Publications, who first encouraged the idea of the book and initiated the project, and to Marsha Melnick, who organized and guided our initial efforts. Finally, we wish to thank our editor, Bonnie Silverstein, whose unwavering patience and efficiency saw us through to completion, and Bob Fillie, for the excellent design of the book.

CONTENTS

BERNARDI SIEGFRIED ALBINI

TABULAE

SCELETI

ET

MUSCULORUM

CORPORIS HUMANI.

LUGDUNI BATAVORUM
Proftant apud JOANNEM & HERMANNUM VERBEEK Bibliop.
CIƆIƆCCXLVII.

The initial idea of compiling an edition of the anatomical works of Bernard Siegfried Albinus, the greatest descriptive anatomist of the eighteenth century, for the use of artists occurred about three years ago. We were in the process of looking for fine Old Master prints and anatomical illustrations for *Anatomy Lessons from the Great Masters*. Filed away, deep in the dusty archives of the Rare Book Room of the New York Academy of Medicine, were two huge old volumes holding the magnificent collection of copperplate engravings of the anatomical works of Albinus that promised to be a fine addition to our book. But, on further consideration, we felt that the beauty, skill, artistry, anatomical accuracy, and completeness of these plates seemed to merit a separate book. We felt certain that they would make a very useful contribution to the study of anatomy by artists and be of great interest to students of science and medical history as well.

This anatomical project was a unique collaboration of scientist and artist. Albinus worked with relentless dedication for a period of over twenty years, ten of these with the artistic aid of Jan Wandelaar, and produced the two volumes used in this book, *Tabulae Sceleti et Musculorum Corporis Humani* (Tables of the Human Body) and *Tabulae Ossium Humanorum* (Tables of the Human Bones). Medical historian Dr. Charles Singer praised Albinus' accomplishment: "He introduced a new standard of accuracy into practical anatomy and of accuracy and beauty into anatomical illustrations." Singer adds: "These illustrations, with their finely wrought ornamental backgrounds, were intended for artists as well as for physicians, and no finer work of their type has ever been executed."

Other than a few isolated plates published here and there in anatomy and art instruction books, these two major works of Albinus have not been available to the general public since their publication in 1747.

The publication of Albinus' major works in this convenient modern edition, makes available to the art student an invaluable aid to his study. No artist can be regarded as fully equipped without a knowledge and understanding of the basic shapes of the body.

The artist must study the muscular system of the human form with his own art in mind, for so much of the language of art lies in the rhythmic relationships of

elements. The artist must consider how the bones and the masses of the muscles below the surface of the skin modify the external forms of his model and help create the shape and outline of the body. They are the materials by which he creates, and by which he expresses his perception. As in music, they are the notes and phrases of his composition. And in order to play them, he must be familiar with their structure and functions.

Muscles move by contracting and shortening their size and pulling on the bones across the joints. The size, shape, and position of a muscle are related to the size of the parts it must move and the distance from which it must pull. When the body is in motion, its forms are dragged and pushed in complex ways out of their normal shapes. Hence the need to first see and understand these muscular shapes in their relaxed states with their origins and insertions plainly evident and not partly hidden behind other muscles. The artist is then able to go from the simple to the complex, comparing the inert state to one of action. The differences become obvious. The inexperienced artist struggles in representing the course of a swelling muscle and the depressions about a joint. To the uninformed student, the bone and muscular variations have little meaning, even if he should notice them.

Albinus' beautifully detailed and precise engravings aid the art student in observing more clearly than ever the shape and position of bodily forms. Observation, not memorization of facts is the goal of anatomical study. Simply memorizing facts does not lead to real understanding or creative work. The artist should have a sound idea of how the body is put together, how the parts relate to one another, how they are shaped, and how they function, even if he forgets the specific names of the many structures that make up the body.

By separating the muscles from each other, as well as by showing them together, Albinus makes it easy for the student to compare the forms. He can then analyze the exact size, shape, direction, and attachments of a muscle and, in the convenient "musclemen" at the front of the book, he will see the same muscle in position with other muscles. The student can then logically proceed to the study of the great masters of the figure in action, combined with drawing and painting from the actual model. In his *Essays on the Anatomy of Expression in Painting* (1806), the eminent anatomist, Sir Charles Bell, reminded us that, "Anatomy is the true basis of the arts of design. It bestows on the painter a minuteness of observation which he cannot otherwise attain, . . . will enable him to give vigour to the whole form, and will also teach him to represent certain niceties of expression, which, otherwise, are altogether beyond his reach."

This book is primarily for artists, and details of the body that do not show on the surface or influence surface forms have been omitted in the labeling. Any archaic terminology in the original book that is not found in contemporary anatomy books has been brought up to date. Also, the order of the plates and of the bones and muscles within the plates have been reorganized.

The knowledge of bony and muscular structure was surprisingly accurate in Albinus' time, and the few minor differences from contemporary anatomy that were found are of little importance to the artist. Nevertheless, corrections on these will be found in the tracings and in the labeling.

Albinus was very successful and greatly appreciated in his time. Historians in the fields of medicine and art have long been aware of his unique contribution. This convenient edition will finally make it possible for many to enjoy this fine work of science and art, which offers a fresh approach to artists in their study of the human body.

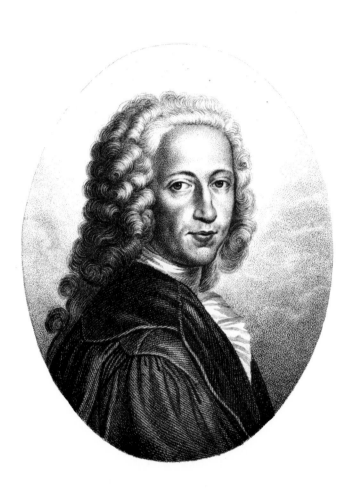

Bernard Siegfried Albinus (1697–1770) was born at the close of the seventeenth century, the eldest of three sons of the Professor of Medicine at the University of Frankfort in Oder, Germany. A few years later, in 1702, Albinus' father was transferred to the University of Leyden in the Netherlands. It was there, in Leyden, that Albinus began his education.

The century into which Albinus was born was one of great achievements in art, literature, and science, particularly in the Netherlands, where there was a period of great prosperity, accompanied by a sudden and almost unparalleled burst of national genius. Leyden was a prominent academic and cultural center of the Netherlands. Rembrandt himself had been born in Leyden, registered at the University, and was no doubt familiar with the anatomy lessons there. It was here that Albinus studied with the famous anatomist Boerhaave. In 1718 he went to Paris, where he studied anatomy and botany. The following year Boerhaave called him back to Leyden to lecture on anatomy and surgery. In 1721, he succeeded his father as Professor of Anatomy and Surgery; he was to remain in that position for the next fifty years.

Albinus soon became one of the most famous teachers of anatomy in Europe, and students came from as far away as the American Colonies to study with him. However, he did more than teach anatomy. With Boerhaave, Albinus edited the works of other famous anatomists, such as Eustachius, Harvey, and Vesalius. He also wrote numerous publications of his own, the best known of which were *Tabulae Sceleti et Musculorum Corporis Humani* (1747) and *Tabulae Ossium Humanorum* (1753), both of which constitute this present volume.

An Account of the Work. At the beginning of the 1747 edition of *Tabulae Sceleti et Musculorum Corporis Humani*, Albinus wrote a long preface describing in great detail his working methods, the problems he encountered along the way during the more than twenty years of this project, and his reasons for adopting the methods that he used. The following is a summary of this preface.

In 1724, Albinus set out to do a fresh examination of the human body from direct observations of his dissections as Professor of Anatomy and Surgery at

Leyden. He started by having an artist, Jan Wandelaar, make drawings of the body, beginning with the surface and proceeding inward by layers. To this end, Albinus exposed the various layers of muscles before Wandelaar. But as he worked, Wandelaar found it difficult to make accurate drawings of the parts, since the muscles were continually being disturbed by deeper dissections. Albinus then decided that since the skeleton was the one stable part of the anatomy that could give him a fixed point of reference, he would start by preparing a skeleton and make very accurate, measured drawings and engravings of this.

He wrote, "what I wanted was something more than even the best anatomists trouble their heads about, it being usual for them to make only random figures of the parts, without considering either the order, dimensions, continuations, or connections of them with one another."

The Skeleton. At the end of the year 1725, he found a fresh skeleton of a fully grown male of about twenty-five, of middle stature and very well proportioned, with signs of agility, ". . . with all the tendons, ligaments, and cartilages attached . . . and I preserved these from decay by soaking them in vinegar."

The skeleton was arranged in a natural posture on a low table at the engraver's eye level, and held upright with tensed cords at the spine, shoulder girdle, and arms. The pelvis rested on a metal tripod. "I tied a chord to the upper part of the spine, where it is firm and less flexible," he explained, "and pulling it straight to the ceiling, fastened the end of it to a hook in the wall." Several days were then spent in adjusting the skeleton's posture by tightening or relaxing the cords until all was perfect.

The Model. "I next looked for a thin man, the same size as my skeleton, and making him stand naked in the same position, I compared the skeleton with him, especially the hip bone, spine, thorax, scapula, and clavicles; because if these parts were put into proper positions, there would not be any great difficulty in the rest."

Albinus overcame the problem of obtaining correct proportions between the parts of the body in the drawings of his artist by using grids or nets made of cords and divided into squares. These were placed at selected intervals between the artist and the skeleton. One grid was placed almost in contact with the skeleton by which the artist could draw from a distance of up to forty feet. For the drawing of detail, a second grid with the squares greatly reduced in size, was placed four feet in front of the first grid. The artist would look through the grid and place himself so that the cords of the two grids lined up with one another on his view of the skeleton, and could check his accuracy by means of these lines and their intersections.

The Drawing. Wandelaar made general drawings of the whole skeleton at the greatest distance (forty feet) and then moved closer to it to verify the finer details.

The three first figures of the skeleton "could not be finished in less than three months," so in order to slow the drying and putrefaction, I moistened it with

water, and cutting the ligaments, poured it into the joints when the putrefaction was to be checked, I sprinkled it with vinegar, . . . wrapped it up in the night time with paper dipped in vinegar." While he was working on the first skeleton, a hard frost came on and the skeleton was frozen which kept it firm and fresh. The second could have been done frozen, Albinus says, but the thaw came, and it was further complicated by the fire he was obliged to have when the naked man stood for them.

The positions of the first and second skeleton show it standing in an erect posture. In the third view of the skeleton, the figure is in a walking position.

When the skeletons were finished in position they were disassembled, cleaned of ligaments, and engraved separately in their natural size for greater accuracy. He regularly had tracings made from the muscle specimens of his dissections and those of his students.

When the drawings were completed, they were reduced and then engraved on copperplates.

The Printing. The printing was done with many tests and experiments to avoid distortion in running them through the press. Artistic and accurate representations of the precise form and connection of anatomic structures were discovered through endlessly repeated comparative studies. Albinus believed that in order to accurately portray the bones and muscles, what was required was not merely an illustration of the result of a single dissection as was usually done. He felt that it would require the careful measuring and drawing of a great many specimens over a period of many years. This would give him a composite picture illustrating an anatomic norm or average.

The most important factors to be observed and recorded about the muscles were the position, size, shape, origin, insertion, and the general course of the fibers. After carefully corrected drawings of the various layers of muscles had been made, the plates were engraved and then printed for the finished work.

The Tables. Two kinds of tables were used, one containing the general connection and position of the muscles all over the body, and the other containing the engraving of each muscle separately. The full "musclemen" show the order of the muscles in general and whatever more is required can be supplied by comparing these general figures with those of the single muscles.

Albinus did not disfigure the beautifully detailed engravings of his artist with reference numbers or labels. Instead, he had Wandelaar engrave an exact copy of the same figure, but in outline only. These were placed on an adjacent page. On these outline engravings were placed keys by which the parts in the original engraving were identified. Where the details in the original engraving were not clear due to the shading, they could be easily distinguished in the outline engraving. This was a new innovation in anatomical illustration and a useful contribution to its development.

Backgrounds. The landscape backgrounds, which were Wandelaar's idea, were added to avoid harshness and create harmony of value relationships, and to give

the illusion of three-dimensional reality to the plates. The backgrounds usually included some animal or architectural fragment. Albinus relates that in 1742, a two and a half year old rhinoceros, a creature rarely seen in that era, was incorporated into the background design of two of the plates for additional interest. All of such ornamentation was kept in natural scale to the human figures.

The Artist. Albinus had very high praise for his skilled artist-engraver, Jan Wandelaar (1690−1759): "I have not only studied the correctness of the figures, but likewise the neatness and elegancy of them. For this end I employed an artist very skillfull both in drawing and engraving. . . . For a great many years by-past, he has worked for very few besides myself; and for these last ten (most part of which he has been wholly employed in these tables) almost for me only. He both drew and engraved them under my direction. I endeavoured to make him understand as well as possible what was to be drawn, and I was constantly with him, to direct him how everything was to be done, assisting him in the drawing, and correcting what was drawn. And thus he was instructed, directed, and as entirely ruled by me, as if he was a tool in my hands, and I made the figures myself."

Wandelaar added ornaments, not only to fill up the empty spaces of the tables, and make them appear more interesting, but also so that in the carefully planned shading of these ornaments he could selectively introduce areas of contrast between the figure and the background. By this means he could increase the illusion of depth while still maintaining the harmony and unity of the whole.

The entire project, which was started in 1725, was completed in 1747, when the tables were published.

<div align="right">Terence Coyle</div>

If you are a layman or a beginner, and wish to draw the figure, there are rather obvious problems that you will have to solve before you can make a successful figure drawing.

The Problem of the Identity of Form. Artists know that they cannot create the illusion of a three-dimensional form unless they are aware that the form exists. Laymen, I assure you, are woefully unaware of the totality of forms that comprise the human body. Oh, they are aware of the nose and the nipples and a few other obvious bumps, but that is about all. A first-rate artist, however, is aware of every muscular and skeletal form on the human body that might in any way be of use to him. This information is not very hard to get because every single form the artist needs to know is listed in the index of this or any other decent book on artistic anatomy, and the artist soon learns that quite a number of the forms so listed are too trivial to worry about.

The Problem of Creation of Shape. It seems clear that you cannot hope to create the illusion of the shape of a form unless you yourself have decided in advance what shape you wish that form to take. You see, if you do not have in mind a conception of the shape of a form, you cannot communicate a conception of that shape to other people, and drawing, something like a language, is a matter of communicating to others through the illusion of shape.

It is most difficult to explain to a student that the shape of a bodily form is a matter of his own decision, a creative act that conforms to the drawing at hand. If he wishes to offer the illusion of the shape of a muscular mass, he is guided by his knowledge of the shapes of the bones to which the muscular mass originates and is inserted, his knowledge of the function of the muscular mass, his knowledge of comparative anatomy, and so forth. He may even characterize the shape so that it looks more like itself than it does on the model. He may subtly transform the shape so that it will more readily reveal itself in the light he has created to fall upon it, and he may alter the shape to conform to his overall demands of rhythm and design. This book should offer you many suggestions as to the shapes of the various forms that comprise the human body.

The Problem of Proportion. When you have become aware that a bodily form exists, and have come to a conclusion as to its shape, you have a further problem. You must come to a conclusion as to its proportional relationship to all the other shapes in the body.

The best way to do this is to create in your own mind your own personal image of a human figure that has what you believe to possess the normal proportions of the human race. You see, nobody knows what a normal human figure really is. So it is your responsibility as an artist to create a personal image, or Secret Figure, that you assume to be normal. You must ultimately learn to draw this Secret Figure out of your imagination in any position or aspect. Then when you draw the model, you mostly set down what you have long since created. Of course, you will make changes here and there to conform with certain abnormal characteristics of the individual model since there is no way to perceive or measure these abnormal characteristics unless you can compare them with what you yourself perceive to be the normal.

In creating your Secret Figure, pay particular attention to the skeleton. Adult skeletons may vary greatly in height, but the proportions of the bones each to each remain remarkably similar.

Of course, there are sexual differences between skeletons. Women are not as tall as men, but the artist may well assume that their proportional heights, landmark to skeletal landmark, are about the same. However widths are another matter. A man's pelvis may be considered as wide as his rib cage, but a woman's pelvis is always wider proportionally, as wide, perhaps, as the width from the outer end of one collar bone (clavicle) to another. Yet once the artist has fixed the width of either a male or female pelvis, the artist may assume that the landmarks will hold very similar proportional relationships each to each in relation to the full width of the pelvis. The sacrum, for instance, will remain one third the total width of the pelvis, in both male and female, the tuberosities of the ischium will remain half a pelvis length apart, and so forth. As an artist, you can invent any proportional system you like or borrow any you wish, such as the one set down herein.

In my own Secret Figure I use the width of the head as a useful unit. By the width of the head I mean the diameter of the mass conception of the ball or sphere so clearly sensed on the back of the skull. Artists call this diameter the five-eyed line. This unit seems to me to be better than the length of the head so commonly used. This is because as a vertical, horizontal, or depth measurement, the head so frequently strikes skeletal landmarks. You see, in figure drawing, skeletal landmarks retain their position, but fleshy landmarks, like the nipples and the navel, are not to be trusted; they move about like traveling salesmen.

Good proportions may be at once obtained by the proper positioning of landmarks. Artists frequently proceed their drawing down the paper with dots that indicate landmarks, for they know that figure drawing, to a great extent, is but a matter of driving lines from one known landmark to another known landmark. There are eight well-known lines, for instance, that may be driven to each pelvic point, or superior anterior iliac spine.

To show the convenience of the five-eyed line in placing landmarks, take, for

example, the front elevation of the figure. From the top of the head, two of these lines down will strike the pit of the neck. From here one as width will indicate the end of the collar bone (clavicle). One more down will reach the bottom of the sternum. One more down will be the level of the tips of the 10th rib, one more down the level of the pelvic points, from here one half down will strike the symphysis pubis. You will find similar coincidences on the posterior aspect of the body and on the arms and the legs.

The Problem of Position and Aspect. In figure drawing, position has to do with the position of a form in space in relation to fixed reference planes, and aspect has to do with the tilt of the long axis of the form and the amount of rotation about this axis. It always amazes a beginner to be told that an artist does not just copy the position and aspect of a form as he sees it on the figure, but that he actually creates the position and aspect of form to further his expressive intent. Unfortunately, the problem of position and aspect cannot be solved unless the student is willing to study and comprehend perspective as well as architectural drawing from which perspective is derived. This done, he will find that the following conditions pertain.

Position and aspect of bodily forms may at once be detected if the student can see them from the point of view of architectural drawing. To transfer this vision into perspective, the student must encase these forms in either rectangular solids or cylinders. In order to clarify the aspect of a form, the rectangular solid alone will present perfect aspect. The cylinder will only give the tilt of the long axes of the form, although this is often very valuable.

As a student, start encasing your forms in these mass conceptions even though you may not have learned perspective. Do it many times in the beginning and then you will not have to do it any more, as you will be able to visualize the forms so encased in your imagination after you have learned perspective.

Frankly, in order to draw a figure in perspective, the student need only acquire the ability to draw a cube in any position or aspect. Rectangular solids are but extensions of cubes, and the cylinder may be encased within a rectangular solid.

Perspective can be learned from books. My favorite is *Principles of Perspective* by Nigel V. Walters and John Bromham (published by Whitney Library of Design, an imprint of Watson-Guptill Publications, 1974)—a most professional job. The figures and skeletons in Albinus are most subtly presented in perspective. You might take a look at Dr. Paul Richer's *Artistic Anatomy* which is offered in architectural drawing and the figures and diagrams are in scale from page to page. And what of the problem of foreshortening, which all my students ask me about? It cannot be solved without a full knowledge of perspective.

The Problem of Light and Shade. Once the artist has identified the form, conceived its shape, noted its proportional relationship to other forms, decided on its proper position and aspect, he has a further problem. He must render the form in light and shade so that it looks like the shape he has conceived and not something else. In other words, when people look at the illusion of the shape the

artist has produced, they must instantly receive a conception of the exact shape the artist had in mind.

Traditionally, this is best accomplished if the artist lights his form with two lights, and two alone. The reason for this may well be that since life appeared on the planet some four billion years ago, all earthly forms were lit by the sun and its reflected light by day, and the moon and its reflected light by night. Thus we have inherited the ability to recognize with one instantaneous glance the shape of a form lit by two lights, and this ability seems to be deeply buried in our subconscious.

But the sun and the moon are constantly moving, you will say, and therefore represent innumerable sources of light. Of course, the artist knows this; but he also knows that a drawing is a kind of prolonged instantaneous glance, and in the instantaneous instant it must be assumed that nothing moves at all. It is for this reason that he goes to all the trouble of holding his point of sight, his reference planes and his model, fixed and still, and his light source fixed and still as well. What is more, he can still the movement of time itself. If you don't believe this last statement, just draw a picture of the second hand of your watch.

Perhaps painters of the sea are more aware of these matters than most, for they must not only still the sun, but the moving waves and the flying spray as well. If the artist draws indoors, he must be aware of the many sources of light that man himself has so recently invented: candles, lamps, windows, electric lights, and such. He must also learn to ignore these if he chooses and to substitute light sources of his own invention that will best bring into being the illusion of the shape he has in mind.

The creation of fixed sources of light seems to be a special ability of the trained artist. Laymen, primitives, and beginners cannot do this and they are always greatly surprised when told such a thing is possible. However, a trained artist can not only create his own sources of light, but he can also creatively control the position of a source, its size, its intensity, and its color.

Traditionally, the artist lights a form with a so-called direct light coming from above and to the right or the left of the form, and a secondary or reflected light coming from the opposite direction. He is then able to work in terms of two major planes that are brought into existence by his two lights. One is a front plane, which is that area of the form illuminated by his direct light, and the other is a side plane, which is that area illuminated by his less brilliant secondary light. Thus he can visualize any form in this universe in terms of these two major light planes. This, of course, simplifies matters and is a great convenience.

What becomes most important to the artist is the exact place where these two major light planes meet. In figure drawing it is always contour line, or a series of contour lines. It is the outline of the figure that the artist would see if he can imagine himself to be the direct light itself. A knowledge of the correct and exact placing of these contour lines where the major light planes meet is a most important factor in the creation of the illusion of shape and underlying mass.

The techniques used by artists in the creation of light and shade are thoroughly discussed in *Drawing Lessons from the Great Masters* (Watson-Guptill, 1964). Basically, they consist of learning by heart the shade movements on simple

geometrical solids, the mass conceptions mentioned earlier. To do this, you must actually procure these shapes. They are usually around the house: white boxes, eggs, white balls, white rubber tubing, and the like—or you can make them out of paper. To proceed, place each object near a window and observe the two types of lights that fall on it. The light from the window represents the direct light, and the light from the room the reflected light. Note and memorize the movement of tones on these homemade mass conceptions until you can render any one of them with perfect ease in any aspect. Now any individual bodily plane may be considered as the total visible surface, or a part of such a surface, of some mass conception. This being so, it is not too difficult to transfer the tonal movement of a plane on a mass conception to a similar plane on a model. However, you must make sure that the plane on the model has the same aspect as the plane of the mass conception, and that the very same fixed sources of light are falling on both model and mass conception.

If you have a natural feel for architectural drawing, the problem of shade becomes greatly simplified because then you can imagine planes and elevations of the body in terms of vertical and horizontal cross sections. Such sections may be easily imagined if you have constantly practiced drawing both horizontal and vertical contour lines during your training. Then on these planes and elevations, you may imagine the light rays arriving as parallel lines from your two conceived sources. Where these rays strike the surface of the body at the perpendicular, the skin will be light. As the rays strike at more and more acute angles, the skin will become darker.

In ending this brief passage on light and shade, let me warn you about the terrible danger of cast shadows. You must learn to recognize every one of them on the model, and learn to annihilate them ruthlessly. For they can give the illusion of great black crevasses on the form on which they fall, they can obscure the meetings of the planes, and, most terrible of all, the meetings of the major light planes. As your critical ability improves, you may allow them to return, domesticated, weakened, and often greatly shrunken. By then, they may be of occasional help to you in the creation of the illusion. They will subordinate themselves to the tonal values of the major light planes. They will cease to be jet black and contain tonal movements within themselves. They will develop most subtle outer contours, thus hinting of the shape of the form from which they fall as well as accentuating the illusion of the shape of the form *upon* which they fall.

Using This Book. Much knowledge of light and shade and other procedures mentioned in this introduction may be gained through a careful study of the full-length skeleton and muscle figures and backgrounds in this book. On these, the principal source of light is imaginary and falls from the right. The artist, Jan Wandelaar, working under the direction of anatomist Bernard Siegfried Albinus, has succeeded magnificently in creating a most exact illusion of three-dimensional reality upon his flat working surface. He was obviously aware of the problems we have been discussing; he has solved them with instinctive grace.

Robert Beverly Hale

THE PLATES

THE BONES AND MUSCLES OF THE BODY

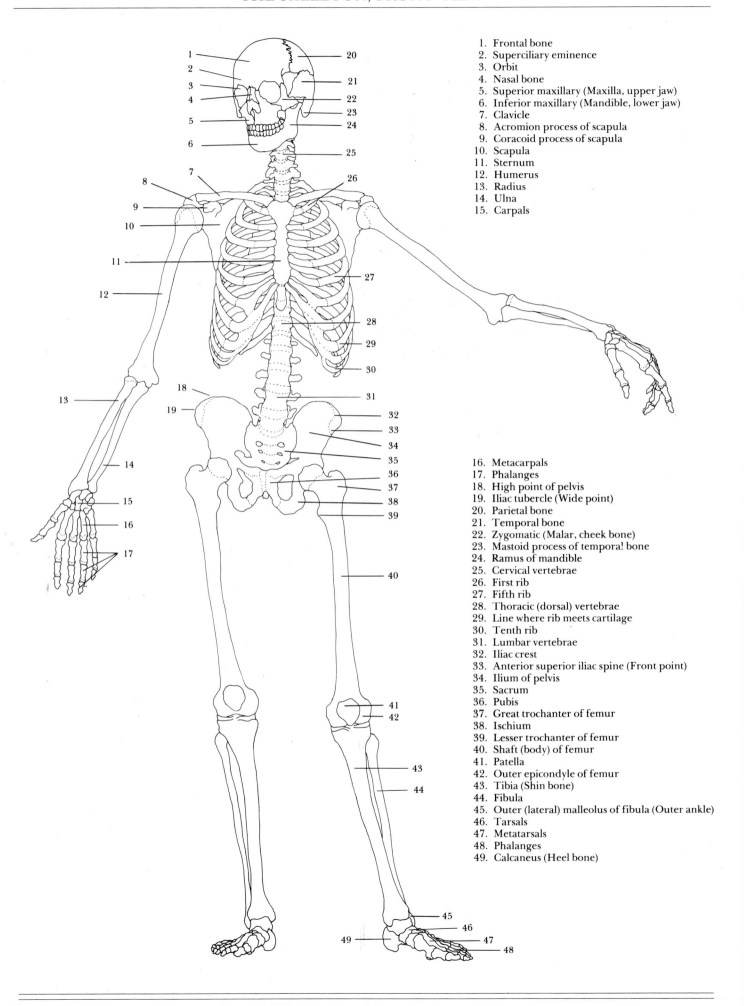

1. Frontal bone
2. Superciliary eminence
3. Orbit
4. Nasal bone
5. Superior maxillary (Maxilla, upper jaw)
6. Inferior maxillary (Mandible, lower jaw)
7. Clavicle
8. Acromion process of scapula
9. Coracoid process of scapula
10. Scapula
11. Sternum
12. Humerus
13. Radius
14. Ulna
15. Carpals

16. Metacarpals
17. Phalanges
18. High point of pelvis
19. Iliac tubercle (Wide point)
20. Parietal bone
21. Temporal bone
22. Zygomatic (Malar, cheek bone)
23. Mastoid process of temporal bone
24. Ramus of mandible
25. Cervical vertebrae
26. First rib
27. Fifth rib
28. Thoracic (dorsal) vertebrae
29. Line where rib meets cartilage
30. Tenth rib
31. Lumbar vertebrae
32. Iliac crest
33. Anterior superior iliac spine (Front point)
34. Ilium of pelvis
35. Sacrum
36. Pubis
37. Great trochanter of femur
38. Ischium
39. Lesser trochanter of femur
40. Shaft (body) of femur
41. Patella
42. Outer epicondyle of femur
43. Tibia (Shin bone)
44. Fibula
45. Outer (lateral) malleolus of fibula (Outer ankle)
46. Tarsals
47. Metatarsals
48. Phalanges
49. Calcaneus (Heel bone)

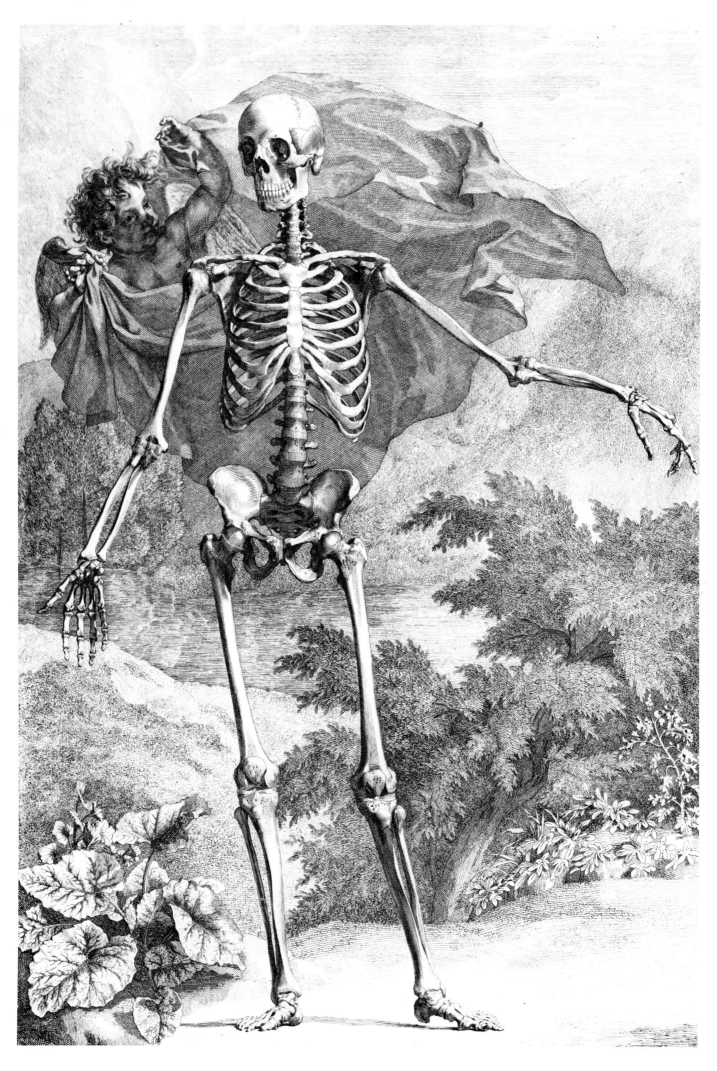

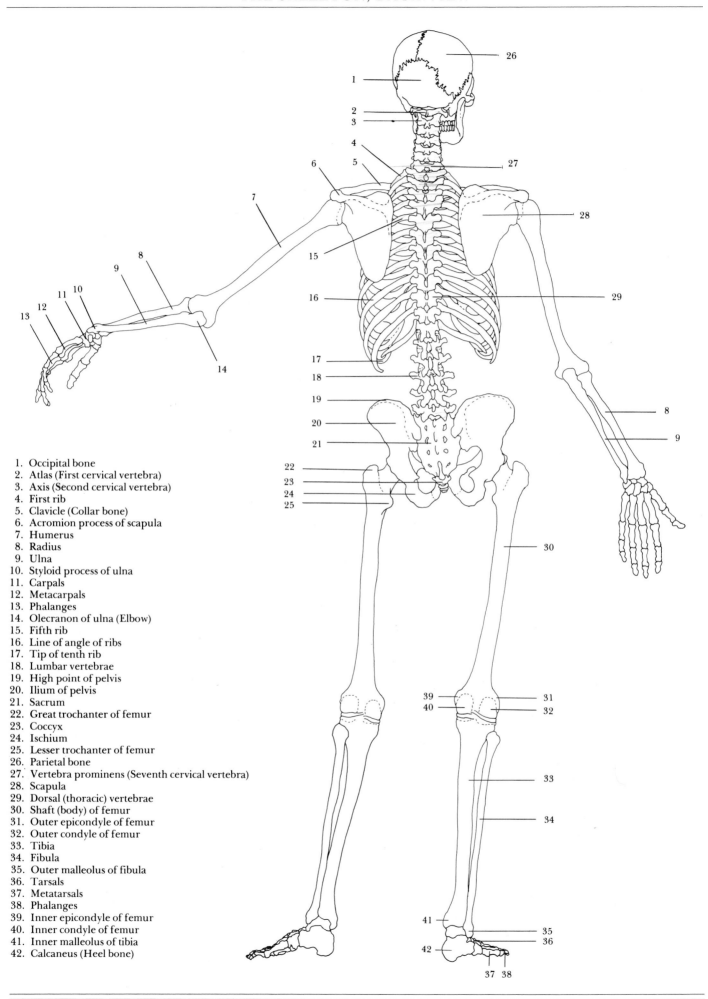

1. Occipital bone
2. Atlas (First cervical vertebra)
3. Axis (Second cervical vertebra)
4. First rib
5. Clavicle (Collar bone)
6. Acromion process of scapula
7. Humerus
8. Radius
9. Ulna
10. Styloid process of ulna
11. Carpals
12. Metacarpals
13. Phalanges
14. Olecranon of ulna (Elbow)
15. Fifth rib
16. Line of angle of ribs
17. Tip of tenth rib
18. Lumbar vertebrae
19. High point of pelvis
20. Ilium of pelvis
21. Sacrum
22. Great trochanter of femur
23. Coccyx
24. Ischium
25. Lesser trochanter of femur
26. Parietal bone
27. Vertebra prominens (Seventh cervical vertebra)
28. Scapula
29. Dorsal (thoracic) vertebrae
30. Shaft (body) of femur
31. Outer epicondyle of femur
32. Outer condyle of femur
33. Tibia
34. Fibula
35. Outer malleolus of fibula
36. Tarsals
37. Metatarsals
38. Phalanges
39. Inner epicondyle of femur
40. Inner condyle of femur
41. Inner malleolus of tibia
42. Calcaneus (Heel bone)

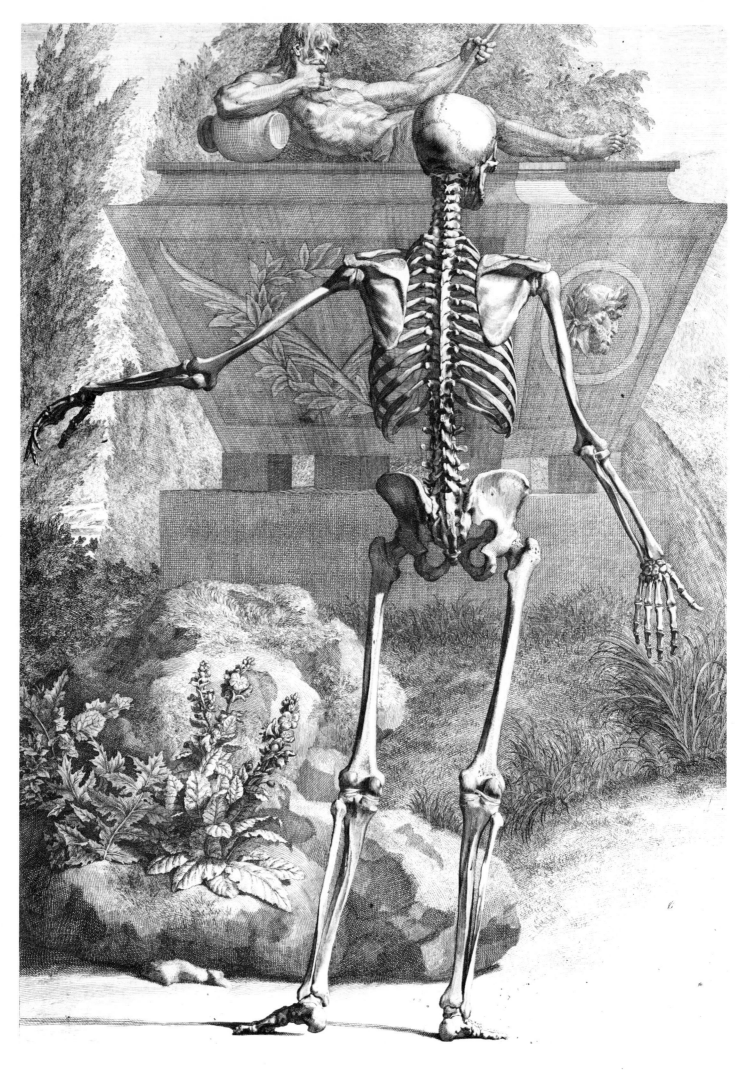

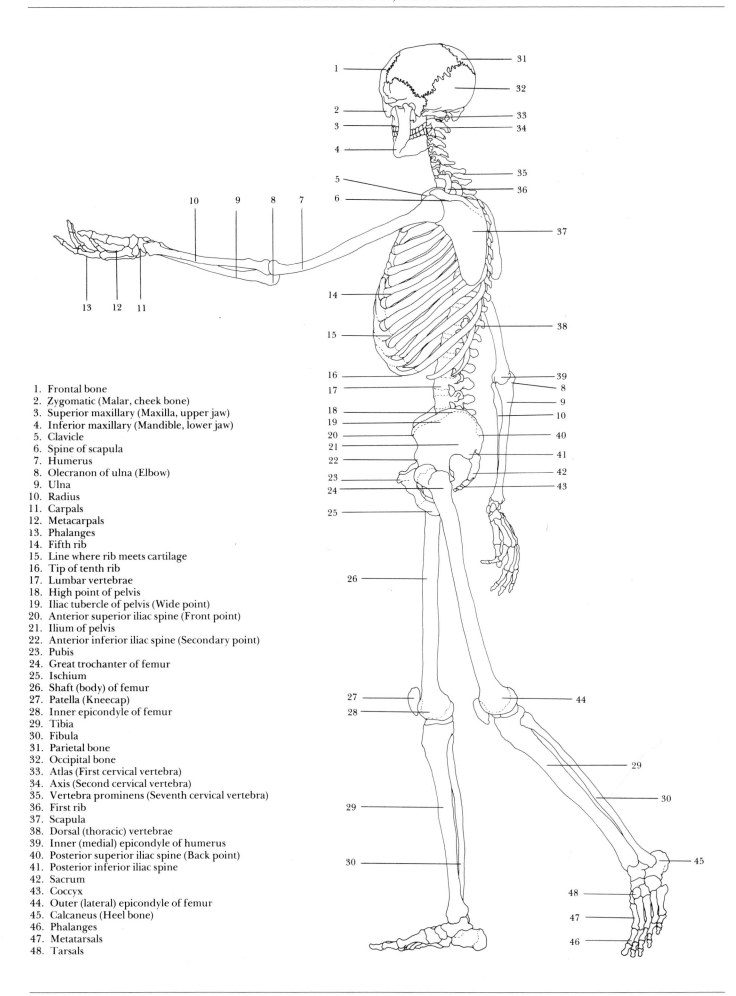

1. Frontal bone
2. Zygomatic (Malar, cheek bone)
3. Superior maxillary (Maxilla, upper jaw)
4. Inferior maxillary (Mandible, lower jaw)
5. Clavicle
6. Spine of scapula
7. Humerus
8. Olecranon of ulna (Elbow)
9. Ulna
10. Radius
11. Carpals
12. Metacarpals
13. Phalanges
14. Fifth rib
15. Line where rib meets cartilage
16. Tip of tenth rib
17. Lumbar vertebrae
18. High point of pelvis
19. Iliac tubercle of pelvis (Wide point)
20. Anterior superior iliac spine (Front point)
21. Ilium of pelvis
22. Anterior inferior iliac spine (Secondary point)
23. Pubis
24. Great trochanter of femur
25. Ischium
26. Shaft (body) of femur
27. Patella (Kneecap)
28. Inner epicondyle of femur
29. Tibia
30. Fibula
31. Parietal bone
32. Occipital bone
33. Atlas (First cervical vertebra)
34. Axis (Second cervical vertebra)
35. Vertebra prominens (Seventh cervical vertebra)
36. First rib
37. Scapula
38. Dorsal (thoracic) vertebrae
39. Inner (medial) epicondyle of humerus
40. Posterior superior iliac spine (Back point)
41. Posterior inferior iliac spine
42. Sacrum
43. Coccyx
44. Outer (lateral) epicondyle of femur
45. Calcaneus (Heel bone)
46. Phalanges
47. Metatarsals
48. Tarsals

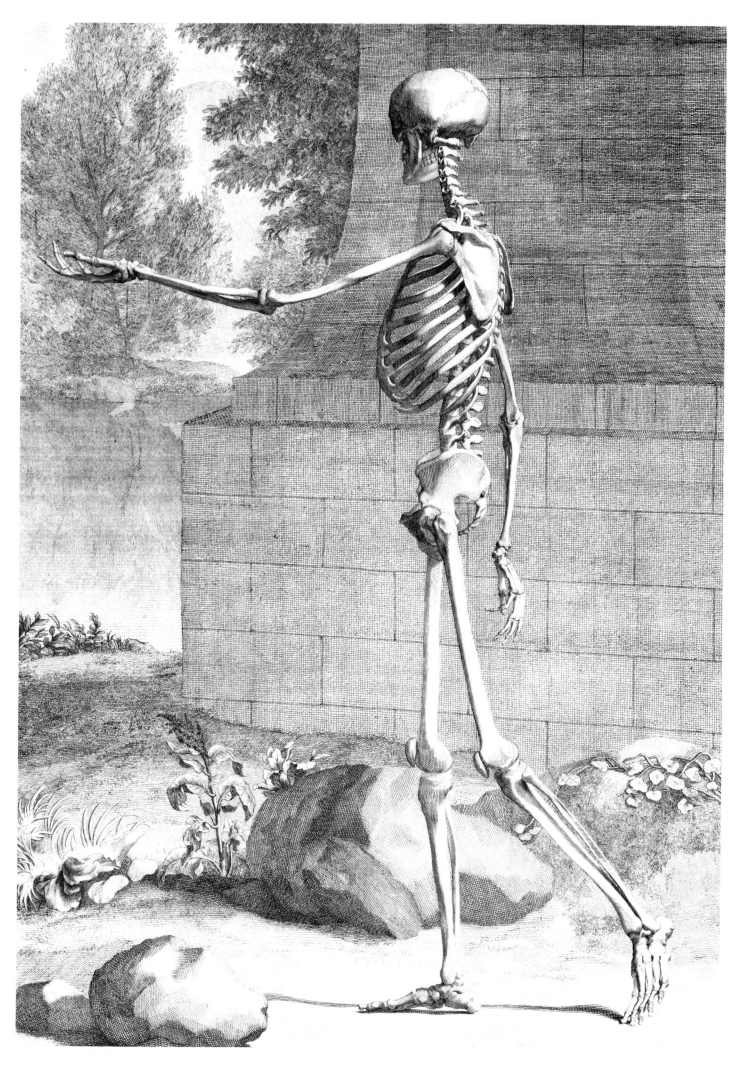

THE OUTERMOST ORDER OF MUSCLES, FRONT VIEW

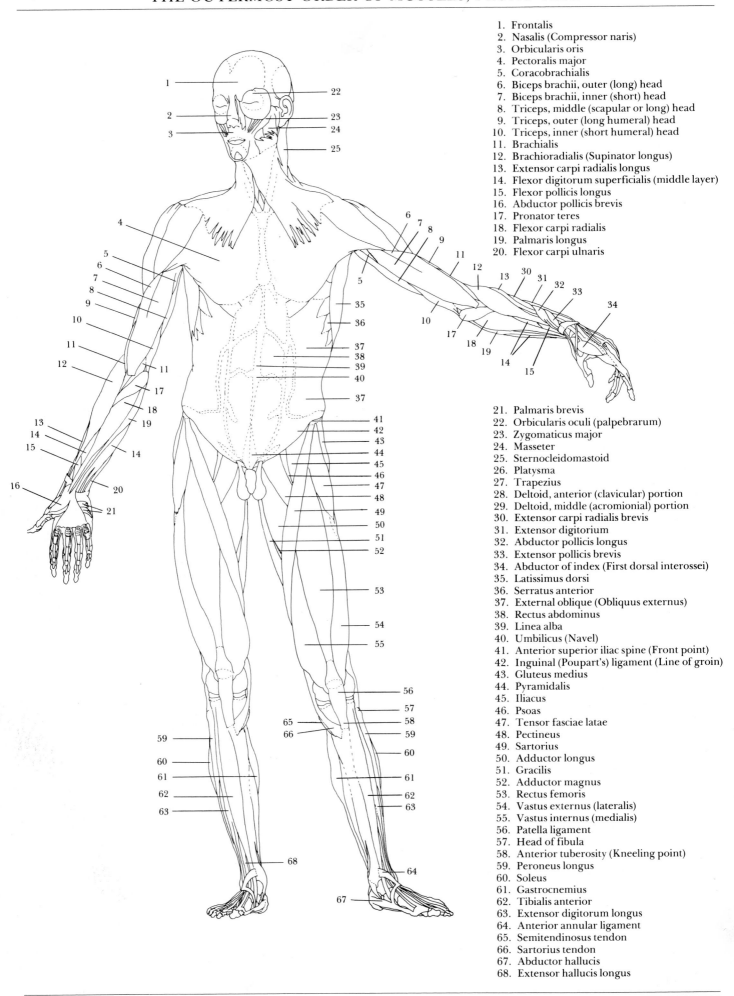

1. Frontalis
2. Nasalis (Compressor naris)
3. Orbicularis oris
4. Pectoralis major
5. Coracobrachialis
6. Biceps brachii, outer (long) head
7. Biceps brachii, inner (short) head
8. Triceps, middle (scapular or long) head
9. Triceps, outer (long humeral) head
10. Triceps, inner (short humeral) head
11. Brachialis
12. Brachioradialis (Supinator longus)
13. Extensor carpi radialis longus
14. Flexor digitorum superficialis (middle layer)
15. Flexor pollicis longus
16. Abductor pollicis brevis
17. Pronator teres
18. Flexor carpi radialis
19. Palmaris longus
20. Flexor carpi ulnaris

21. Palmaris brevis
22. Orbicularis oculi (palpebrarum)
23. Zygomaticus major
24. Masseter
25. Sternocleidomastoid
26. Platysma
27. Trapezius
28. Deltoid, anterior (clavicular) portion
29. Deltoid, middle (acromionial) portion
30. Extensor carpi radialis brevis
31. Extensor digitorium
32. Abductor pollicis longus
33. Extensor pollicis brevis
34. Abductor of index (First dorsal interossei)
35. Latissimus dorsi
36. Serratus anterior
37. External oblique (Obliquus externus)
38. Rectus abdominus
39. Linea alba
40. Umbilicus (Navel)
41. Anterior superior iliac spine (Front point)
42. Inguinal (Poupart's) ligament (Line of groin)
43. Gluteus medius
44. Pyramidalis
45. Iliacus
46. Psoas
47. Tensor fasciae latae
48. Pectineus
49. Sartorius
50. Adductor longus
51. Gracilis
52. Adductor magnus
53. Rectus femoris
54. Vastus externus (lateralis)
55. Vastus internus (medialis)
56. Patella ligament
57. Head of fibula
58. Anterior tuberosity (Kneeling point)
59. Peroneus longus
60. Soleus
61. Gastrocnemius
62. Tibialis anterior
63. Extensor digitorum longus
64. Anterior annular ligament
65. Semitendinosus tendon
66. Sartorius tendon
67. Abductor hallucis
68. Extensor hallucis longus

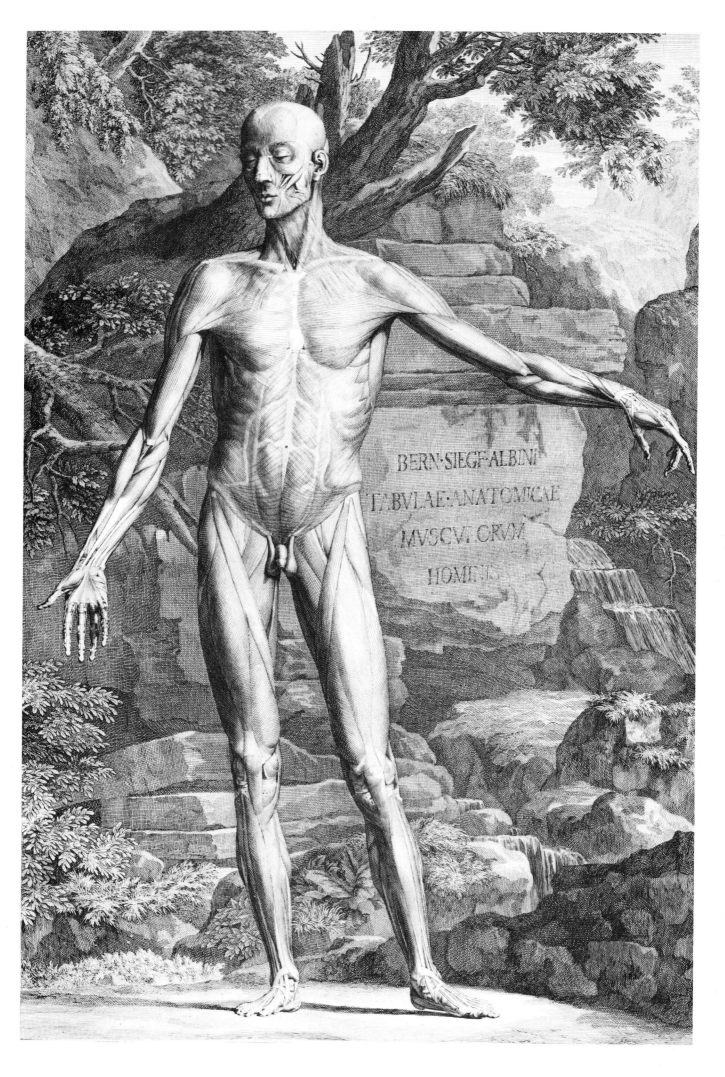

The engraved stone reads:

BERN·SIEGF·ALBINI
TABVLAE·ANATOMICAE
MVSCVLORVM
HOMINIS

1. Occipitalis
2. Sternocleidomastoideus
3. Deltoid, posterior (scapular) portion
4. Deltoid, middle (acromionial) portion
5. Triceps, middle (scapular or long) head
6. Triceps, outer (long humeral) head
7. Brachialis
8. Brachioradialis (Supinator longus)
9. Extensor carpi radialis longus
10. Extensor carpi radialis brevis
11. Extensor digitorum
12. Extensor digiti minimi
13. Extensor carpi ulnaris
14. Triceps, inner (short humeral) head
15. Palmaris longus
16. Anconeus

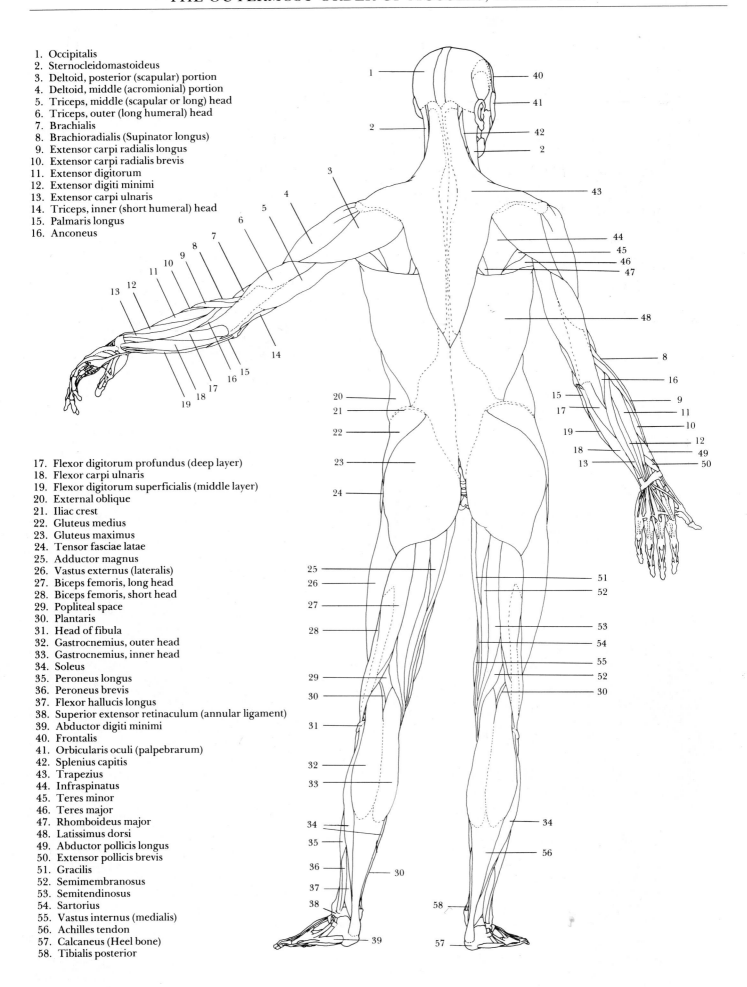

17. Flexor digitorum profundus (deep layer)
18. Flexor carpi ulnaris
19. Flexor digitorum superficialis (middle layer)
20. External oblique
21. Iliac crest
22. Gluteus medius
23. Gluteus maximus
24. Tensor fasciae latae
25. Adductor magnus
26. Vastus externus (lateralis)
27. Biceps femoris, long head
28. Biceps femoris, short head
29. Popliteal space
30. Plantaris
31. Head of fibula
32. Gastrocnemius, outer head
33. Gastrocnemius, inner head
34. Soleus
35. Peroneus longus
36. Peroneus brevis
37. Flexor hallucis longus
38. Superior extensor retinaculum (annular ligament)
39. Abductor digiti minimi
40. Frontalis
41. Orbicularis oculi (palpebrarum)
42. Splenius capitis
43. Trapezius
44. Infraspinatus
45. Teres minor
46. Teres major
47. Rhomboideus major
48. Latissimus dorsi
49. Abductor pollicis longus
50. Extensor pollicis brevis
51. Gracilis
52. Semimembranosus
53. Semitendinosus
54. Sartorius
55. Vastus internus (medialis)
56. Achilles tendon
57. Calcaneus (Heel bone)
58. Tibialis posterior

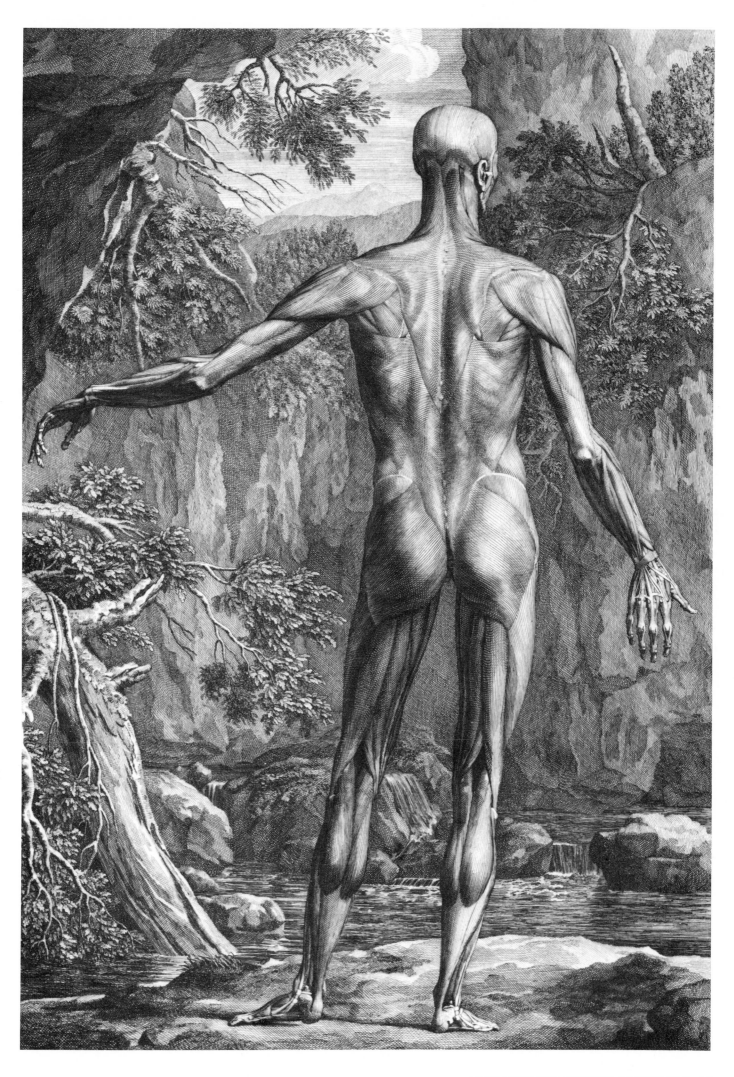

1. Frontalis
2. Auricularis
3. Temporalis
4. Orbicularis oculi (palpebrarum)
5. Platysma
6. Deltoid, middle (acromionial) portion
7. Deltoid, posterior (scapular) portion
8. Biceps brachii, outer (long) head
9. Brachialis
10. Brachioradialis (Supinator longus)
11. Flexor carpi radialis
12. Triceps, middle (scapular or long) head
13. Triceps, outer (long humeral) head

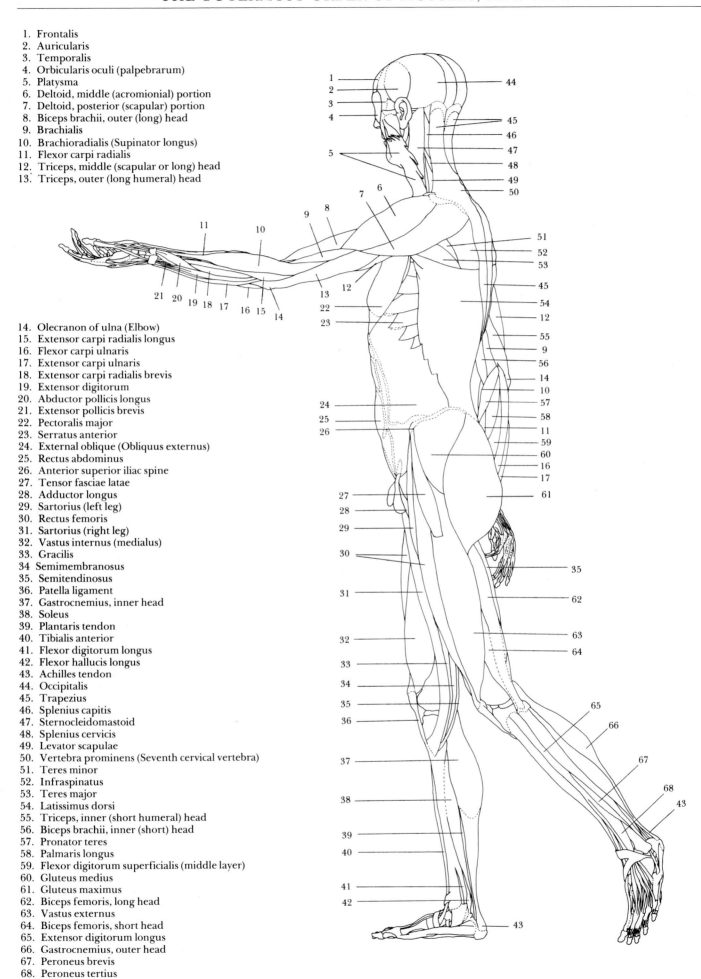

14. Olecranon of ulna (Elbow)
15. Extensor carpi radialis longus
16. Flexor carpi ulnaris
17. Extensor carpi ulnaris
18. Extensor carpi radialis brevis
19. Extensor digitorum
20. Abductor pollicis longus
21. Extensor pollicis brevis
22. Pectoralis major
23. Serratus anterior
24. External oblique (Obliquus externus)
25. Rectus abdominus
26. Anterior superior iliac spine
27. Tensor fasciae latae
28. Adductor longus
29. Sartorius (left leg)
30. Rectus femoris
31. Sartorius (right leg)
32. Vastus internus (medialus)
33. Gracilis
34. Semimembranosus
35. Semitendinosus
36. Patella ligament
37. Gastrocnemius, inner head
38. Soleus
39. Plantaris tendon
40. Tibialis anterior
41. Flexor digitorum longus
42. Flexor hallucis longus
43. Achilles tendon
44. Occipitalis
45. Trapezius
46. Splenius capitis
47. Sternocleidomastoid
48. Splenius cervicis
49. Levator scapulae
50. Vertebra prominens (Seventh cervical vertebra)
51. Teres minor
52. Infraspinatus
53. Teres major
54. Latissimus dorsi
55. Triceps, inner (short humeral) head
56. Biceps brachii, inner (short) head
57. Pronator teres
58. Palmaris longus
59. Flexor digitorum superficialis (middle layer)
60. Gluteus medius
61. Gluteus maximus
62. Biceps femoris, long head
63. Vastus externus
64. Biceps femoris, short head
65. Extensor digitorum longus
66. Gastrocnemius, outer head
67. Peroneus brevis
68. Peroneus tertius

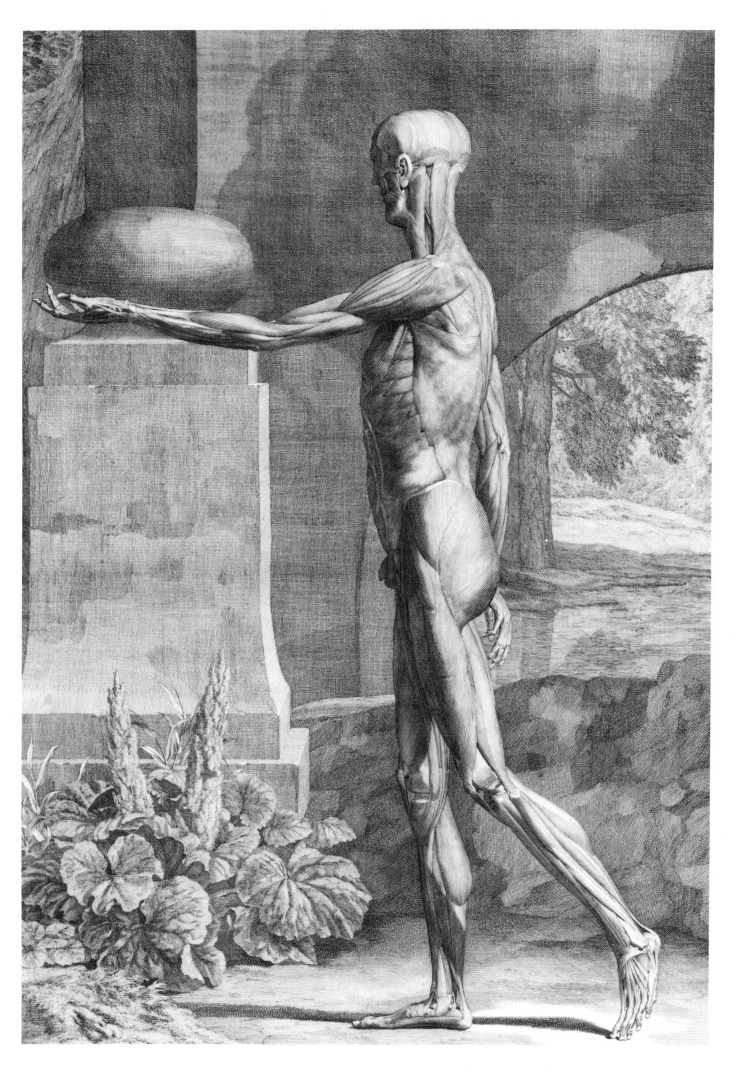

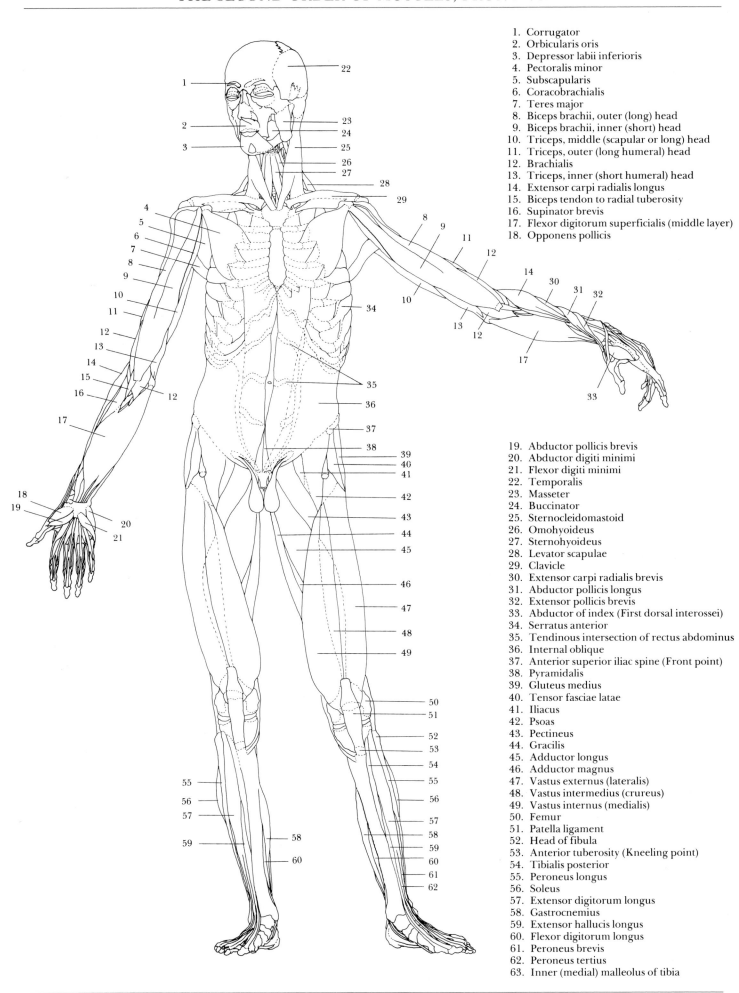

1. Corrugator
2. Orbicularis oris
3. Depressor labii inferioris
4. Pectoralis minor
5. Subscapularis
6. Coracobrachialis
7. Teres major
8. Biceps brachii, outer (long) head
9. Biceps brachii, inner (short) head
10. Triceps, middle (scapular or long) head
11. Triceps, outer (long humeral) head
12. Brachialis
13. Triceps, inner (short humeral) head
14. Extensor carpi radialis longus
15. Biceps tendon to radial tuberosity
16. Supinator brevis
17. Flexor digitorum superficialis (middle layer)
18. Opponens pollicis

19. Abductor pollicis brevis
20. Abductor digiti minimi
21. Flexor digiti minimi
22. Temporalis
23. Masseter
24. Buccinator
25. Sternocleidomastoid
26. Omohyoideus
27. Sternohyoideus
28. Levator scapulae
29. Clavicle
30. Extensor carpi radialis brevis
31. Abductor pollicis longus
32. Extensor pollicis brevis
33. Abductor of index (First dorsal interossei)
34. Serratus anterior
35. Tendinous intersection of rectus abdominus
36. Internal oblique
37. Anterior superior iliac spine (Front point)
38. Pyramidalis
39. Gluteus medius
40. Tensor fasciae latae
41. Iliacus
42. Psoas
43. Pectineus
44. Gracilis
45. Adductor longus
46. Adductor magnus
47. Vastus externus (lateralis)
48. Vastus intermedius (crureus)
49. Vastus internus (medialis)
50. Femur
51. Patella ligament
52. Head of fibula
53. Anterior tuberosity (Kneeling point)
54. Tibialis posterior
55. Peroneus longus
56. Soleus
57. Extensor digitorum longus
58. Gastrocnemius
59. Extensor hallucis longus
60. Flexor digitorum longus
61. Peroneus brevis
62. Peroneus tertius
63. Inner (medial) malleolus of tibia

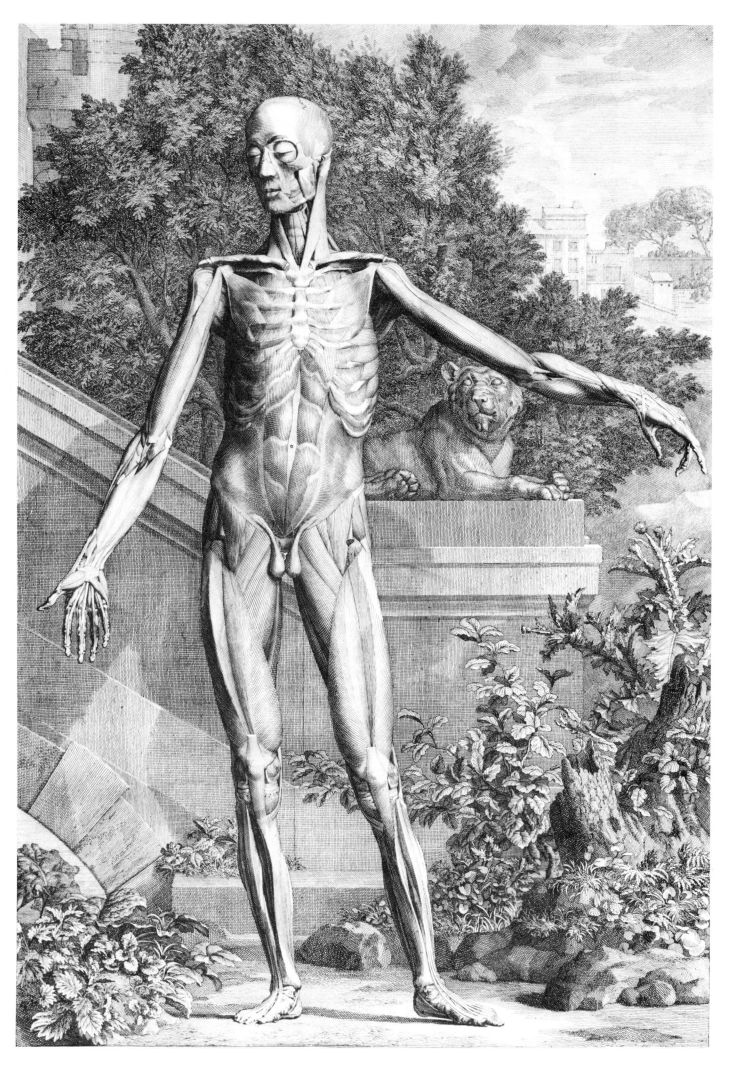

1. Semispinalis capitis
2. Splenius (capitis and cervicis)
3. Serratus posterior superior
4. Levator scapula
5. Triceps, middle (scapular or long) head
6. Biceps brachii, outer (long) head
7. Triceps, outer (long humeral) head
8. Brachialis
9. Extensor carpi radialis longus
10. Extensor carpi radialis brevis
11. Supinator brevis
12. Abductor pollicis longus
13. Extensor pollicis longus
14. Extensor indicis
15. Styloid process of ulna
16. Triceps, inner (short humeral) head
17. Inner (medial) epicondyle of humerus

18. Olecranon of ulna (Elbow)
19. Anconeus
20. Flexor digitorum superficialis (middle layer)
21. Flexor digitorum profundus (deep layer)
22. Flexor carpi ulnaris
23. Spinalis dorsi
24. Serratus posterior inferior
25. Obliquus internus
26. Gluteus medius
27. Great trochanter of femur
28. Vastus lateralis
29. Adductor magnus
30. Biceps femoris, long head
31. Biceps femoris, short head
32. Semitendinosus
33. Semimembranosus
34. Plantaris
35. Popliteus
36. Soleus
37. Achilles tendon, cut off
38. Flexor digitorum brevis
39. Temporalis
40. Masseter
41. Mylohyoid
42. Rhomboideus minor
43. Rhomboideus major
44. Supraspinatus
45. Spine of scapula
46. Infraspinatus
47. Teres minor
48. Teres major
49. Longissimus dorsi
50. Serratus anterior
51. Iliocostalis dorsi (Accessorius)
52. Extensor pollicis brevis
53. Vastus medialis
54. Gracilis
55. Peroneus longus
56. Peroneus brevis
57. Flexor hallucis longus
58. Inner (medial) malleolus of tibia
59. Tibialis posterior tendon
60. Calcaneus (Heel bone)

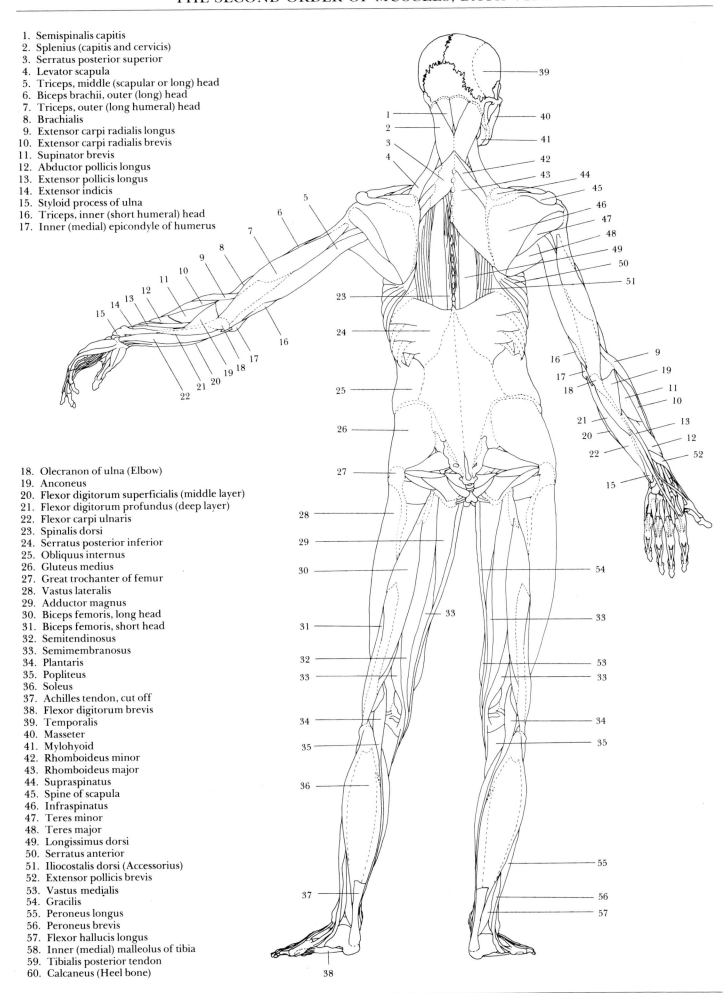

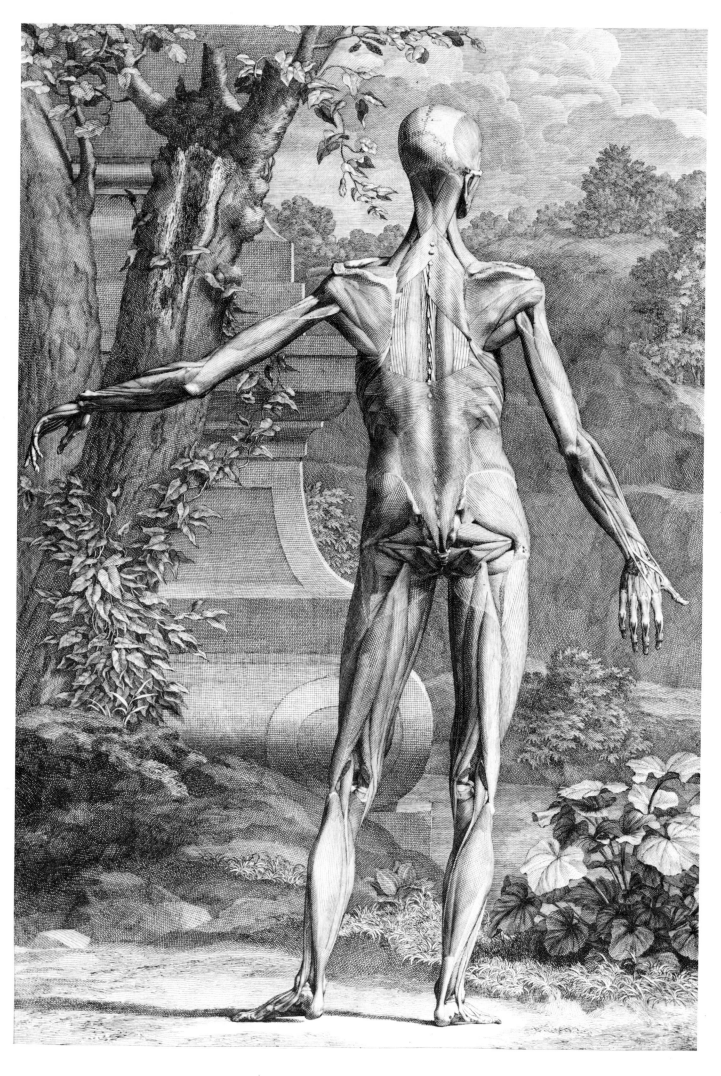

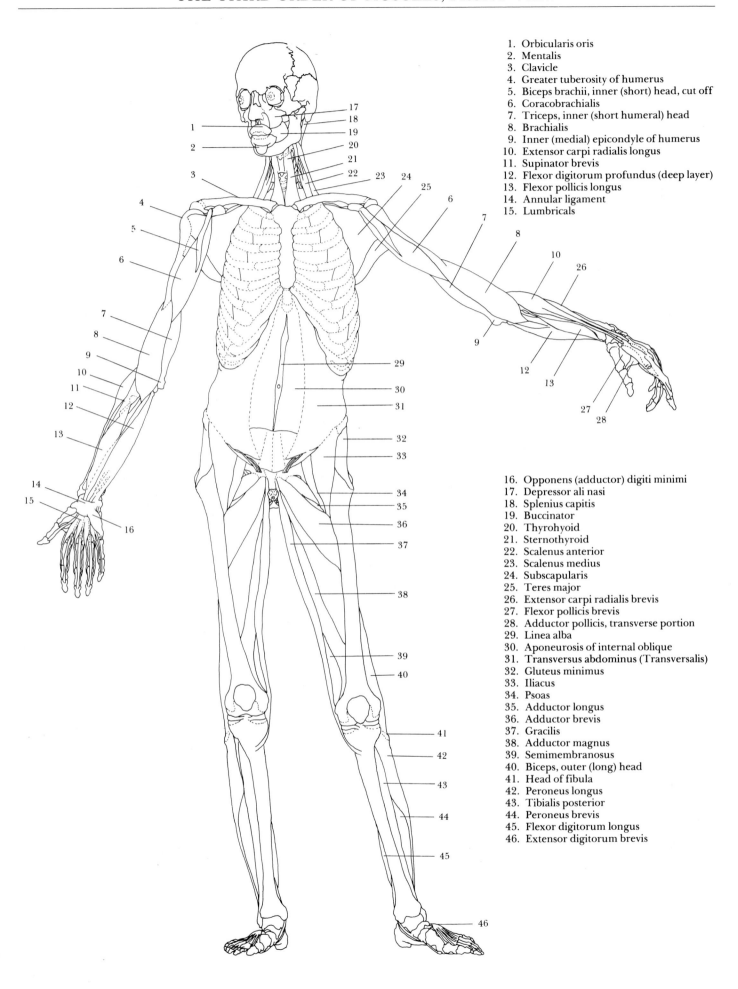

1. Orbicularis oris
2. Mentalis
3. Clavicle
4. Greater tuberosity of humerus
5. Biceps brachii, inner (short) head, cut off
6. Coracobrachialis
7. Triceps, inner (short humeral) head
8. Brachialis
9. Inner (medial) epicondyle of humerus
10. Extensor carpi radialis longus
11. Supinator brevis
12. Flexor digitorum profundus (deep layer)
13. Flexor pollicis longus
14. Annular ligament
15. Lumbricals

16. Opponens (adductor) digiti minimi
17. Depressor ali nasi
18. Splenius capitis
19. Buccinator
20. Thyrohyoid
21. Sternothyroid
22. Scalenus anterior
23. Scalenus medius
24. Subscapularis
25. Teres major
26. Extensor carpi radialis brevis
27. Flexor pollicis brevis
28. Adductor pollicis, transverse portion
29. Linea alba
30. Aponeurosis of internal oblique
31. Transversus abdominus (Transversalis)
32. Gluteus minimus
33. Iliacus
34. Psoas
35. Adductor longus
36. Adductor brevis
37. Gracilis
38. Adductor magnus
39. Semimembranosus
40. Biceps, outer (long) head
41. Head of fibula
42. Peroneus longus
43. Tibialis posterior
44. Peroneus brevis
45. Flexor digitorum longus
46. Extensor digitorum brevis

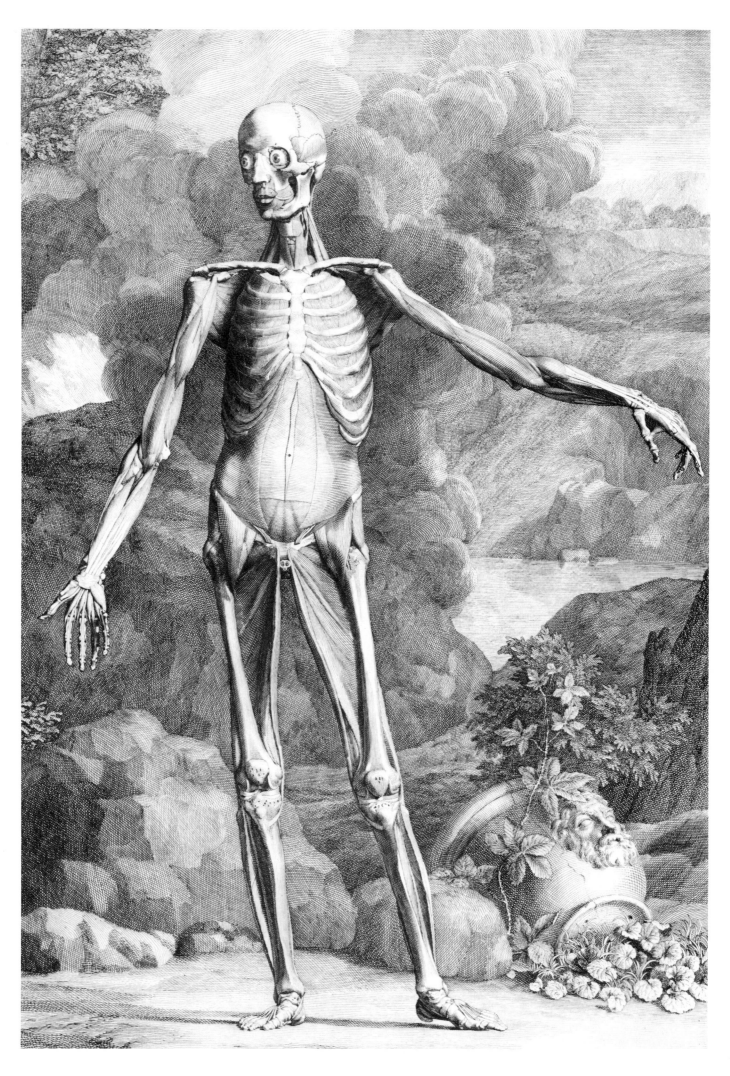

THE THIRD ORDER OF MUSCLES, BACK VIEW

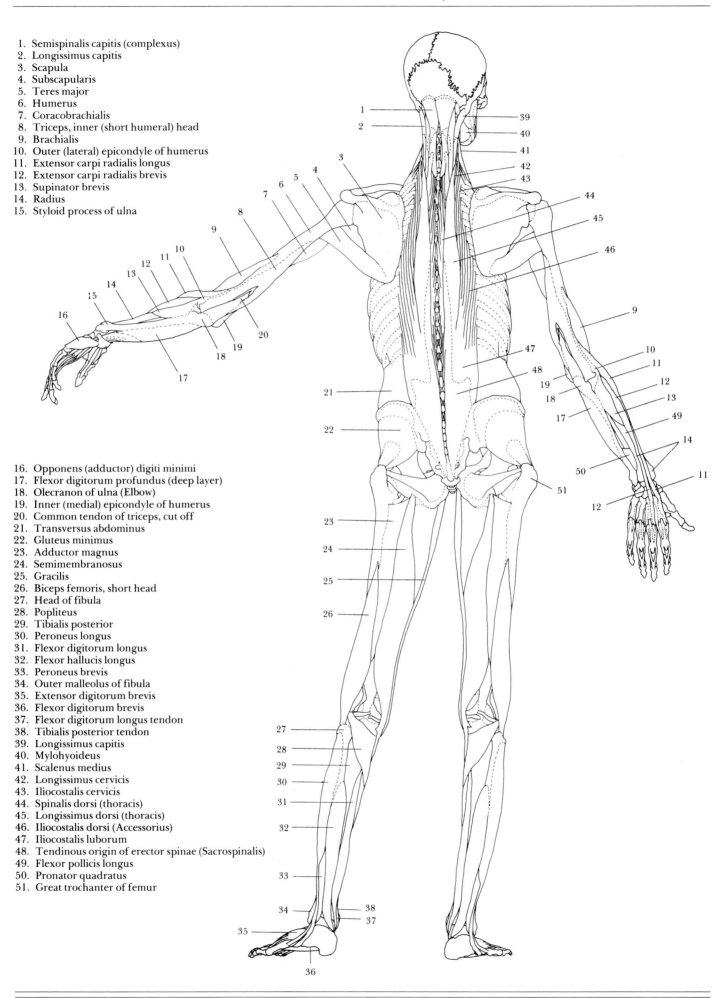

1. Semispinalis capitis (complexus)
2. Longissimus capitis
3. Scapula
4. Subscapularis
5. Teres major
6. Humerus
7. Coracobrachialis
8. Triceps, inner (short humeral) head
9. Brachialis
10. Outer (lateral) epicondyle of humerus
11. Extensor carpi radialis longus
12. Extensor carpi radialis brevis
13. Supinator brevis
14. Radius
15. Styloid process of ulna

16. Opponens (adductor) digiti minimi
17. Flexor digitorum profundus (deep layer)
18. Olecranon of ulna (Elbow)
19. Inner (medial) epicondyle of humerus
20. Common tendon of triceps, cut off
21. Transversus abdominus
22. Gluteus minimus
23. Adductor magnus
24. Semimembranosus
25. Gracilis
26. Biceps femoris, short head
27. Head of fibula
28. Popliteus
29. Tibialis posterior
30. Peroneus longus
31. Flexor digitorum longus
32. Flexor hallucis longus
33. Peroneus brevis
34. Outer malleolus of fibula
35. Extensor digitorum brevis
36. Flexor digitorum brevis
37. Flexor digitorum longus tendon
38. Tibialis posterior tendon
39. Longissimus capitis
40. Mylohyoideus
41. Scalenus medius
42. Longissimus cervicis
43. Iliocostalis cervicis
44. Spinalis dorsi (thoracis)
45. Longissimus dorsi (thoracis)
46. Iliocostalis dorsi (Accessorius)
47. Iliocostalis luborum
48. Tendinous origin of erector spinae (Sacrospinalis)
49. Flexor pollicis longus
50. Pronator quadratus
51. Great trochanter of femur

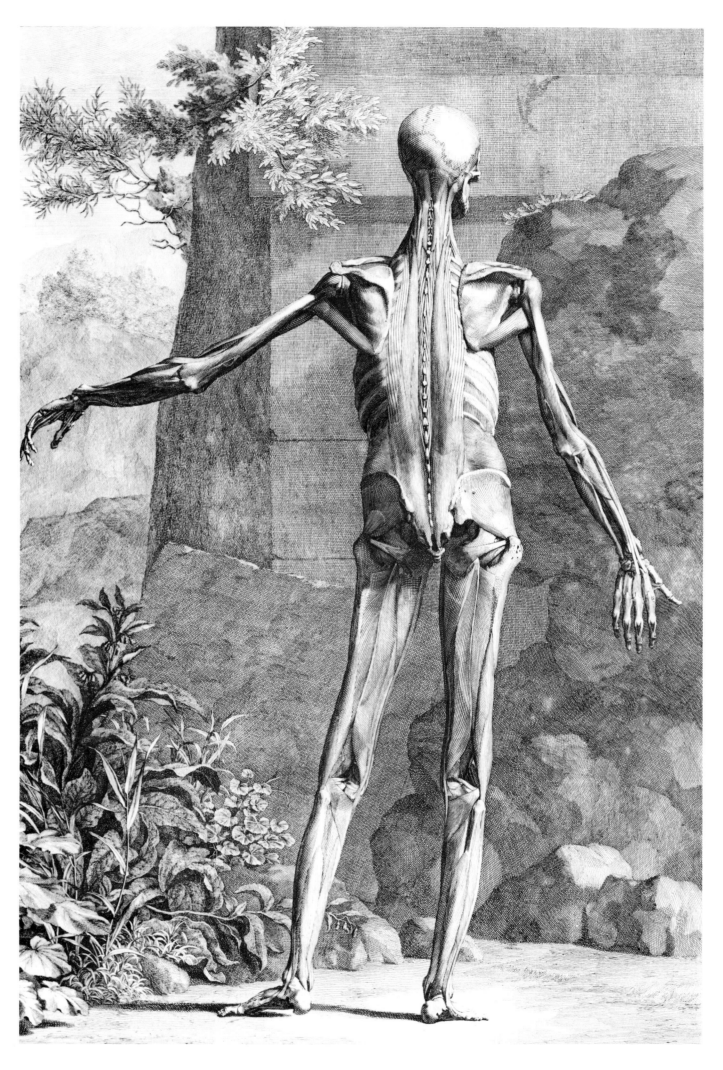

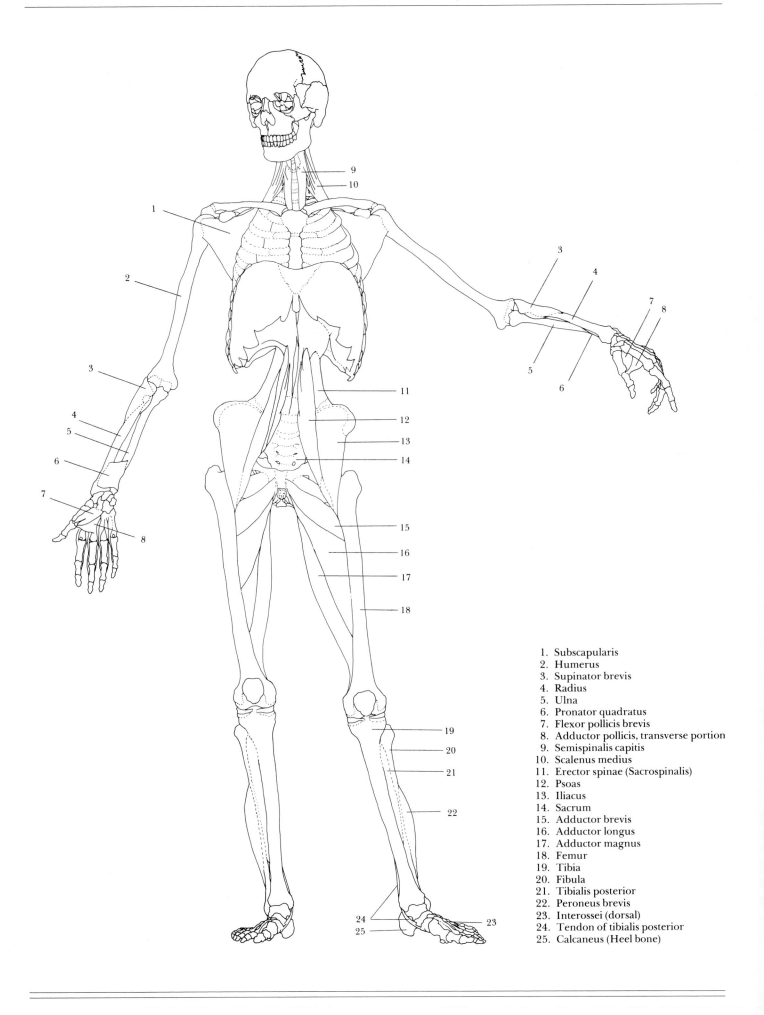

1. Subscapularis
2. Humerus
3. Supinator brevis
4. Radius
5. Ulna
6. Pronator quadratus
7. Flexor pollicis brevis
8. Adductor pollicis, transverse portion
9. Semispinalis capitis
10. Scalenus medius
11. Erector spinae (Sacrospinalis)
12. Psoas
13. Iliacus
14. Sacrum
15. Adductor brevis
16. Adductor longus
17. Adductor magnus
18. Femur
19. Tibia
20. Fibula
21. Tibialis posterior
22. Peroneus brevis
23. Interossei (dorsal)
24. Tendon of tibialis posterior
25. Calcaneus (Heel bone)

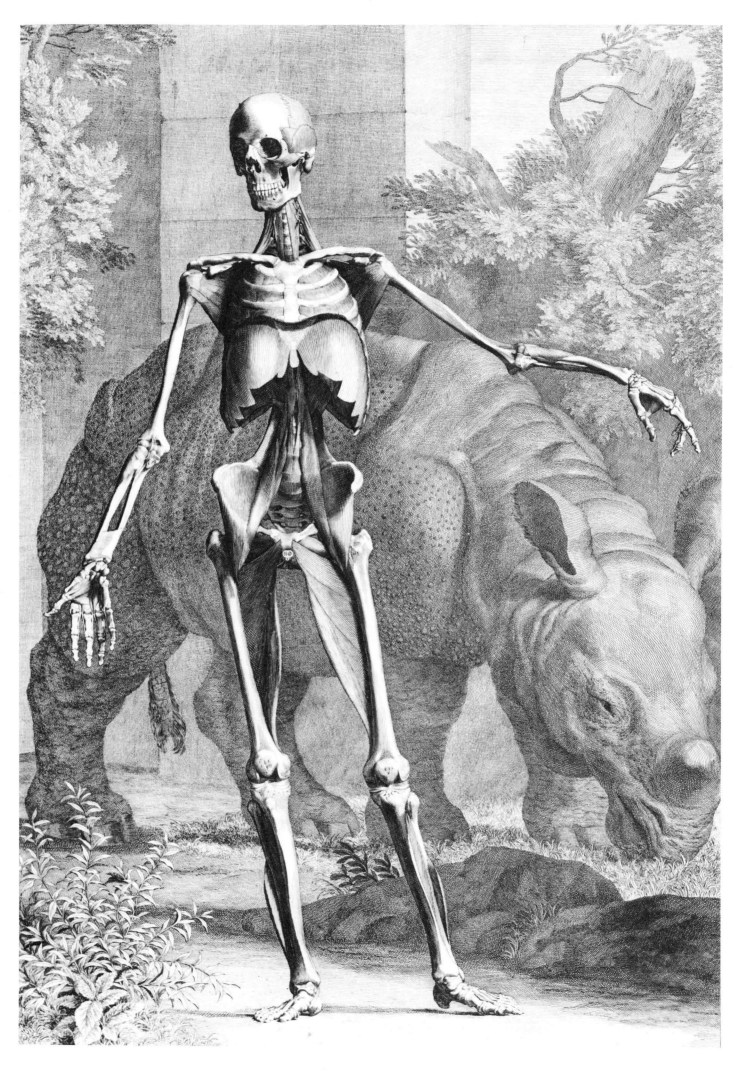

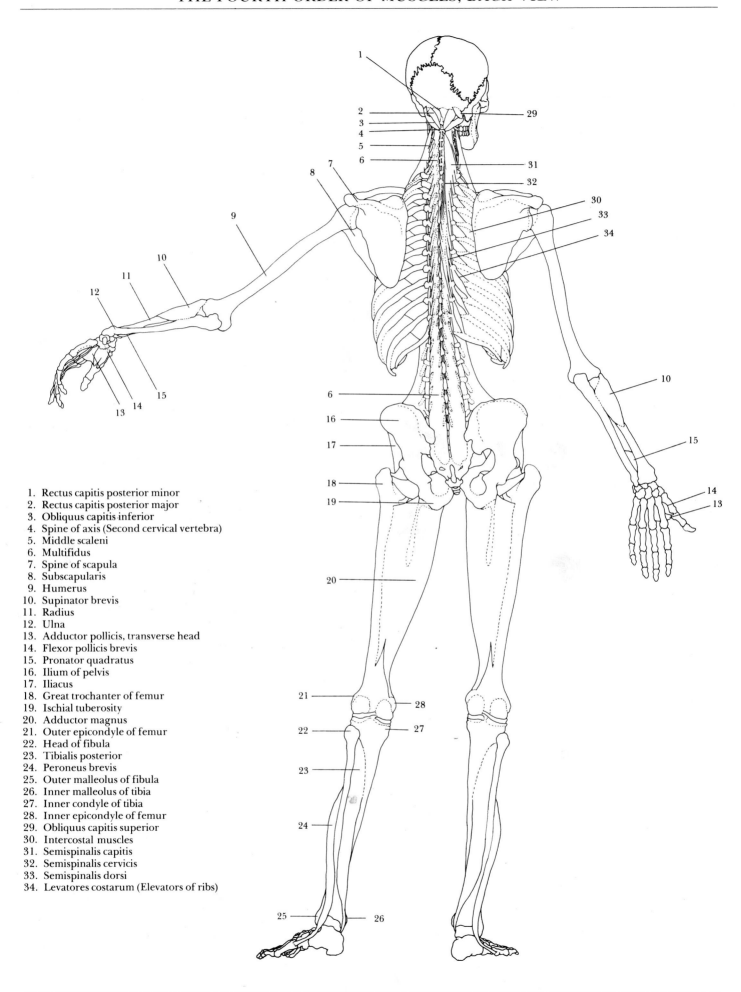

1. Rectus capitis posterior minor
2. Rectus capitis posterior major
3. Obliquus capitis inferior
4. Spine of axis (Second cervical vertebra)
5. Middle scaleni
6. Multifidus
7. Spine of scapula
8. Subscapularis
9. Humerus
10. Supinator brevis
11. Radius
12. Ulna
13. Adductor pollicis, transverse head
14. Flexor pollicis brevis
15. Pronator quadratus
16. Ilium of pelvis
17. Iliacus
18. Great trochanter of femur
19. Ischial tuberosity
20. Adductor magnus
21. Outer epicondyle of femur
22. Head of fibula
23. Tibialis posterior
24. Peroneus brevis
25. Outer malleolus of fibula
26. Inner malleolus of tibia
27. Inner condyle of tibia
28. Inner epicondyle of femur
29. Obliquus capitis superior
30. Intercostal muscles
31. Semispinalis capitis
32. Semispinalis cervicis
33. Semispinalis dorsi
34. Levatores costarum (Elevators of ribs)

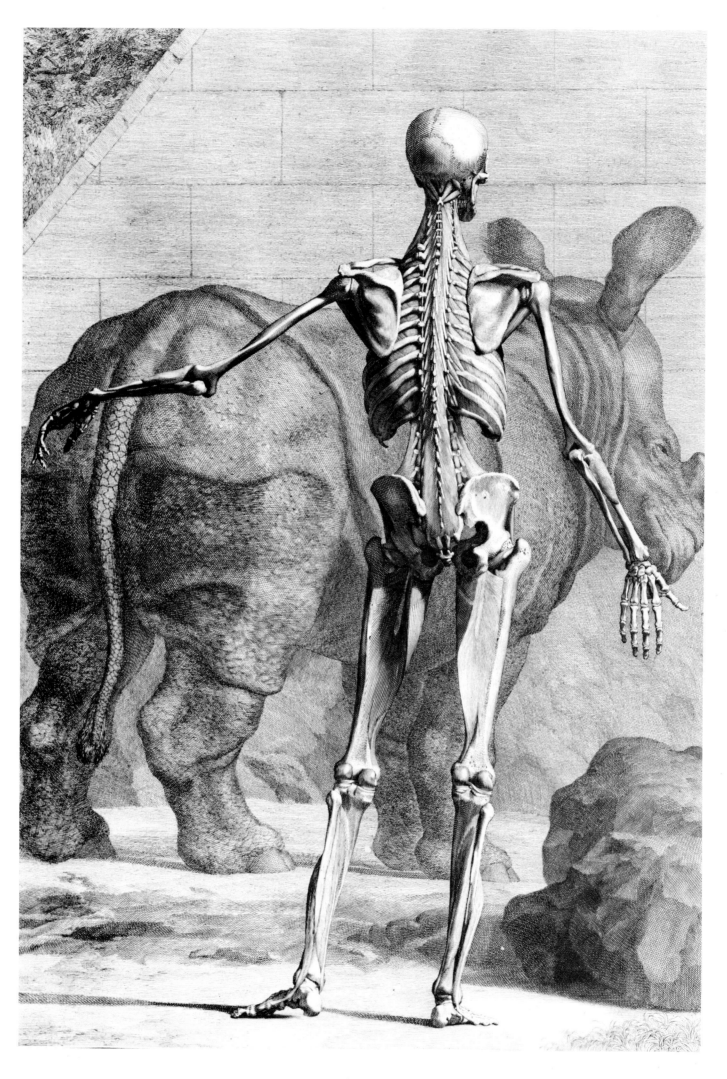

THE HEAD AND NECK

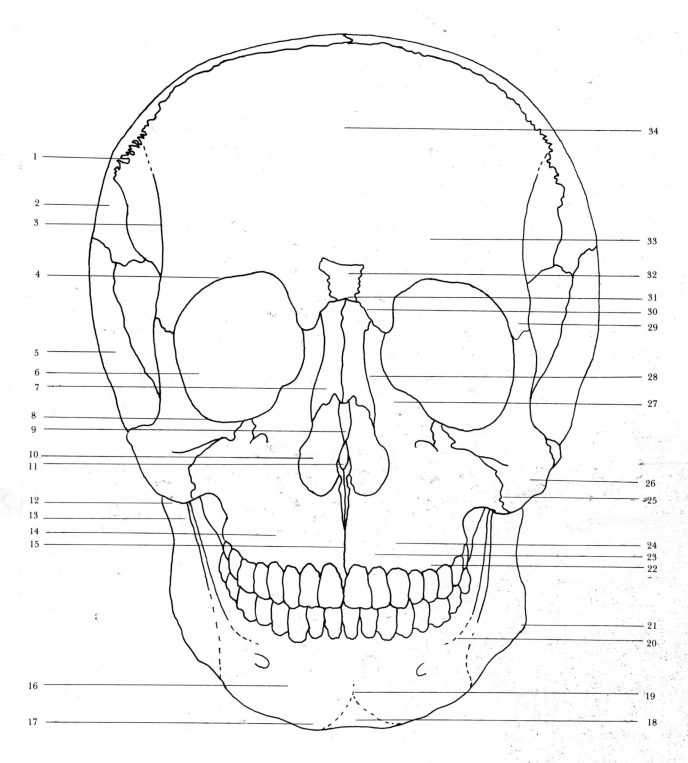

1. Coronal suture
2. Parietal bone
3. Temporal line
4. Orbital arch or margin
5. Temporal fossa
6. Orbit
7. Nasal bone
8. Infraorbital margin
9. Nasal septum (Vomer)
10. Anterior nasal cavity
11. Anterior nasal spine
12. Coronoid process of mandible
13. Ramus of mandible
14. Superior maxillary (Maxilla)
15. Intermaxillary suture (Alveolar point)
16. Inferior maxillary (Mandible)
17. Mental protuberance (tubercle)
18. Mental process
19. Symphysis, median line
20. Oblique line of jaw
21. Angle of jaw (Gonion)
22. Alveolar process or arch
23. Incisive fossa
24. Canine fossa
25. Zygomaxillary suture
26. Zygomatic bone (Malar, cheek bone)
27. Frontal process of superior maxillary
28. Nasomaxillary suture
29. External angular process of frontal bone
30. Frontonasal suture
31. Nasion (Root of nose)
32. Glabella
33. Superciliary ridge
34. Frontal eminence of frontal bone

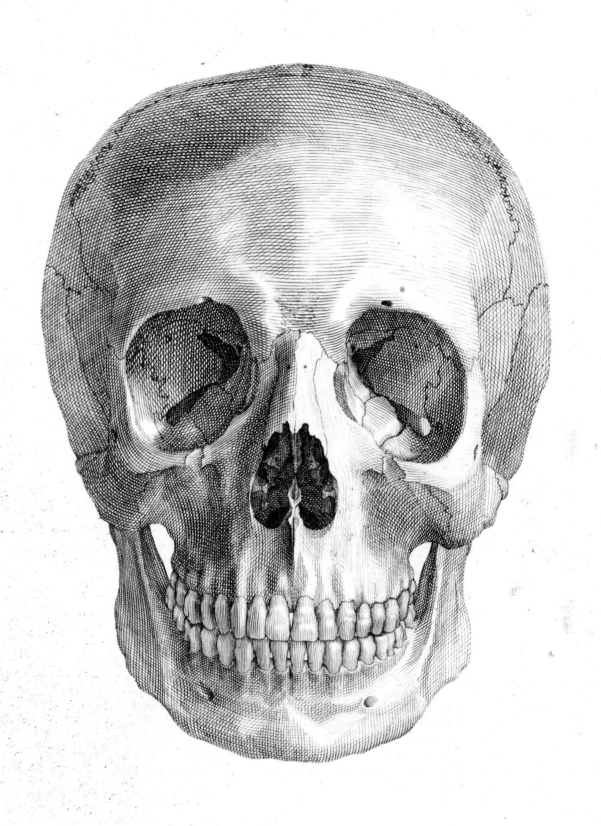

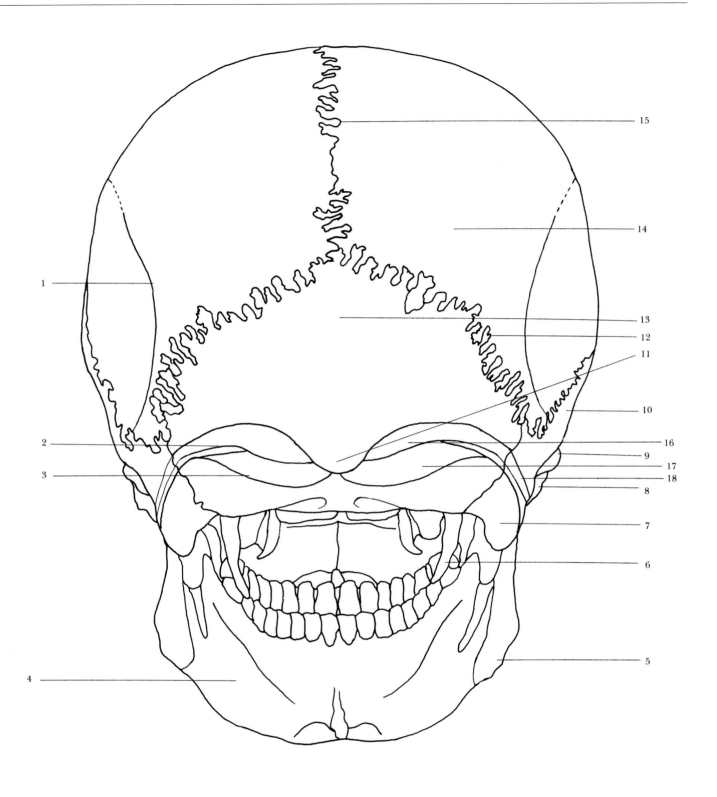

1. Temporal line
2. Superior curved (nuchal) line
3. Inferior nuchal line
4. Inferior maxillary (Mandible, lower jaw)
5. Angle of jaw (Gonion)
6. Styloid process of temporal bone
7. Mastoid process of temporal bone
8. Zygomatic bone (Malar, cheek bone)
9. Zygomatic arch
10. Temporal bone
11. Occipital protuberance
12. Lamboid suture
13. Occipital bone
14. Parietal bone
15. Sagittal suture
16. Origin of trapezius
17. Insertion of semispinalis capitis
18. Insertion of sternocleidomastoideus

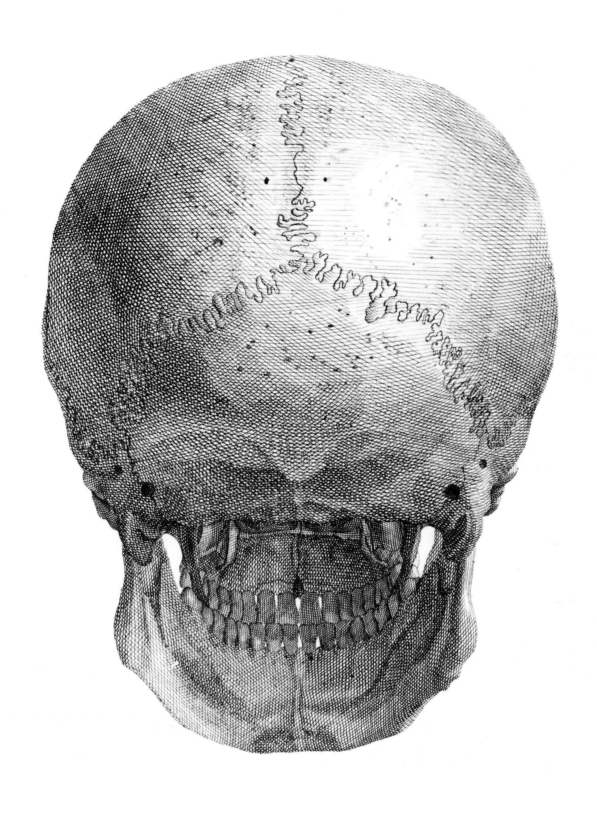

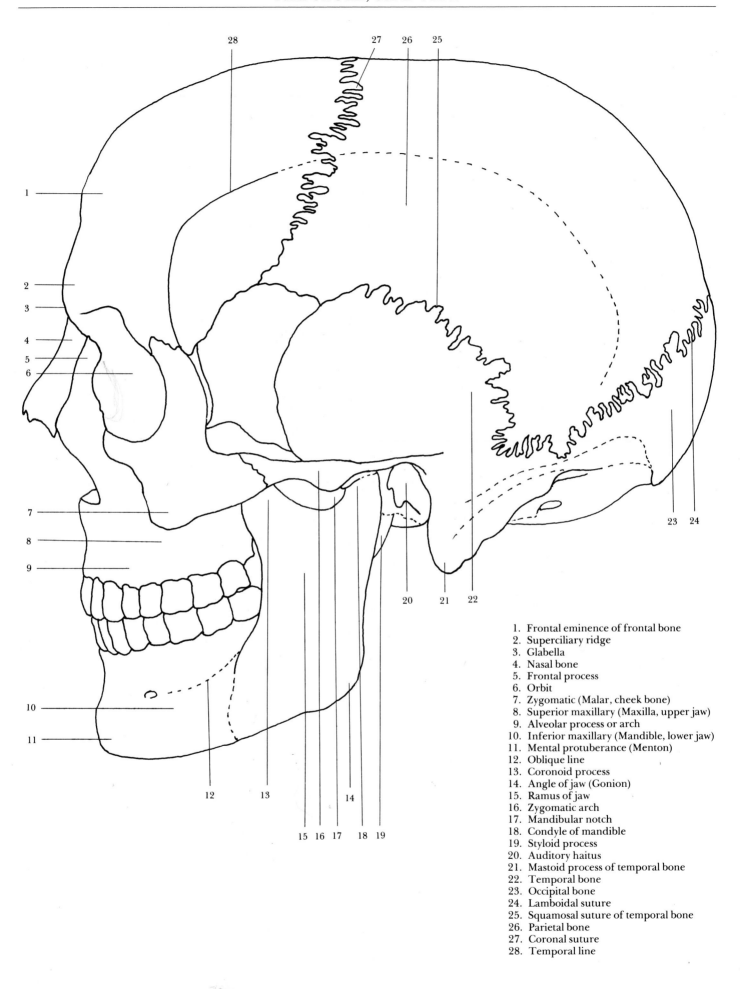

1. Frontal eminence of frontal bone
2. Superciliary ridge
3. Glabella
4. Nasal bone
5. Frontal process
6. Orbit
7. Zygomatic (Malar, cheek bone)
8. Superior maxillary (Maxilla, upper jaw)
9. Alveolar process or arch
10. Inferior maxillary (Mandible, lower jaw)
11. Mental protuberance (Menton)
12. Oblique line
13. Coronoid process
14. Angle of jaw (Gonion)
15. Ramus of jaw
16. Zygomatic arch
17. Mandibular notch
18. Condyle of mandible
19. Styloid process
20. Auditory haitus
21. Mastoid process of temporal bone
22. Temporal bone
23. Occipital bone
24. Lamboidal suture
25. Squamosal suture of temporal bone
26. Parietal bone
27. Coronal suture
28. Temporal line

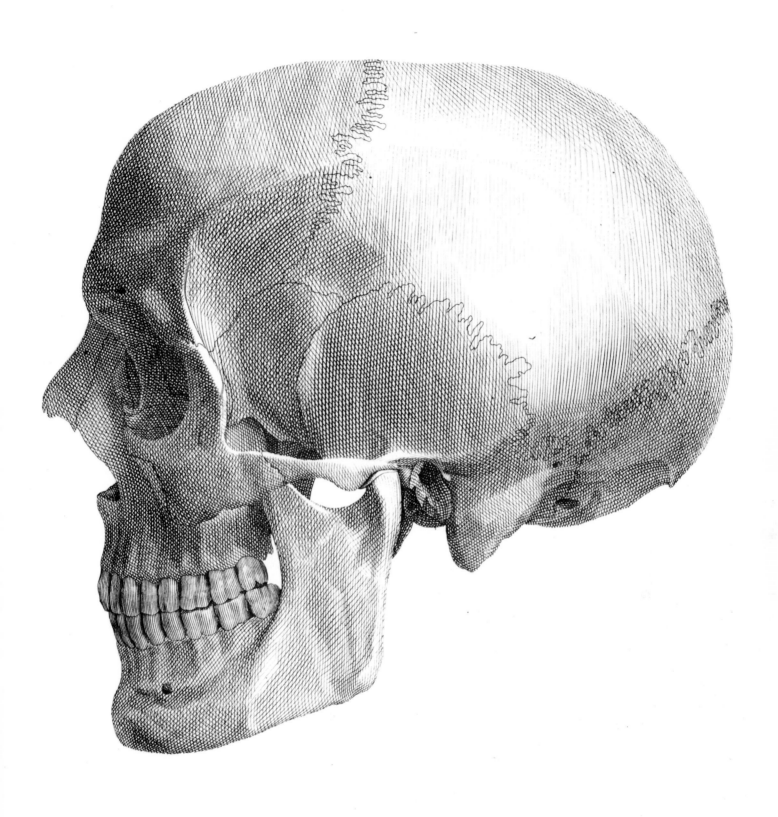

Epicranial Muscles, Back View

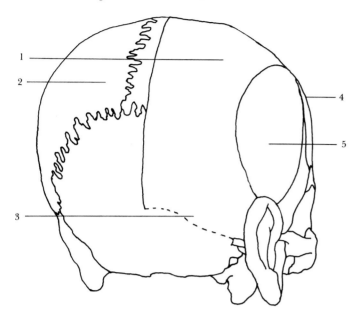

Epicranial Muscles, Front View

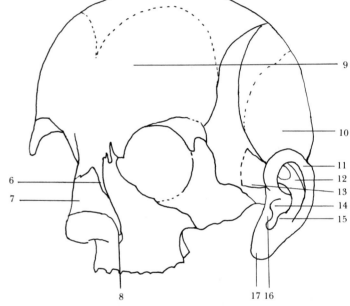

Palpebral Muscles

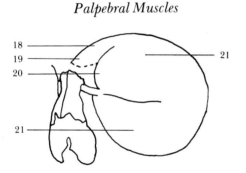

1. Occipitalis
2. Parietal bone
3. Origin of occipitalis in occipital bone
4. Frontalis
5. Auricularis
6. Procerus
7. Nasalis (Compressor naris)
8. Origin of nasalis in root of wing of nose
9. Frontalis
10. Auricularis superior
11. Helix
12. Antihelix
13. Auricularis anterior
14. Concha
15. Antitragus
16. Tragus
17. Lobule
18. Corrugator supercilii
19. Origin from frontal bone
20. Origin of orbicularis oculi from frontal bone
21. Orbicularis oculi (palpebrarum)
22. Fleshy body of muscle
23. Origin from superior maxillary
24. Insertion into root of wing of nose

Depressor Alae Nasi

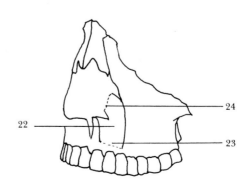

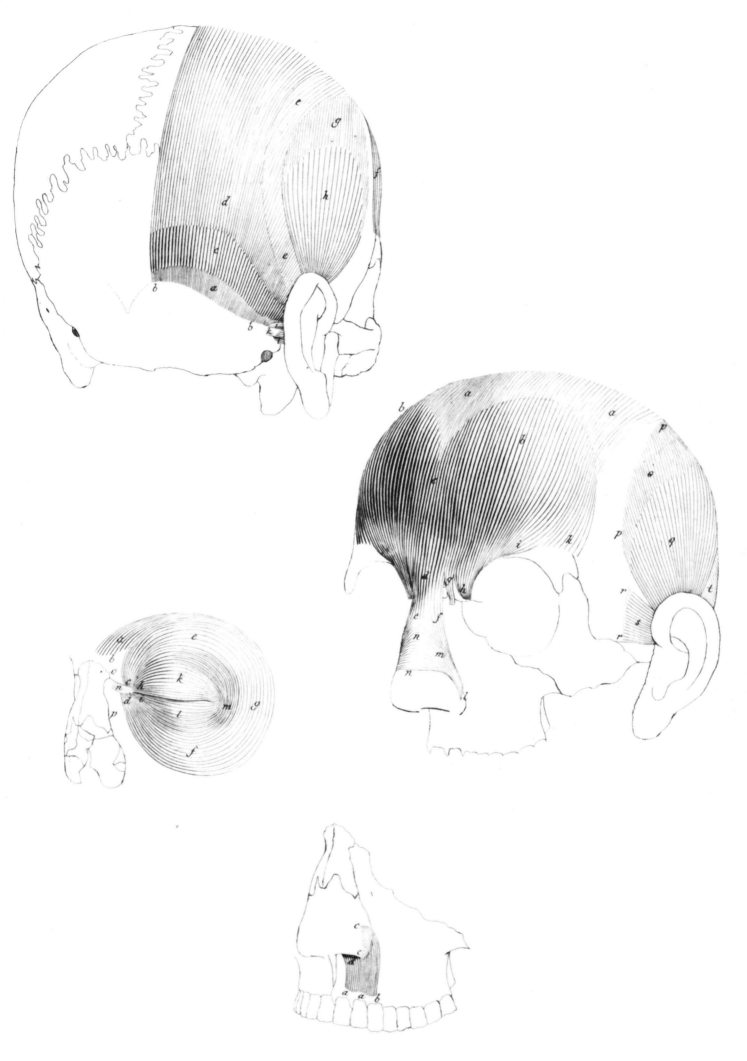

Muscles of the Lips and Cheeks,
Superficial Layer

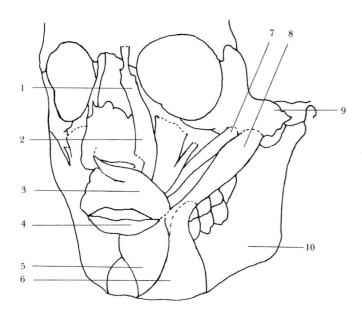

Muscles of the Lips and Cheeks,
Deep Layer

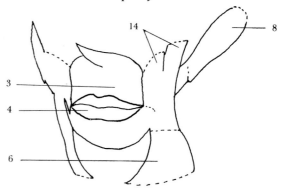

Depressor Labii Inferioris

Buccinator, Deep Layer

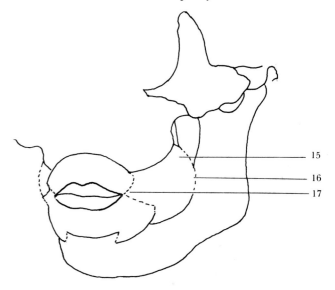

1. Levator labii superioris alaque nasi
2. Levator labii superioris
3. Orbicularis oris
4. Red margin of the lips
5. Depressor labii inferioris
6. Depressor anguli oris
7. Zygomaticus minor
8. Zygomaticus major
9. Zygomatic bone
10. Inferior maxillary
11. Insertion into lower lip
12. Depressor labii inferioris
13. Origin from inferior maxillary
14. Levator anguli oris (caninus)
15. Origin from superior maxillary
16. Origin from inferior maxillary
17. Insertion into angle of mouth
18. Origin from incisive fossa
19. Insertion into skin of chin

Levator Menti (Mentalis)

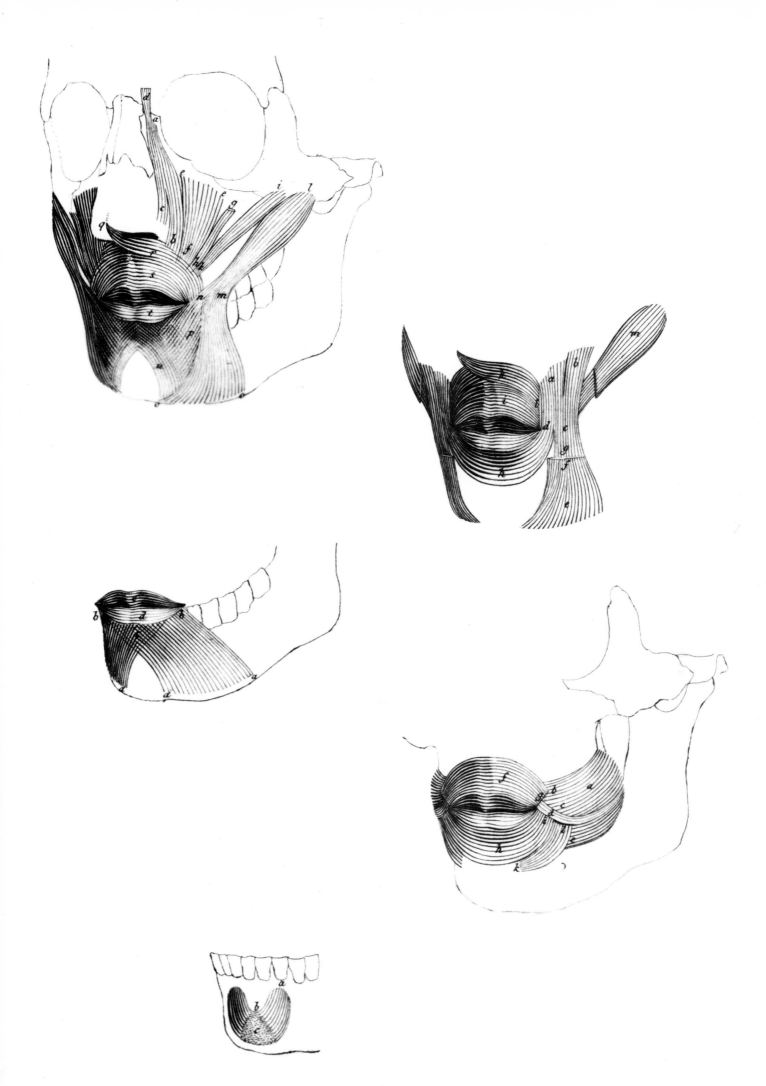

Temporalis

Masseter

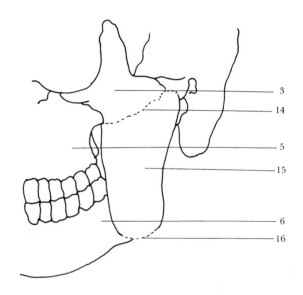

Digastric, Bottom View

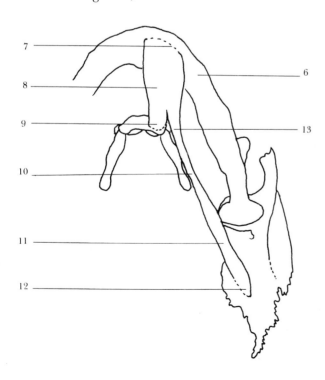

1. Origin of temporalis from temporal fossa
2. Frontal bone
3. Zygomatic bone
4. Insertion into coronoid process of mandible
5. Superior maxillary
6. Inferior maxillary (Mandible, lower jaw)
7. Origin of second belly from inferior maxillary
8. Second belly
9. Insertion of second belly into hyoid bone
10. Middle tendon
11. First (posterior) belly
12. Origin of first belly in mastoid process of temporal bone
13. Insertion of first belly into hyoid bone
14. Origin in zygomatic bone
15. Fleshy body of masseter
16. Insertion into inferior maxillary

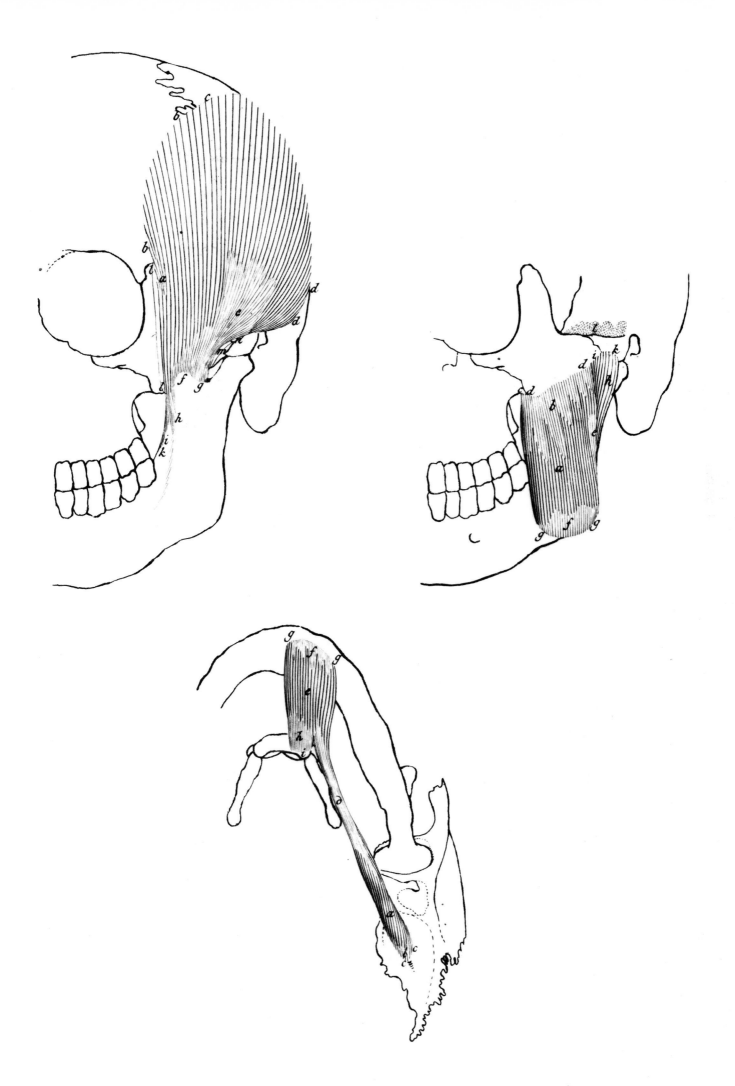

Mylohyoid, Bottom View

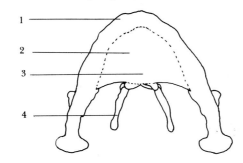

Stylohyoid, Outer View

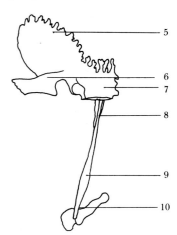

Platysma with
Depressor Labii Inferioris

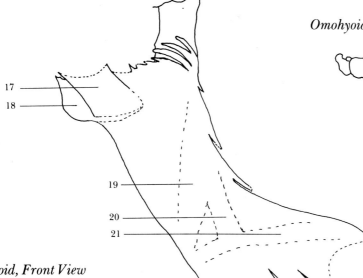

Omohyoid, Front View

Sternohyoid, Front View

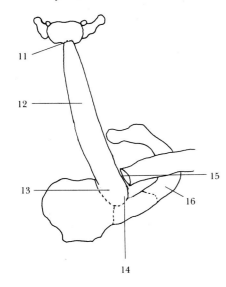

1. Origin from inferior maxillary
2. Fleshy body of mylohyoid
3. Insertion into body of hyoid bone
4. Greater cornu of hyoid bone
5. Squama of temporal bone
6. Zygomatic arch
7. Mastoid process, cut off
8. Origin from root of styloid process
9. Fleshy body of stylohyoid
10. Insertion of stylohyoid into hyoid bone
11. Insertion into hyoid bone
12. Fleshy body of sternohyoid
13. Origin from manubrium of sternum
14. Origin from cartilage of first rib
15. Origin from clavicle
16. First rib
17. Depressor labii inferioris
18. Mental protuberance of inferior maxillary
19. Bulge of sternocleidomastoideus
20. Bulge of clavicular portion of sternocleidomastoideus
21. Bulge of clavicle
22. Insertion of omohyoid into hyoid bone
23. Second belly
24. Middle tendon
25. First belly
26. Origin from superior angle of scapula

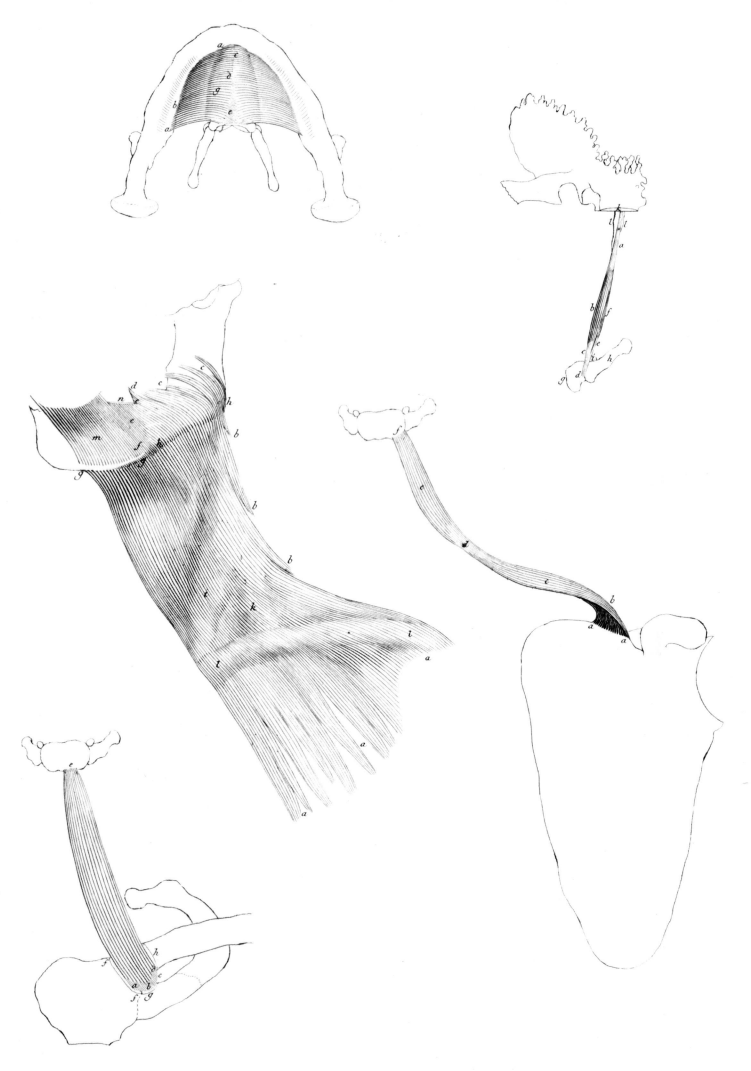

Semispinalis Capitis (Complexus),
Inner View

Semispinalis Capitis (Complexus),
Back View

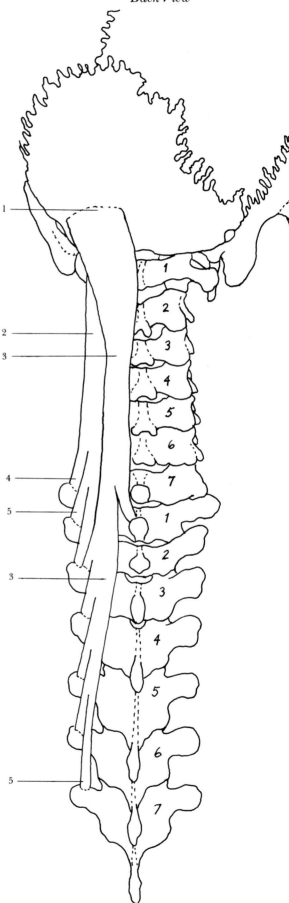

1. Insertion into occipital bone
2. Semispinalis capitis (complexus)
3. Medial portion of complexus (Biventer cervicis)
4. Origin from cervical vertebrae
5. Origin from dorsal (thoracic) vertebrae

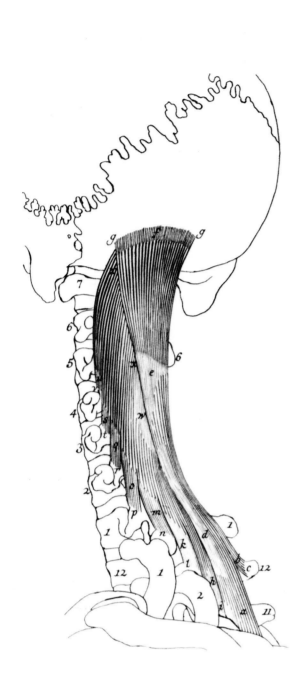

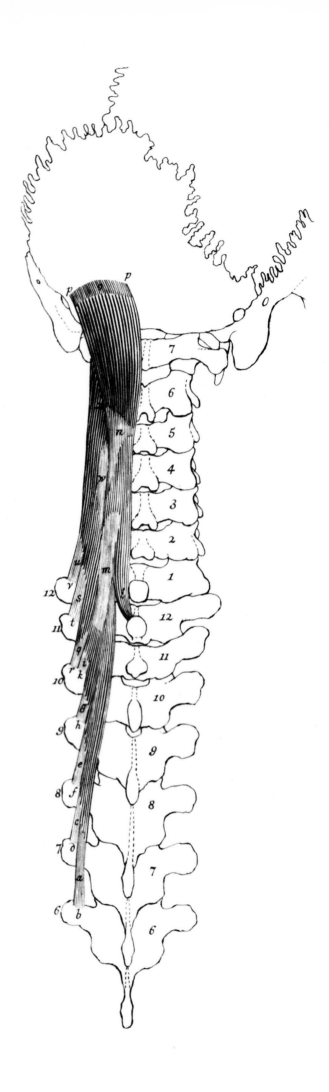

Sternocleidomastoid, Back View

Sternocleidomastoid, Front View

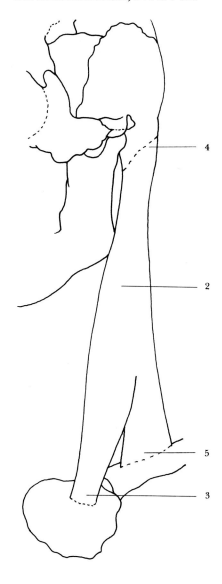

Splenius Capitis, Back View

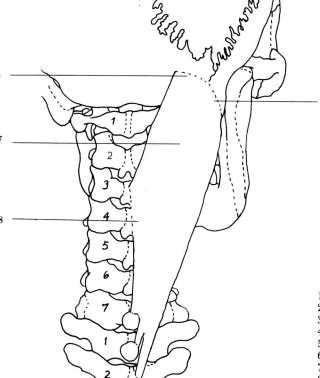

1. Insertion into occipital bone
2. Sternocleidomastoideus
3. Origin from manubrium of sternum
4. Insertion into mastoid process
5. Origin from clavicle
6. Insertion into superior curved line of occipital bone
7. Splenius capitis
8. Origin from spines of vertebrae
9. Insertion into mastoid process

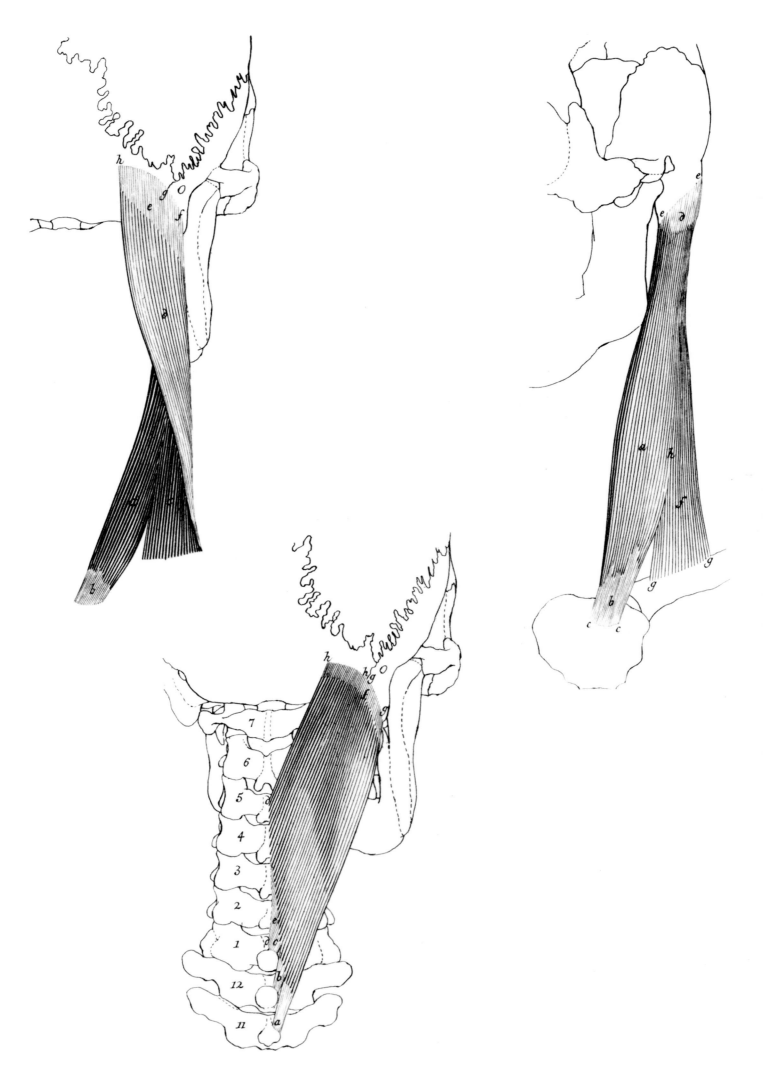

Longissimus Capitis, Back View

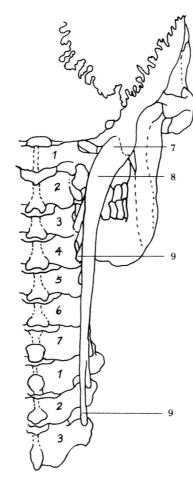

Levator Scapulae, Front View

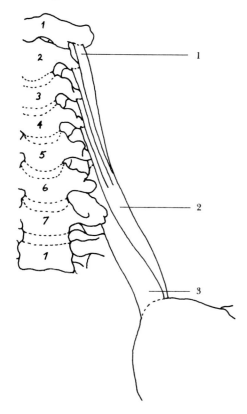

Scalenus Anterior, Front View

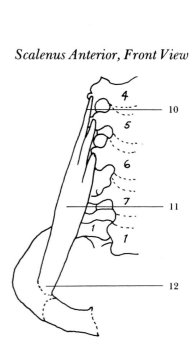

Scalenus Medius, Front View

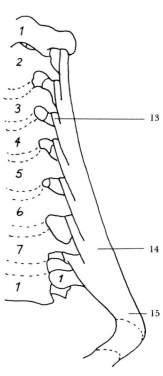

Scalenus Posterior, Back View

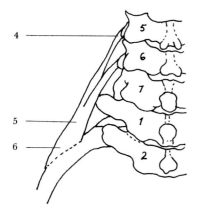

1. Origin of levator scapulae from vertebrae
2. Fleshy body of levator scapulae
3. Insertion into superior angle of scapula
4. Origin of scalenus posterior from vertebrae
5. Fleshy body of scalenus posterior
6. Insertion into second rib
7. Insertion into mastoid process
8. Fleshy body of longissimus capitis
9. Origin of longissimus capitis from vertebrae
10. Origin of scalenus anterior from vertebrae
11. Fleshy body of scalenus anterior
12. Insertion of scalenus anterior into first rib
13. Origin of scalenus medius from vertebrae
14. Fleshy body of scalenus medius
15. Insertion of scalenus medius into first rib

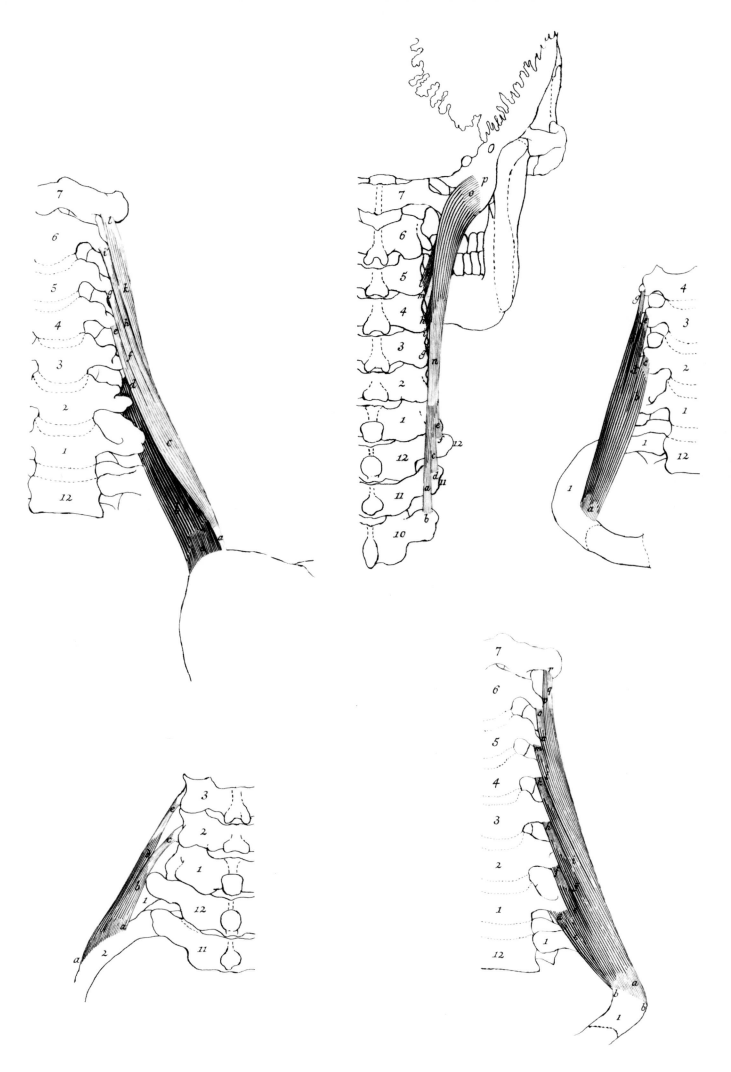

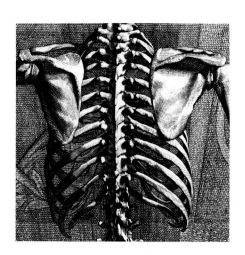

THE VERTEBRAL COLUMN AND RIB CAGE

Front View

Back View

Outer View

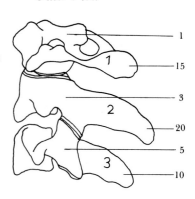

Seventh Cervical Vertebra

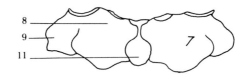

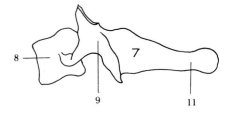

Atlas, Top View

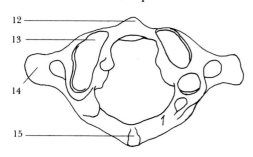

Atlas, Bottom View

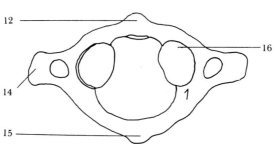

Axis, Front View

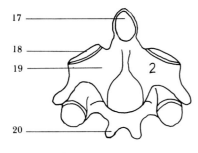

Axis, Top View

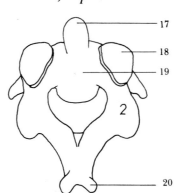

1. Body of atlas
2. Transverse process of atlas
3. Body of axis
4. Transverse process of axis
5. Body of third cervical vertebra
6. Transverse process of third cervical vertebra
7. Surface for intevertebral disk
8. Body of seventh cervical vertebra
9. Transverse process of seventh cervical vertebra
10. Spineous process of third cervical vertebra
11. Spineous process of seventh cervical vertebra
12. Tubercle of anterior arch
13. Superior articular surface for skull
14. Transverse process of atlas
15. Tubercle of posterior arch
16. Inferior articular surface for atlas
17. Odontoid process for atlas
18. Anterior articular surface for atlas
19. Body of axis
20. Spineous process

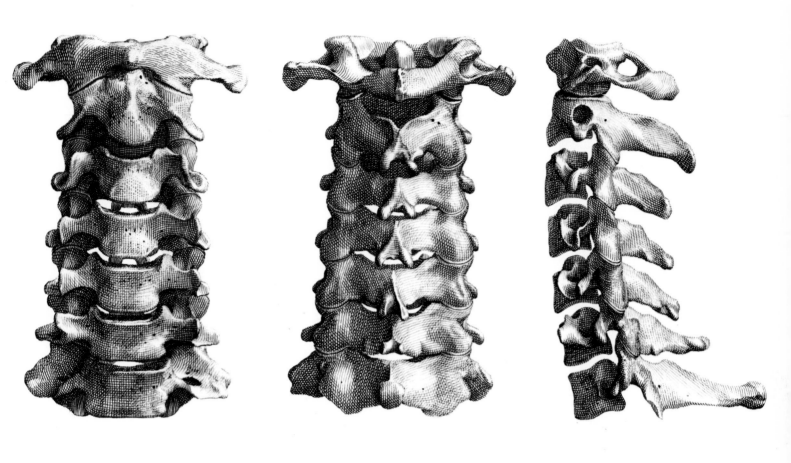

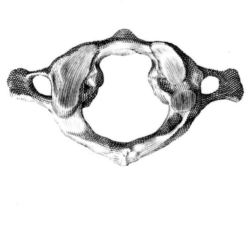

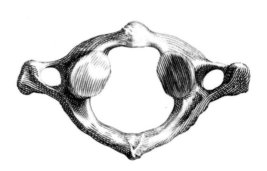

Front View

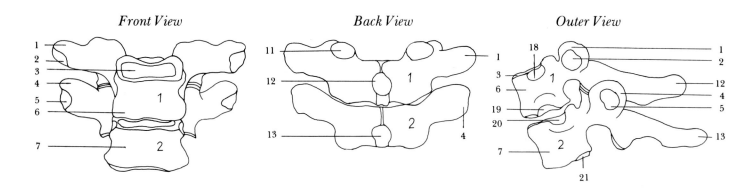

Back View

Outer View

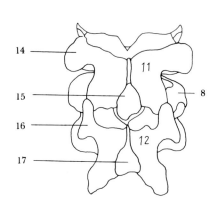

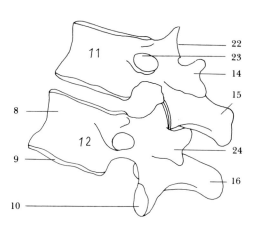

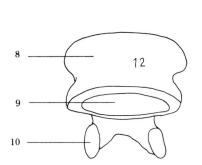

Sixth Vertebra, Top View

Sixth Vertebra, Bottom View

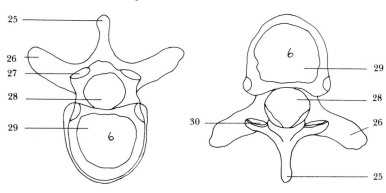

1. Transverse process of first dorsal vertebra
2. Costal facet for tubercle of first rib
3. Articular surface for intervertebral disk
4. Transverse process of second dorsal vertebra
5. Costal facet for tubercle of second rib
6. Body of first dorsal vertebra
7. Body of second dorsal vertebra
8. Body of twelfth dorsal vertebra
9. Articular surface for intervertebral disk
10. Inferior articular process for first lumbar vertebra
11. Superior articular surface for seventh cervical vertebra
12. Spine of first dorsal vertebra
13. Spine of second dorsal vertebra
14. Transverse process of eleventh dorsal vertebra
15. Spineous process of eleventh dorsal vertebra
16. Transverse process of twelfth dorsal vertebra
17. Spineous process of twelfth dorsal vertebra
18. Costal facet for head of first rib
19. Demi-facet for upper head of second rib
20. Demi-facet for lower head of second rib
21. Demi-facet for head of third rib
22. Superior articular facet
23. Costal facet for head of eleventh rib
24. Costal facet for head of twelfth rib
25. Spineous process
26. Transverse process of sixth dorsal vertebra
27. Superior articular surface
28. Vertebral foramen
29. Body of sixth dorsal vertebra
30. Inferior articular surface

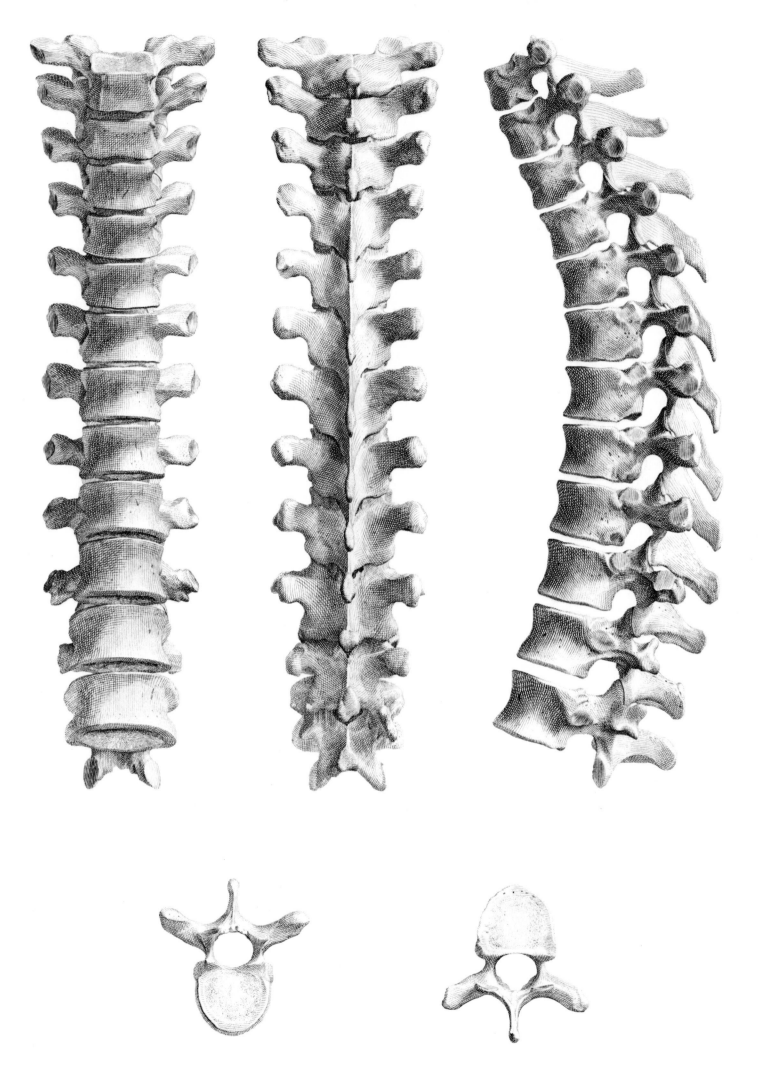

Front View

Back View

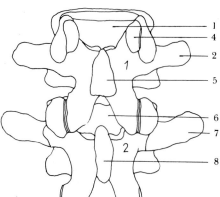

Outer View

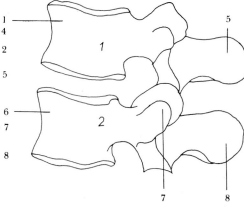

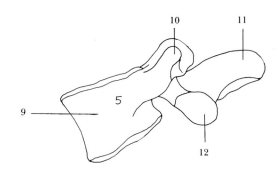

Third Lumbar Vertebra,
Top View

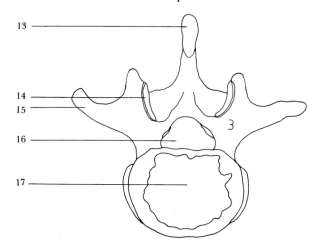

Third Lumbar Vertebra,
Bottom View

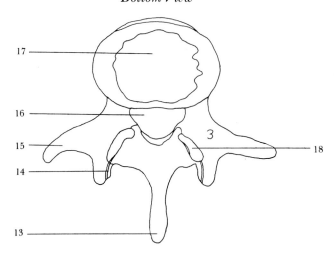

1. Body of first lumbar vertebra
2. Transverse process of first lumbar vertebra
3. Surface for intervertebral disk
4. Articular surface
5. Spineous process of first lumbar vertebra
6. Body of second lumbar vertebra
7. Transverse process of second lumbar vertebra
8. Spineous process of second lumbar vertebra
9. Body

10. Transverse process
11. Spineous process
12. Articular process
13. Spineous process (Back of vertebrae)
14. Superior articular surface
15. Transverse process
16. Vertebral foramen
17. Body
18. Inferior articular process

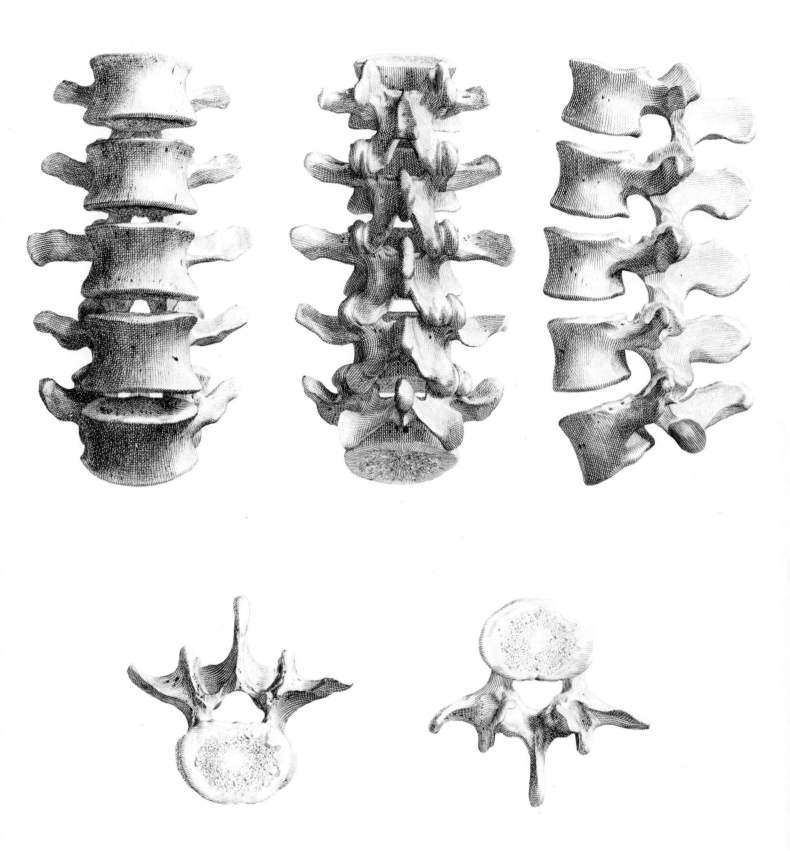

Sacrum, Front View

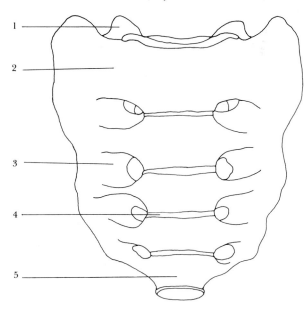

Sacrum, Back View

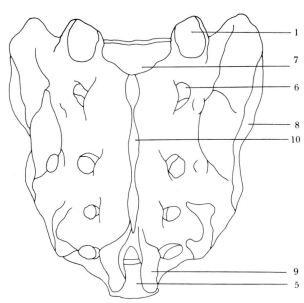

Sacrum, Outer View

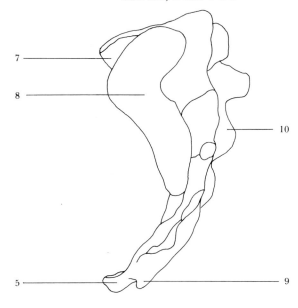

Sacrum, Top View

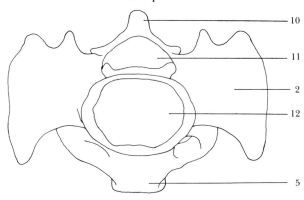

Coccyx, Front View

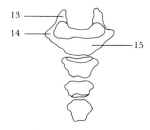

Coccyx, Back View

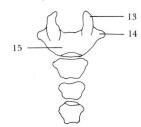

Coccyx, Outer View

1. Superior articular process of sacrum
2. Ala of sacrum
3. Anterior sacral foramen
4. Transverse ridge
5. Apex
6. Posterior sacral foramen
7. Body of sacrum
8. Articular facet
9. Cornu of sacrum
10. Spineous process
11. Sacral canal
12. Articular surface for fifth lumbar vertebra
13. Cornu of coccyx
14. Transverse process
15. Body of coccyx

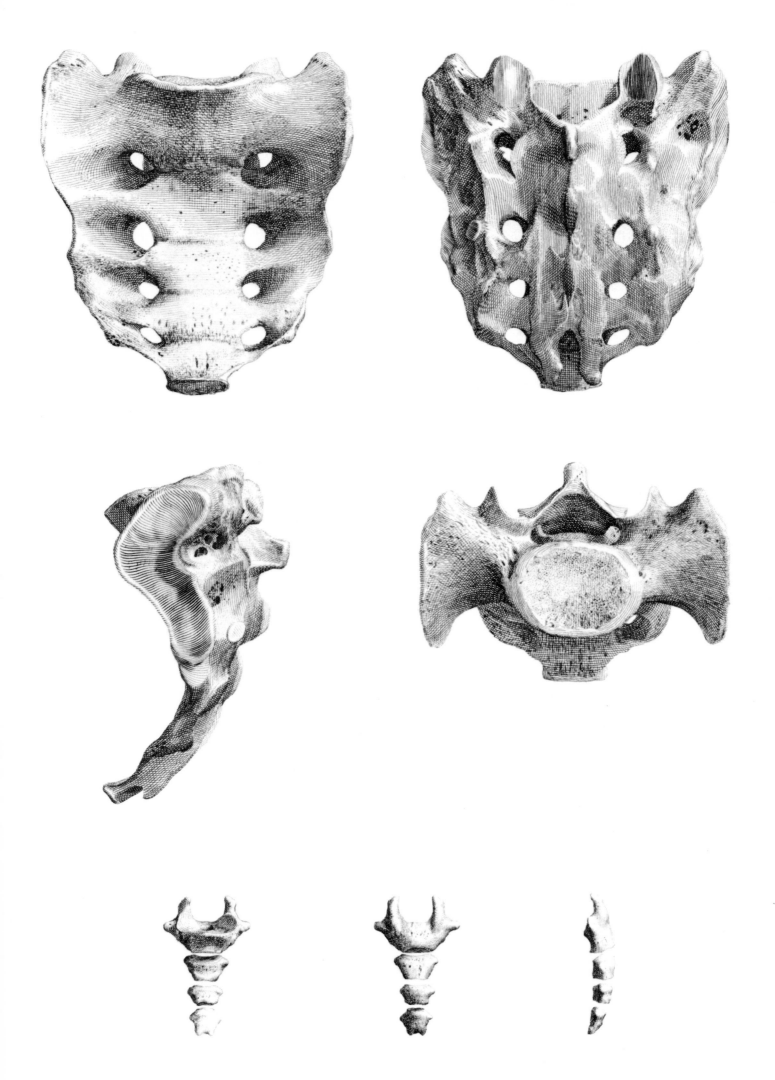

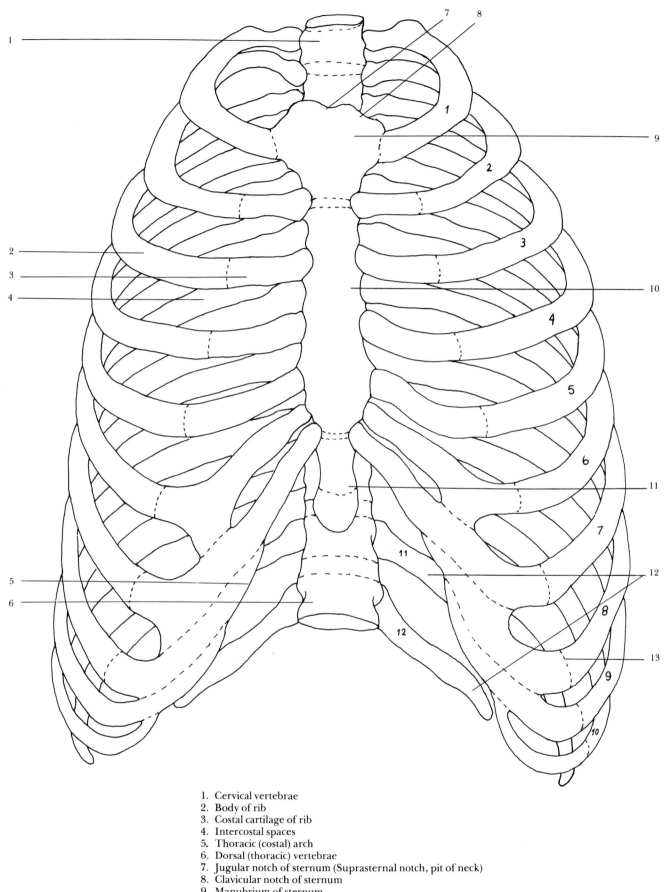

1. Cervical vertebrae
2. Body of rib
3. Costal cartilage of rib
4. Intercostal spaces
5. Thoracic (costal) arch
6. Dorsal (thoracic) vertebrae
7. Jugular notch of sternum (Suprasternal notch, pit of neck)
8. Clavicular notch of sternum
9. Manubrium of sternum
10. Gladiolus of sternum
11. Xiphoid process (Ensiform cartilage) of sternum
12. Floating rib
13. Line where rib meets cartilage

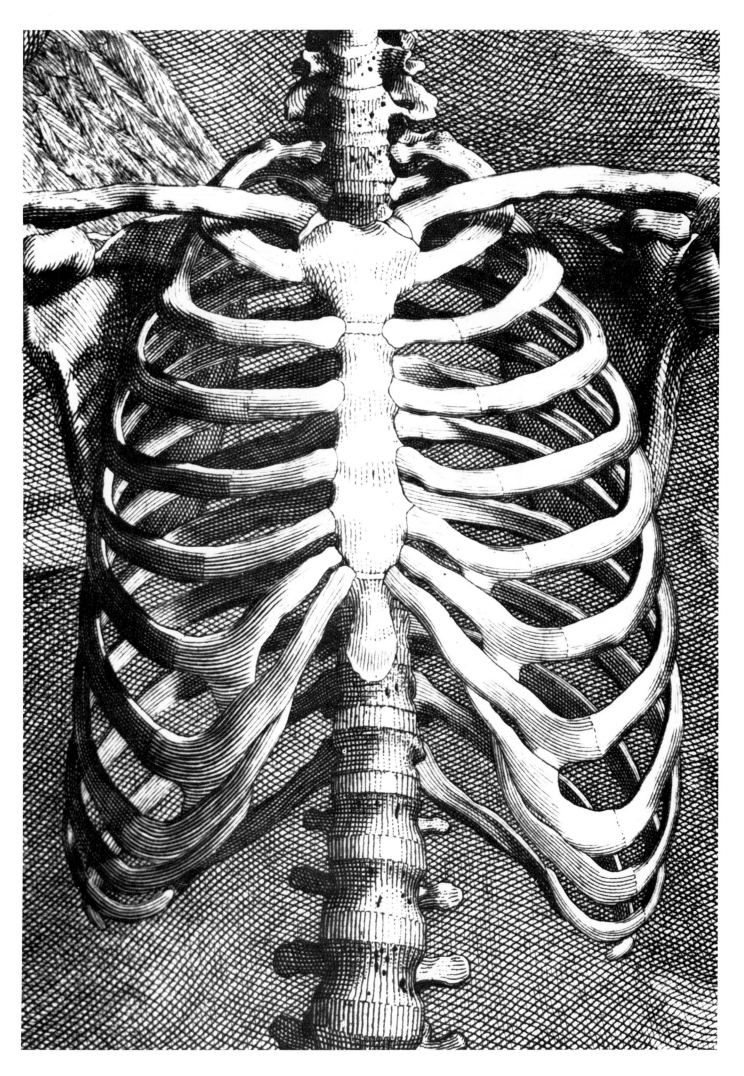

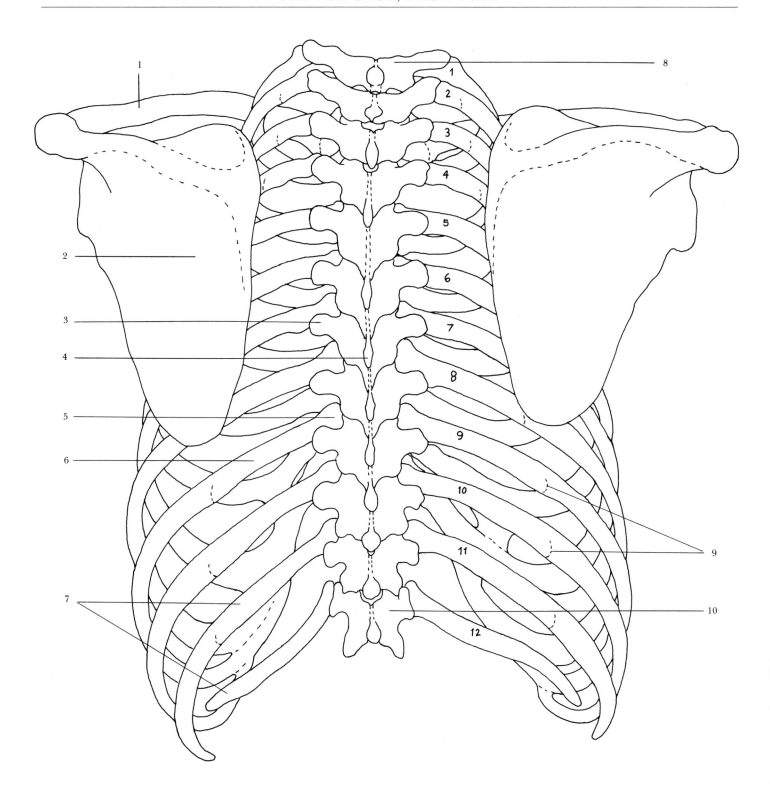

1. Clavicle
2. Scapula
3. Transverse process of dorsal vertebrae
4. Spinous process of dorsal vertebrae
5. Head of rib
6. Body (shaft) of rib
7. Floating rib
8. First dorsal (thoracic) vertebra
9. Line of angle of ribs
10. Twelfth dorsal (thoracic) vertebra

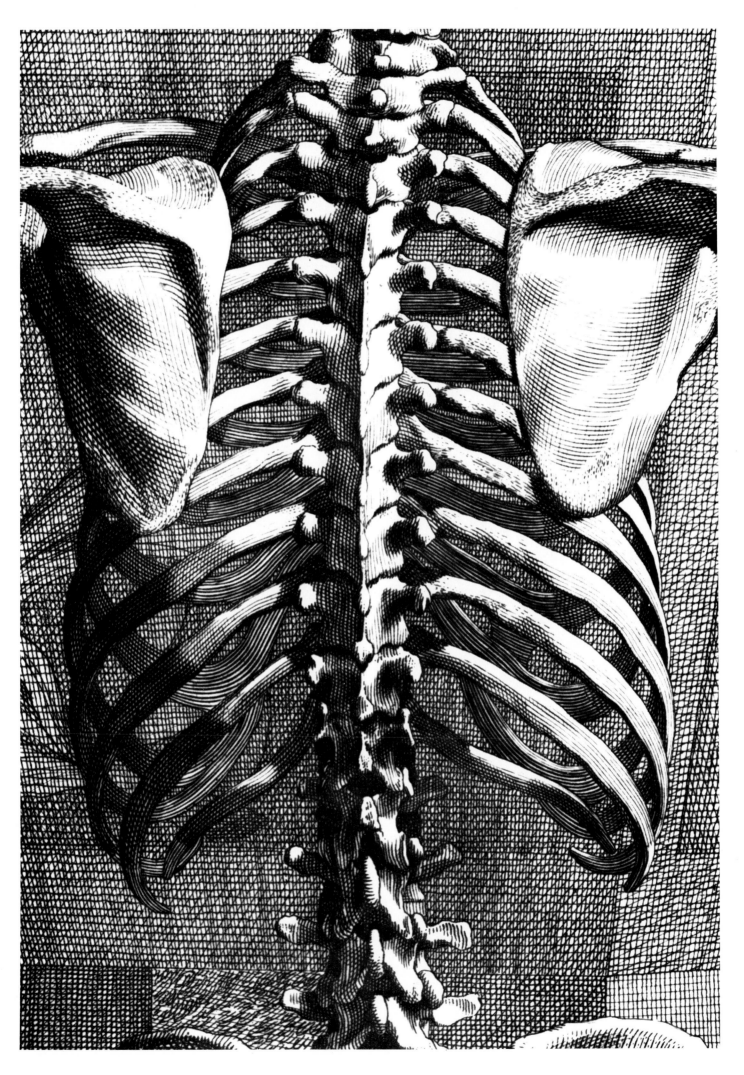

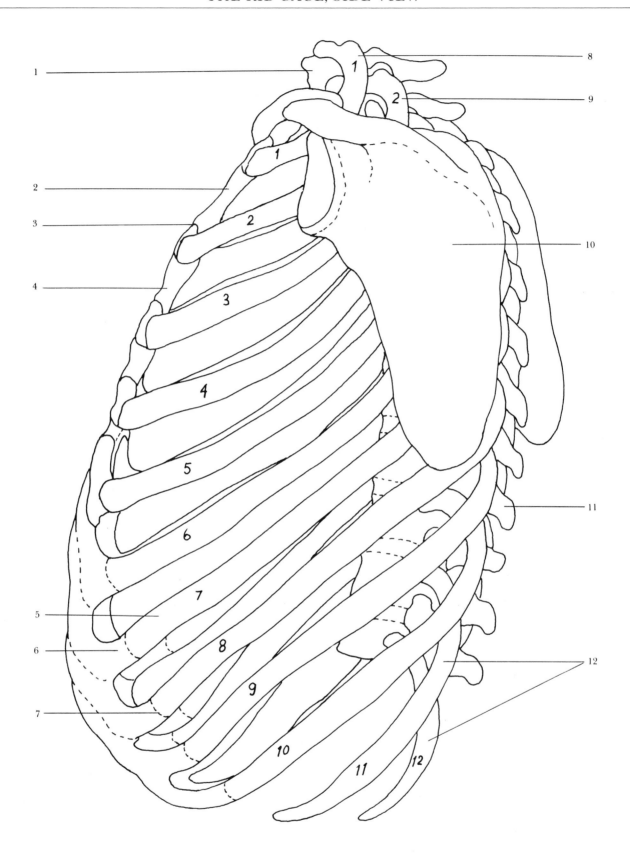

1. First dorsal (thoracic) vertebra
2. Manubrium of sternum
3. Angle of sternum
4. Gladiolus of sternum
5. Body (shaft) of rib
6. Costal cartilage
7. Line where rib meets cartilage
8. First rib
9. Second rib
10. Scapula
11. Spineous process of dorsal vertebrae
12. Floating ribs

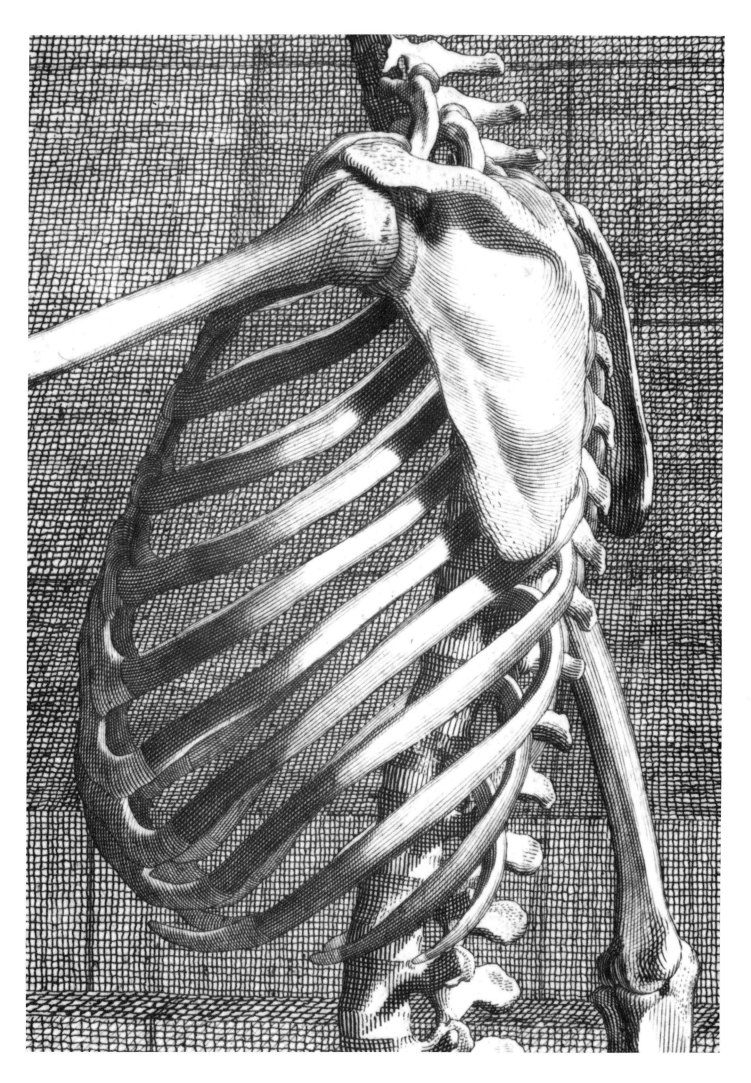

Front View *Back View* *Outer View*

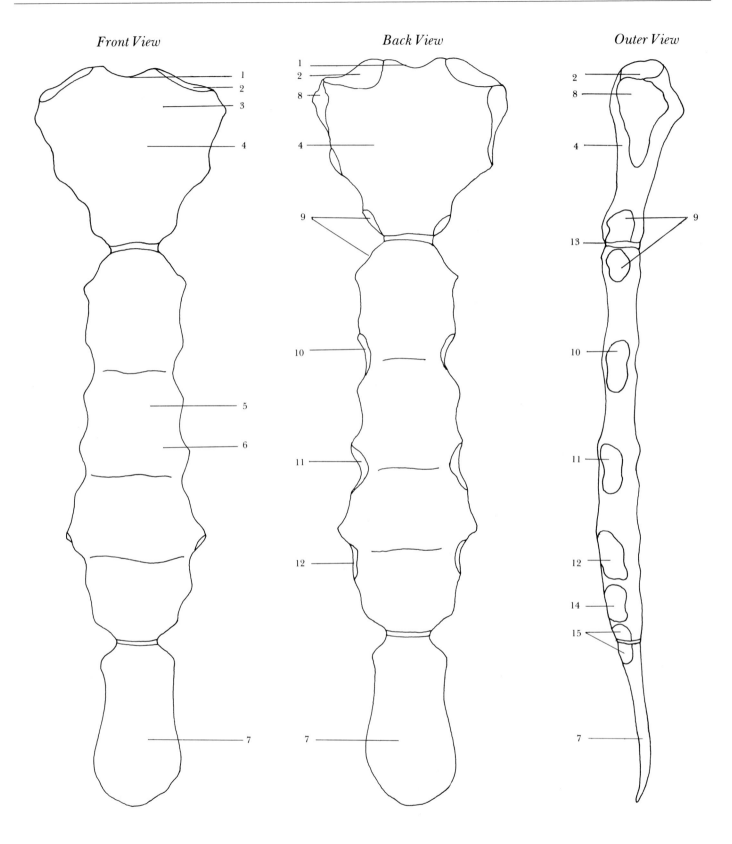

1. Jugular (suprasternal) notch (Pit of neck)
2. Articular surface for clavicle
3. Origin of sternocleidomastoideus
4. Manubrium of sternum
5. Gladiolus (Body of sternum)
6. Origin of pectoralis major
7. Xiphoid process (Ensiform cartilage)
8. Articular surface for cartilage of first rib

9. Articular surface for cartilage of second rib
10. Articular surface for cartilage of third rib
11. Articular surface for cartilage of fourth rib
12. Articular surface for cartilage of fifth rib
13. Sternal angle
14. Articular surface for cartilage of sixth rib
15. Articular surface for cartilage of seventh rib

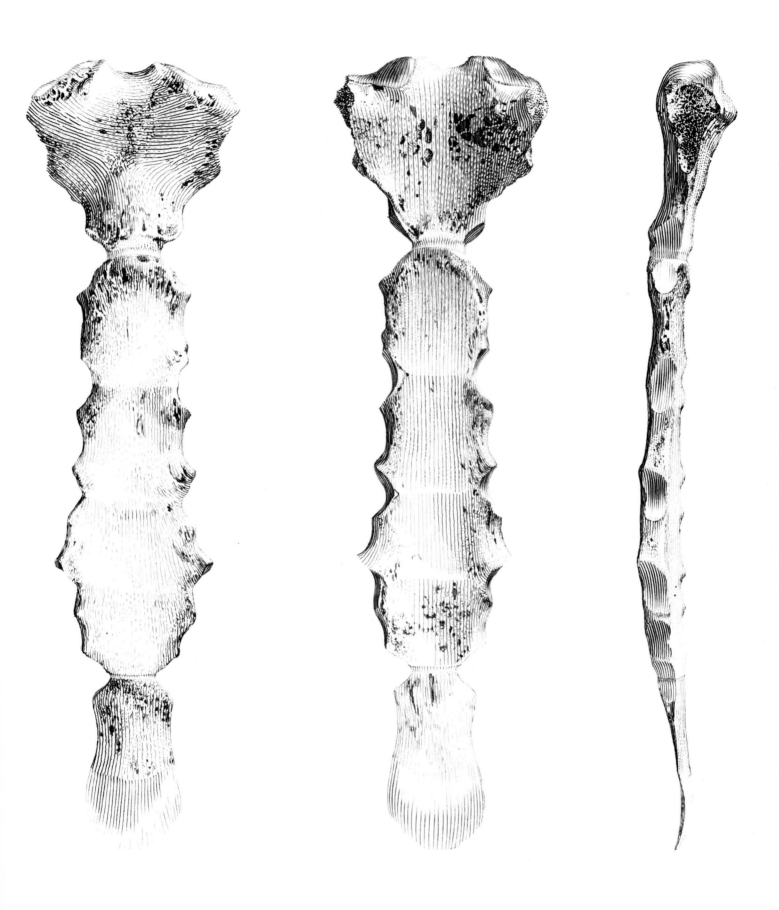

Outer View *Front View*

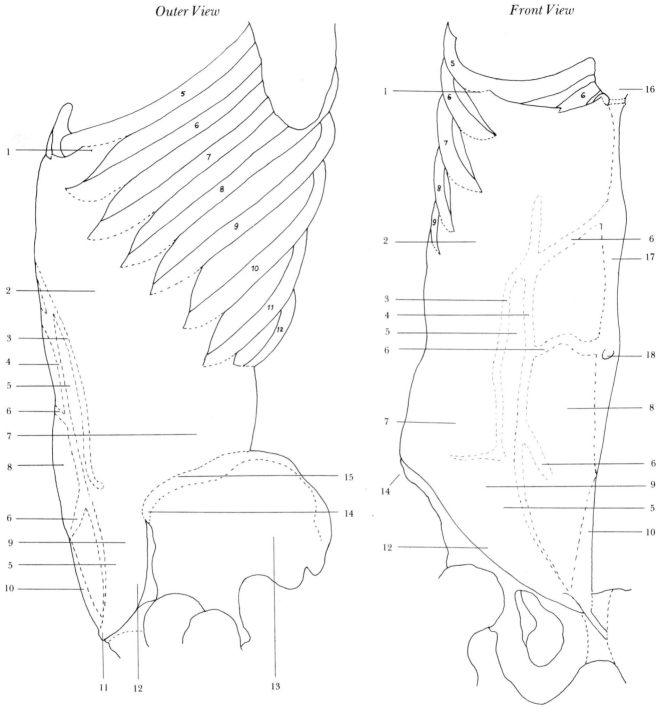

1. Origin from lower eight ribs
2. Thin thoracic portion of external oblique
3. Tendinous expansion of external oblique
4. Semilunar line
5. Bulge of fleshy part of internal oblique
6. Tendinous lines of rectus abdominus (Linea transversae)
7. Fleshy body of external oblique
8. Bulge of fleshy body of rectus abdominus
9. Aponeurosis of external oblique
10. Pyramidalis
11. Insertion of external oblique into crest of pubis
12. Insertion of external oblique into inguinal (Poupart's) ligament
13. Ilium of pelvis
14. Anterior superior iliac spine (Front point)
15. Insertion of external oblique into anterior half of iliac crest
16. Manubrium of sternum
17. Linea alba
18. Umbilicus (Navel)

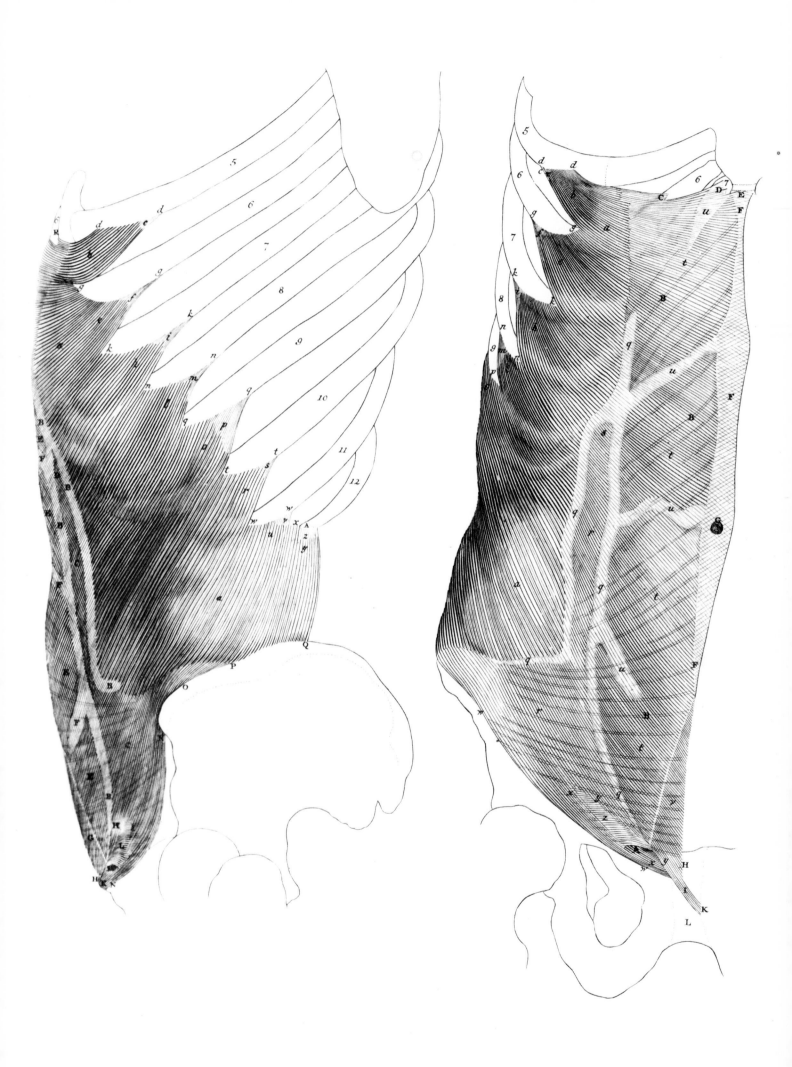

Rectus Abdominus

1. Insertion into cartilage of ribs
2. Insertion into xiphoid process of sternum
3. Tendinous lines (Linea transversae)
4. Upper portion of rectus
5. Middle portion of rectus
6. Lower portion of rectus
7. Origin from crest of pubis of pelvis
8. Origin from symphysis pubis of pelvis
9. Ischium of pelvis
10. Insertion into linea alba
11. Body of pyramidalis
12. Origin from pubis of pelvis

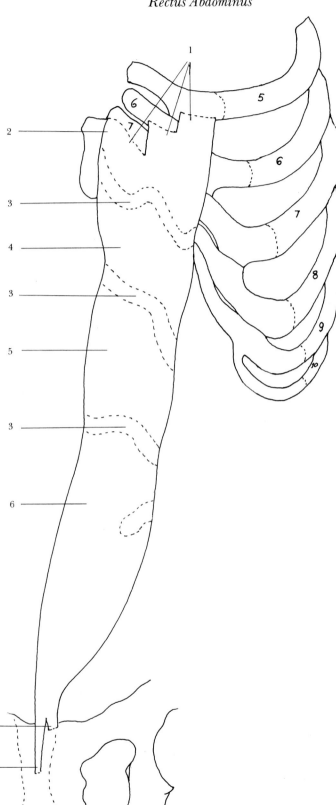

Pyramidalis

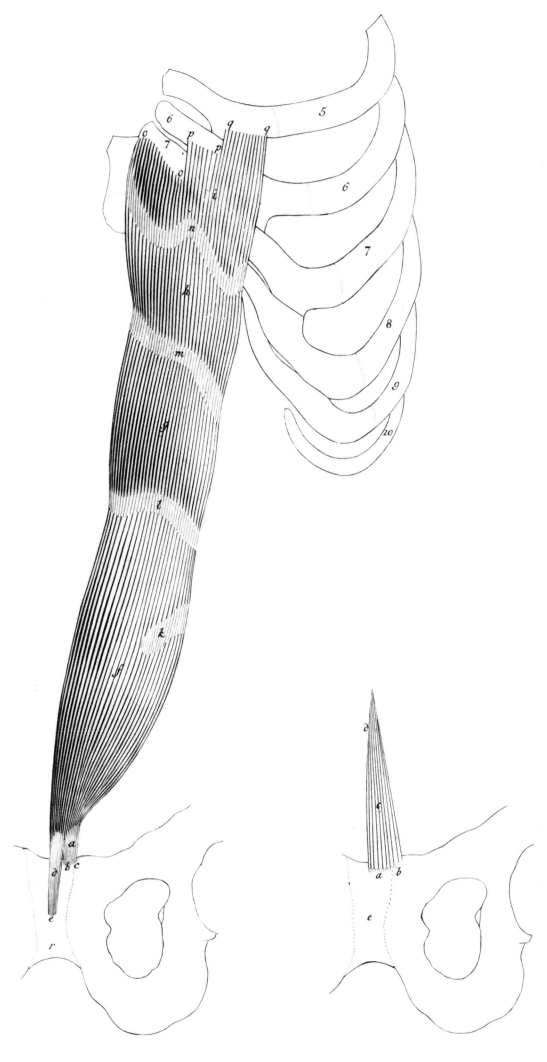

Longissimus

Iliocostalis

Spinalis Dorsi

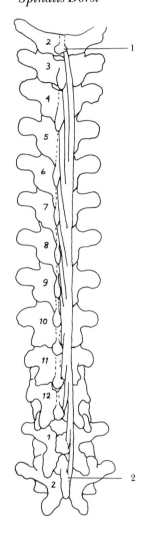

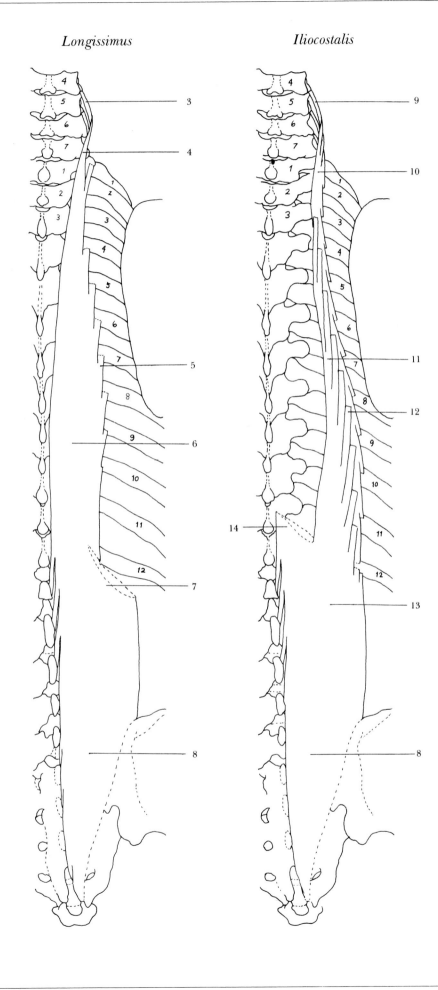

1. Insertion into spines of upper vertebrae
2. Origin in spines of lower vertebrae
3. Tendinous insertion in vertebrae
4. Longissimus cervicis
5. Tendinous insertion in ribs
6. Longissimus dorsi
7. Iliocostalis, cut off
8. Tendinous origin of erector spinae (Sacrospinalis)
9. Slips of origin in vertebrae
10. Iliocostalis cervicis (Cervicalis ascendens)
11. Iliocostalis dorsi (Accessorius)
12. Cut off slips of insertion into ribs
13. Iliocostalis luborum
14. Longissimus, cut off

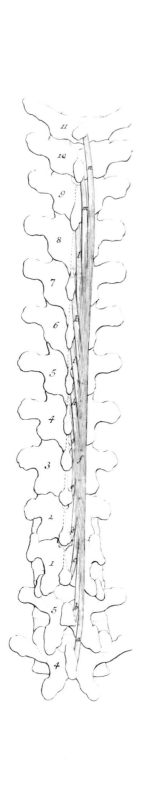

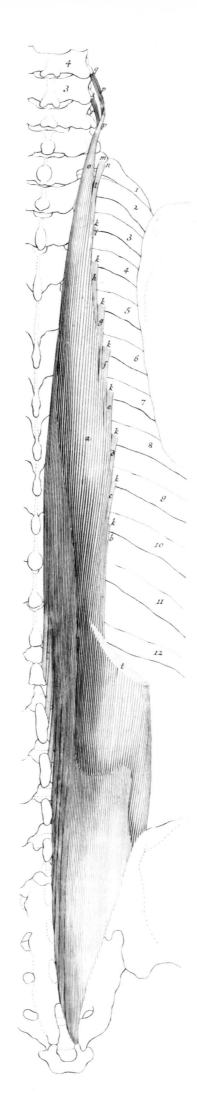

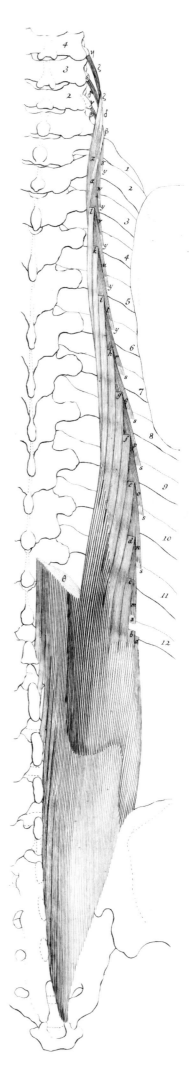

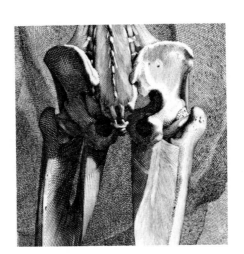

THE PELVIS AND THIGH

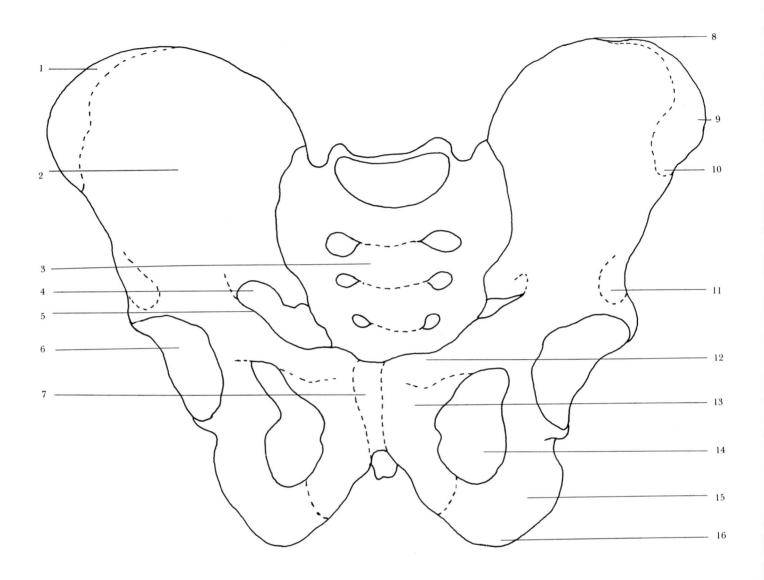

1. Iliac crest
2. Ilium
3. Sacrum
4. Inlet
5. Arcuate (iliopectineal) line, pelvic brim
6. Acetabulum
7. Pubic symphysis
8. High point of iliac crest
9. Iliac tubercle (Wide point)
10. Anterior superior iliac spine (Front point)
11. Anterior inferior iliac spine (Secondary point)
12. Pubic crest
13. Pubis
14. Obturator foramen
15. Ischium
16. Base of ischium (Ischial tuberosity)

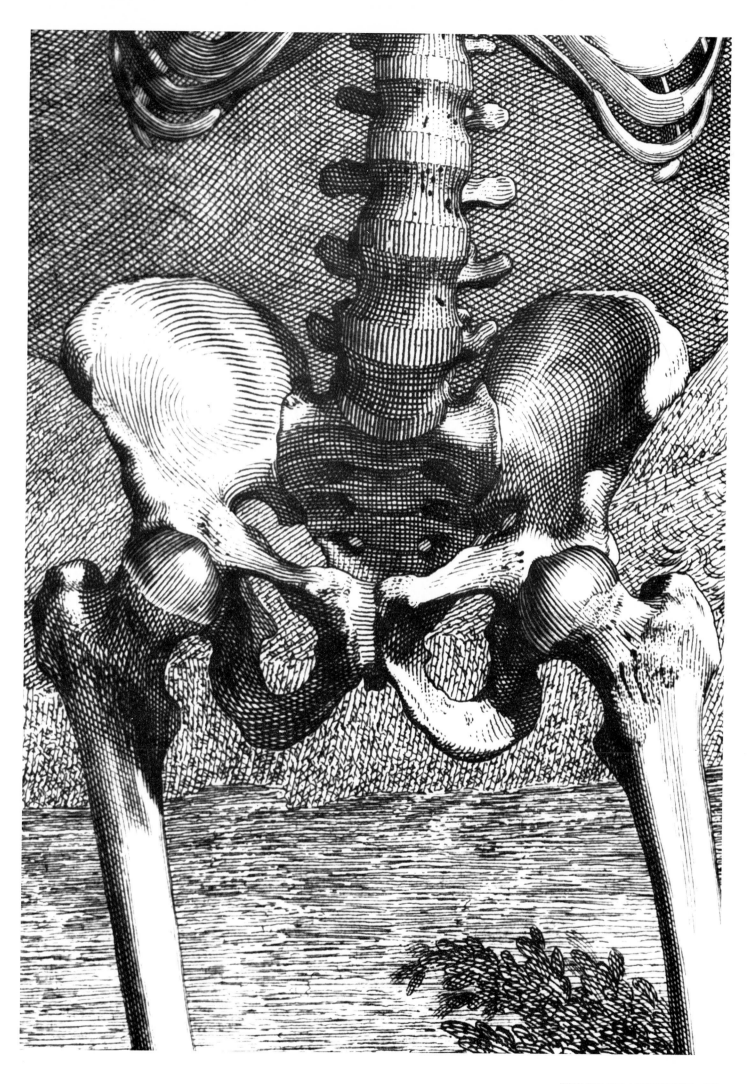

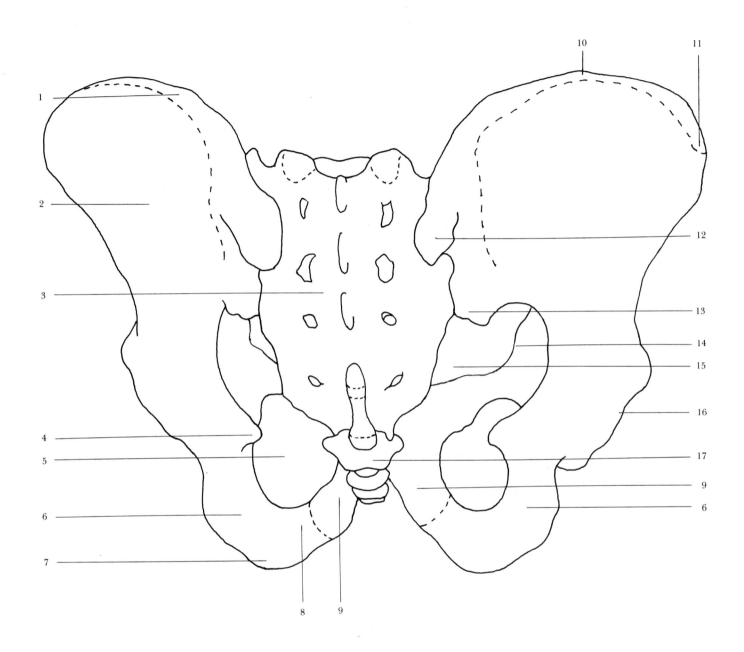

1. Iliac crest
2. Ilium
3. Sacrum
4. Ischial spine
5. Obturator foramen
6. Body of ischium
7. Base of ischium (Ischial tuberosity)
8. Ramus of ischium
9. Ramus of pubis
10. High point of iliac crest
11. Iliac tubercle (Wide point)
12. Posterior superior iliac spine (Back point)
13. Posterior inferior iliac spine
14. Arcuate (iliopectineal) line, pelvic brim
15. Inlet
16. Lip of acetabulum
17. Coccyx

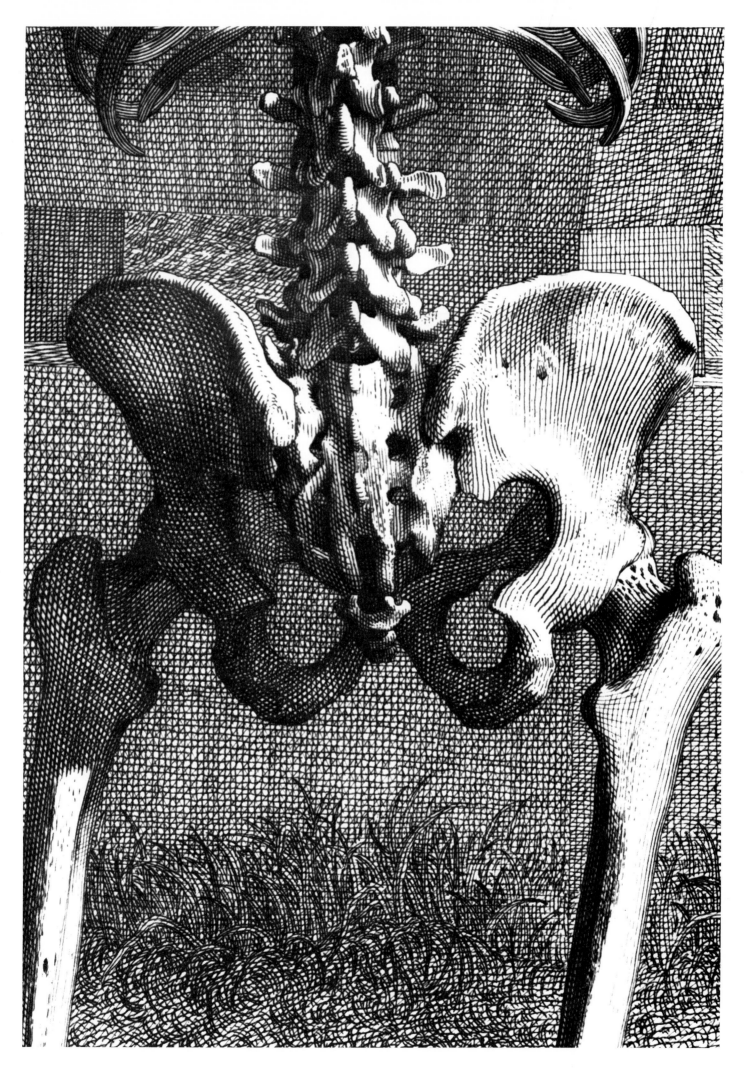

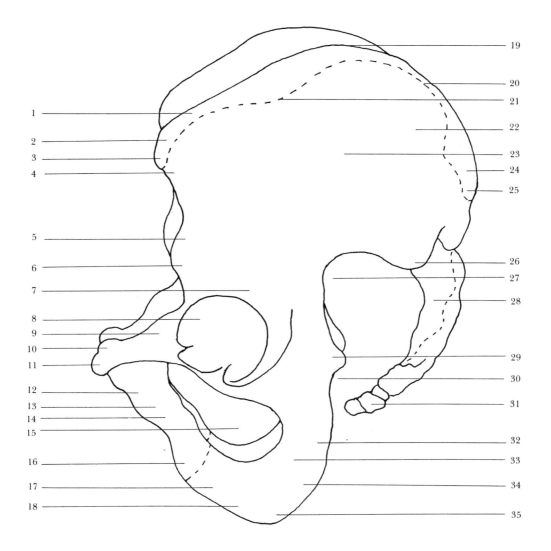

1. Insertion of external oblique
2. Origin of tensor fascae latae
3. Anterior superior iliac spine (Front point)
4. Origin of sartorius
5. Origin of rectus femoris, reflected tendon
6. Anterior inferior iliac spine (Secondary point)
7. Origin of rectus femoris, straight tendon
8. Acetabulum
9. Superior ramus of pubis
10. Origin of rectus abdominus
11. Pubic tubercle
12. Origin of adductor longus
13. Inferior ramus of pubis
14. Origin of adductor brevis
15. Obturator foramen
16. Origin of gracilis
17. Ramus of ischium
18. Origin of adductor magnus

19. High point of iliac crest
20. Origin of latissimus dorsi
21. Iliac tubercle (Wide point)
22. Origin of gluteus medius
23. Ilium
24. Origin of gluteus maximus
25. Posterior superior iliac spine (Back point)
26. Posterior inferior iliac spine
27. Greater sciatic notch
28. Sacrum
29. Ischial spine
30. Lesser sciatic notch
31. Coccyx
32. Origin of semimembranosus
33. Body of ischium
34. Origin of semitendinosus and biceps
35. Base of ischium (Ischial tuberosity)

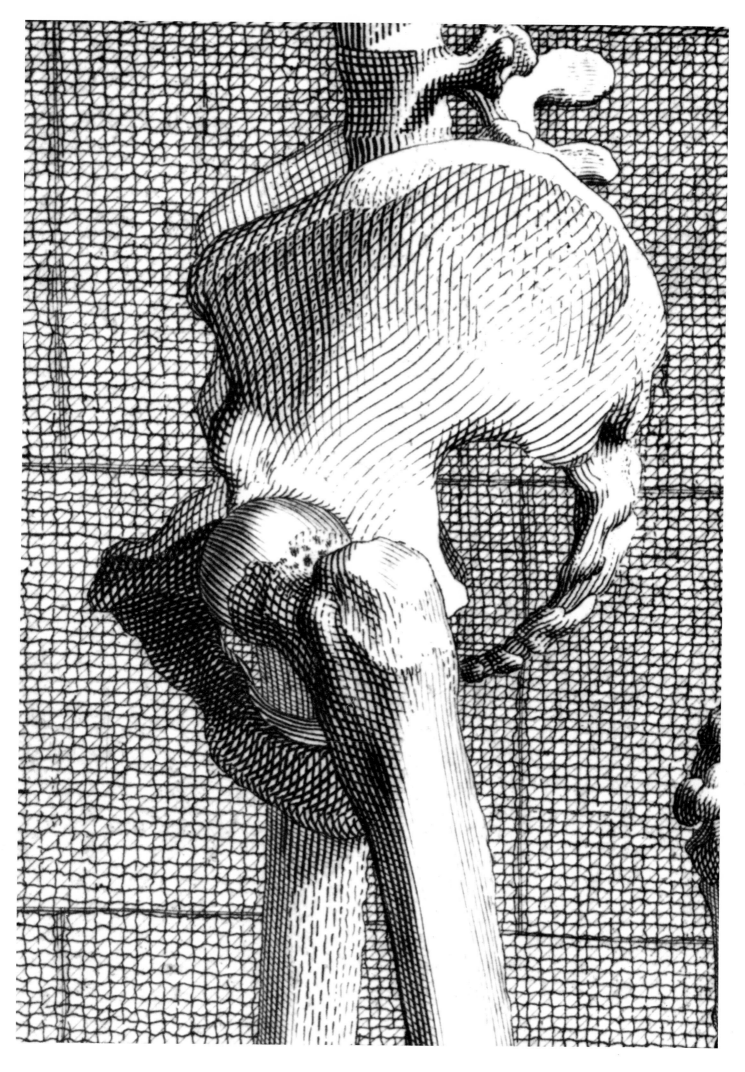

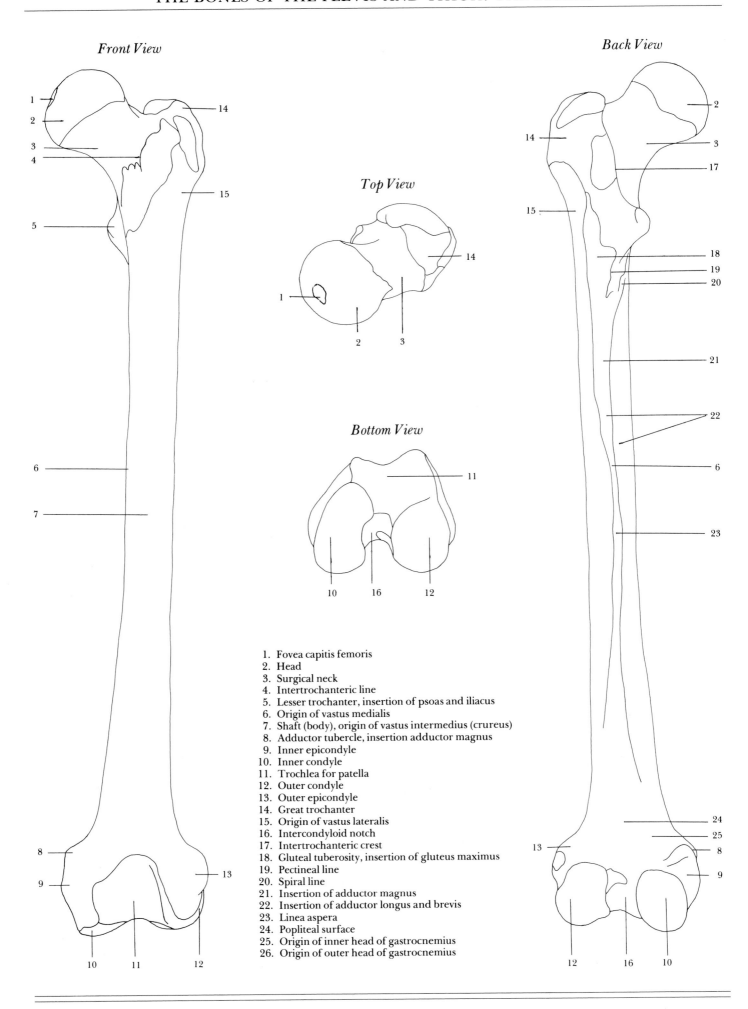

Front View

Top View

Back View

Bottom View

1. Fovea capitis femoris
2. Head
3. Surgical neck
4. Intertrochanteric line
5. Lesser trochanter, insertion of psoas and iliacus
6. Origin of vastus medialis
7. Shaft (body), origin of vastus intermedius (crureus)
8. Adductor tubercle, insertion adductor magnus
9. Inner epicondyle
10. Inner condyle
11. Trochlea for patella
12. Outer condyle
13. Outer epicondyle
14. Great trochanter
15. Origin of vastus lateralis
16. Intercondyloid notch
17. Intertrochanteric crest
18. Gluteal tuberosity, insertion of gluteus maximus
19. Pectineal line
20. Spiral line
21. Insertion of adductor magnus
22. Insertion of adductor longus and brevis
23. Linea aspera
24. Popliteal surface
25. Origin of inner head of gastrocnemius
26. Origin of outer head of gastrocnemius

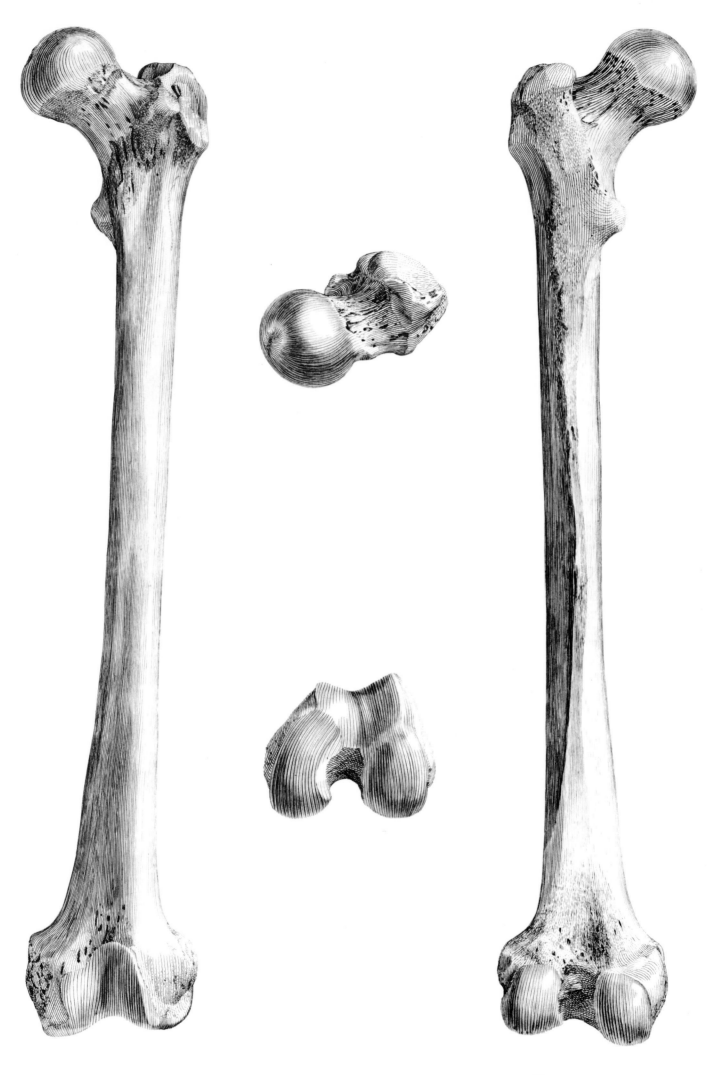

Inner View

Outer View

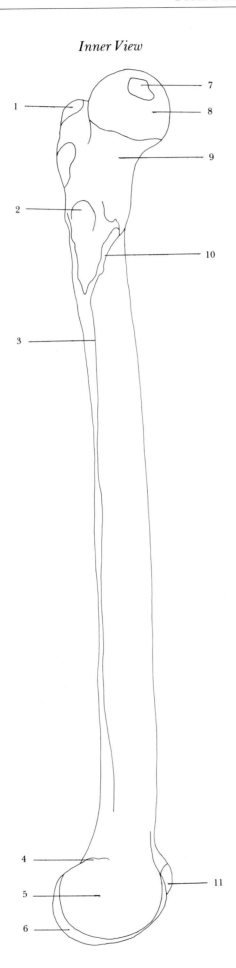

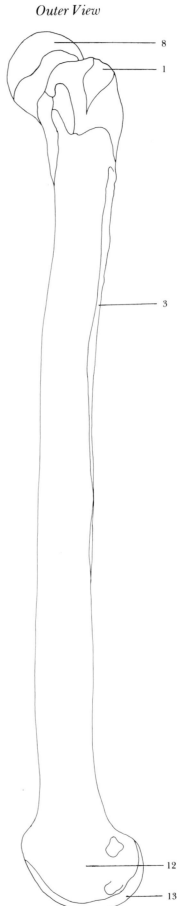

1. Great trochanter
2. Lesser trochanter
3. Linea aspera
4. Adductor tubercle
5. Inner epicondyle
6. Inner condyle
7. Fovea capitis femoris
8. Head
9. Surgical neck
10. Spiral line
11. Trochlea for patella
12. Outer epicondyle
13. Outer condyle

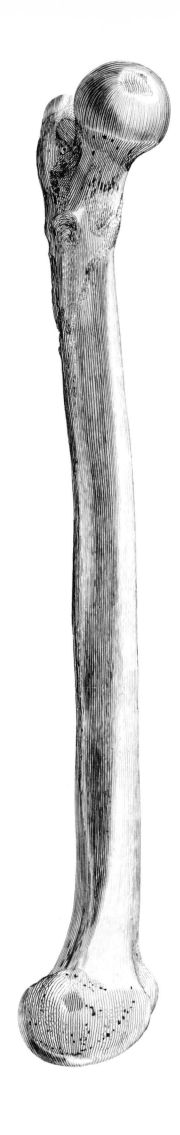
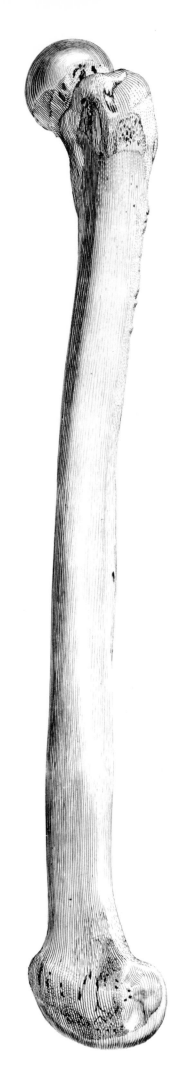

Gluteus Maximus

Gluteus Medius

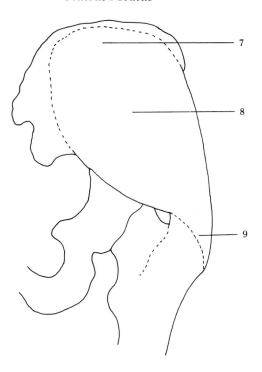

1. Origin of gluteus maximus from posterior ilium of pelvis
2. Fleshy body of gluteus maximus
3. Origin from sacrum
4. Origin from coccyx
5. Insertion into upper linea aspera of femur
6. Great trochanter of femur
7. Origin of gluteus medius from outer ilium of pelvis
8. Fleshy body of gluteus medius
9. Insertion into great trochanter of femur

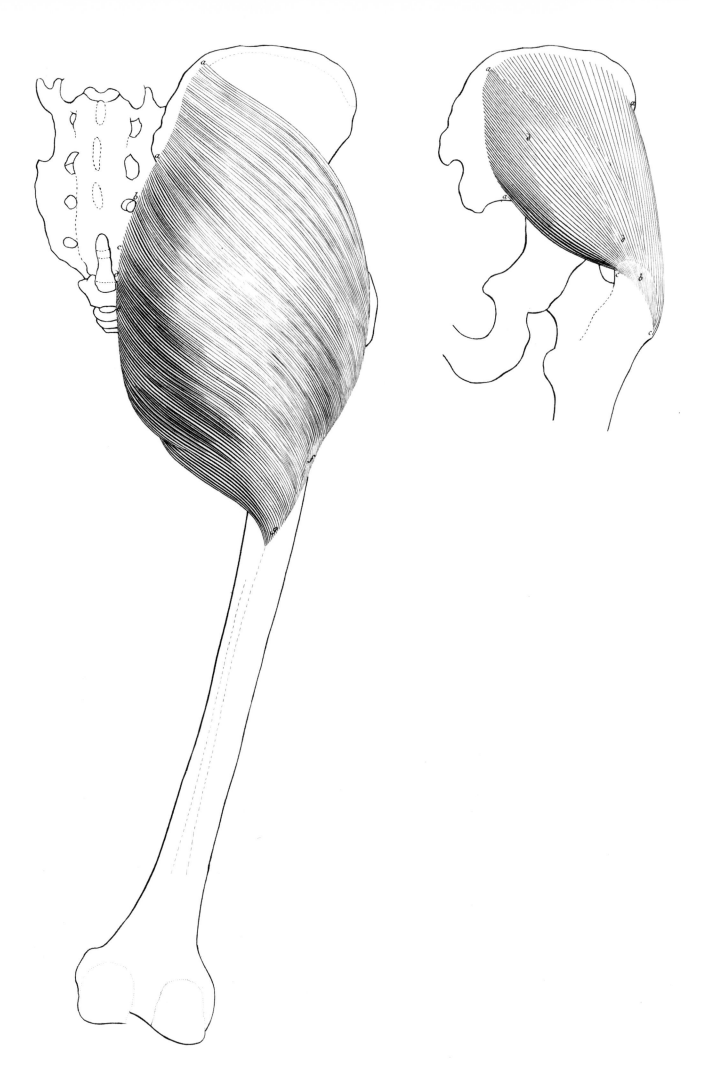

1. Origin of psoas major from vertebrae
2. Fleshy body of psoas major
3. Sacrum
4. Ischium of pelvis
5. Insertion into lesser trochanter of femur
6. Ilium of pelvis
7. Origin of iliacus from iliac fossa of pelvis
8. Fleshy body of iliacus
9. Insertion into femur bone

Psoas Major

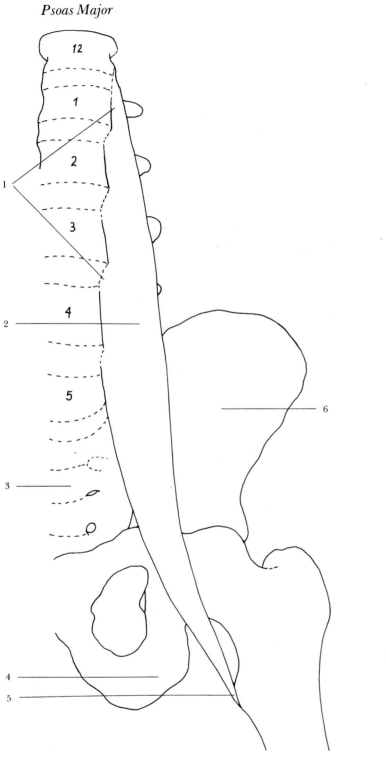

Iliacus

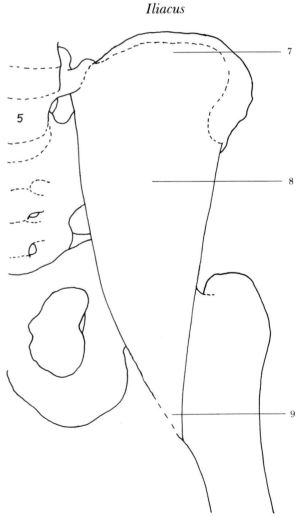

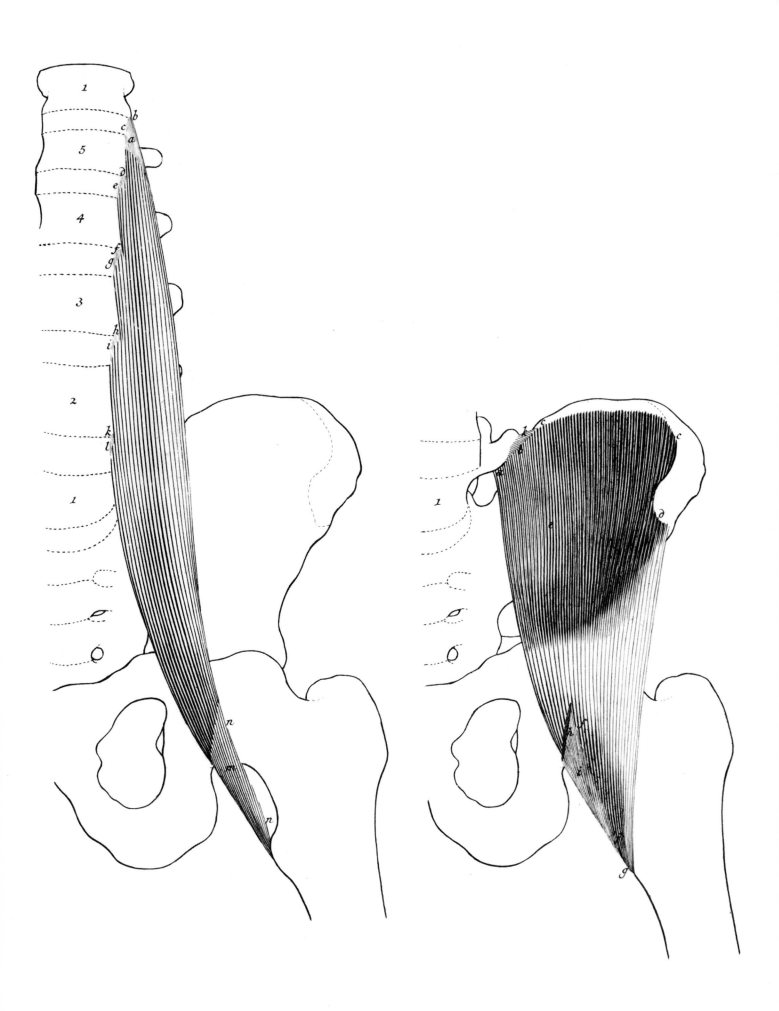

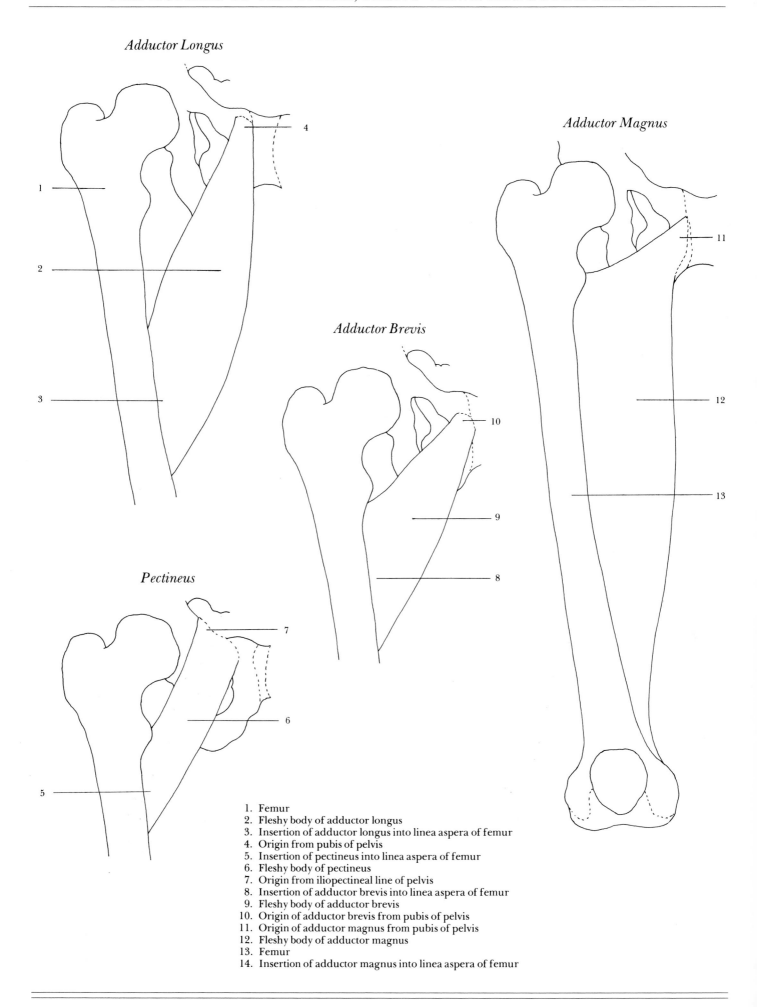

Adductor Longus

Adductor Magnus

Adductor Brevis

Pectineus

1. Femur
2. Fleshy body of adductor longus
3. Insertion of adductor longus into linea aspera of femur
4. Origin from pubis of pelvis
5. Insertion of pectineus into linea aspera of femur
6. Fleshy body of pectineus
7. Origin from iliopectineal line of pelvis
8. Insertion of adductor brevis into linea aspera of femur
9. Fleshy body of adductor brevis
10. Origin of adductor brevis from pubis of pelvis
11. Origin of adductor magnus from pubis of pelvis
12. Fleshy body of adductor magnus
13. Femur
14. Insertion of adductor magnus into linea aspera of femur

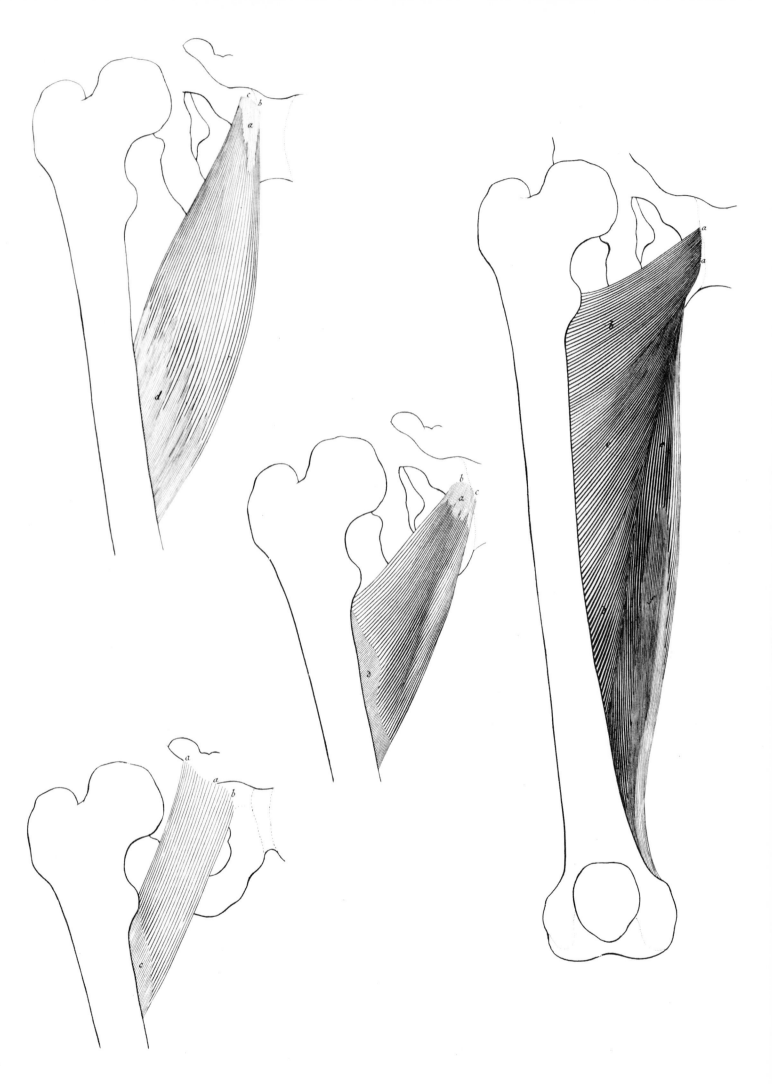

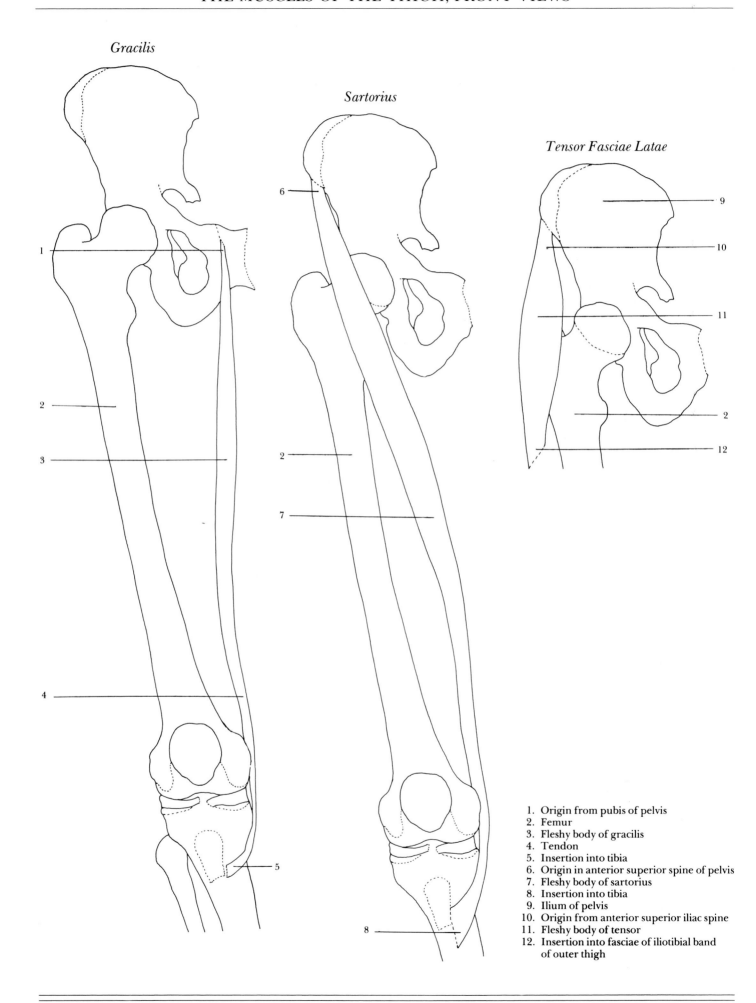

Gracilis

Sartorius

Tensor Fasciae Latae

1. Origin from pubis of pelvis
2. Femur
3. Fleshy body of gracilis
4. Tendon
5. Insertion into tibia
6. Origin in anterior superior spine of pelvis
7. Fleshy body of sartorius
8. Insertion into tibia
9. Ilium of pelvis
10. Origin from anterior superior iliac spine
11. Fleshy body of tensor
12. Insertion into fasciae of iliotibial band
 of outer thigh

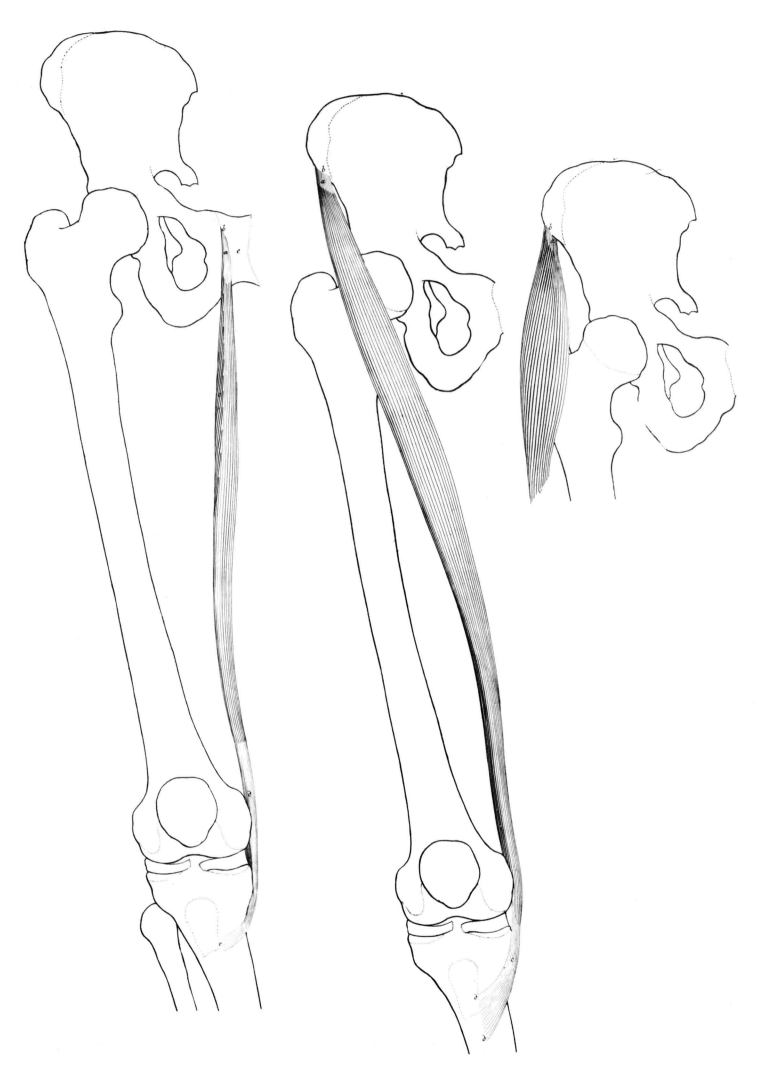

1. Origin from anterior inferior iliac spine of pelvis
2. Femur
3. Fleshy body of rectus
4. Tendon to patella
5. Patella
6. Patella ligament
7. Insertion into anterior tuberosity of tibia
8. Origin of three vasti from upper femur
9. Vastus externus (lateralis)
10. Vastus intermedius (Crureus)
11. Vastus internus (medialis)
12. Insertion with rectus femoris by patella tendon into anterior tuberosity of tibia

Rectus Femoris

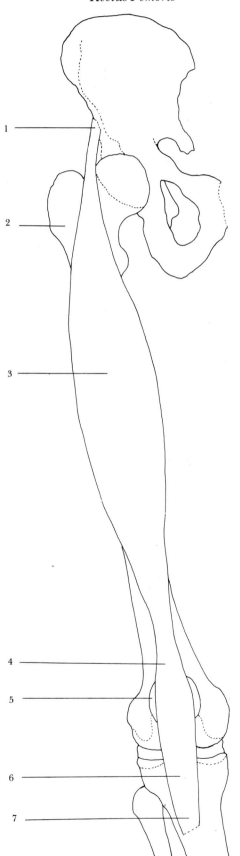

The Three Vasti

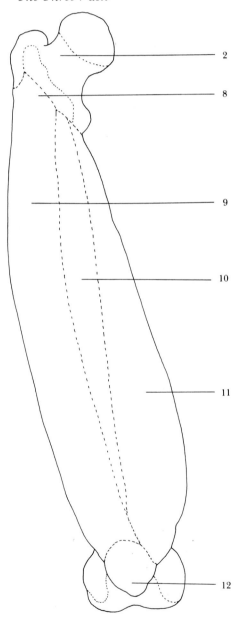

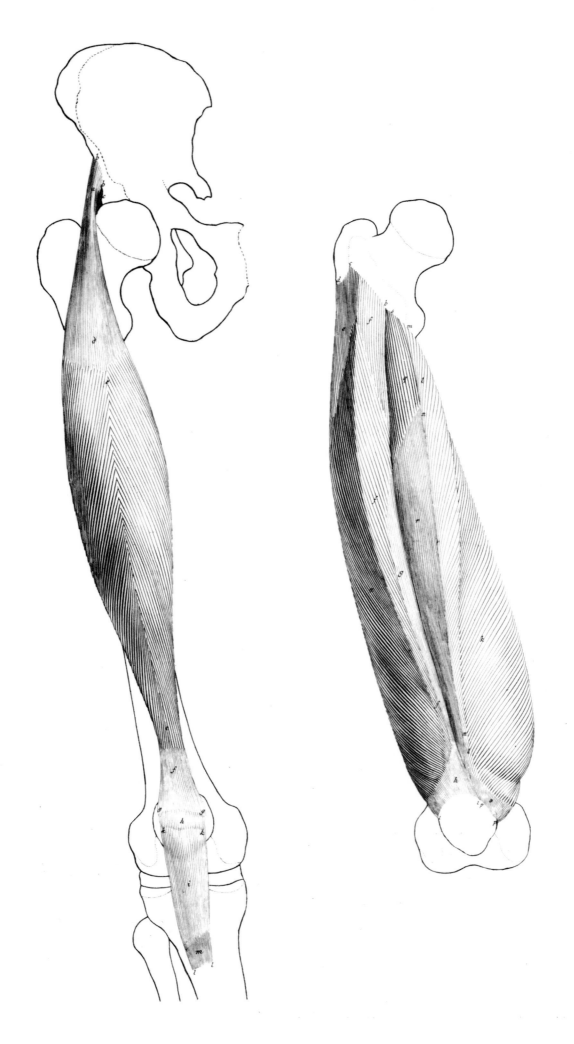

Semitendinosus and Biceps Femoris,
Long Head

Semimembranosus and Biceps Femoris,
Short Head

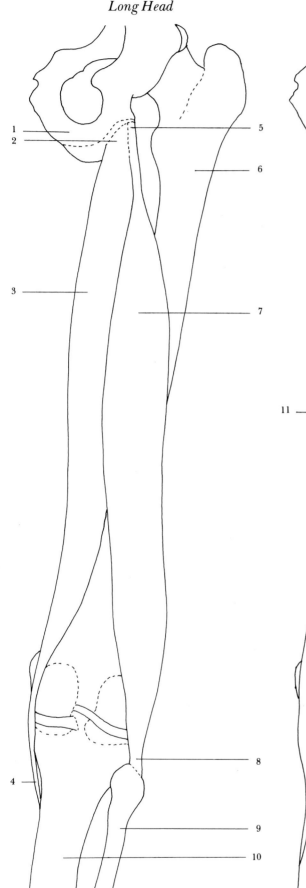

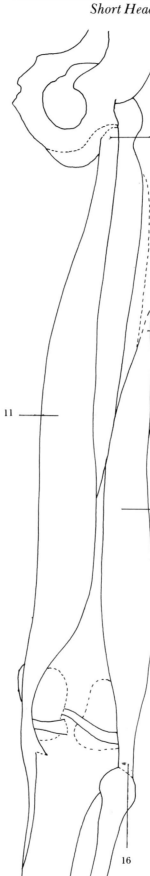

1. Ischium of pelvis
2. Origin of semitendinosus from tubercle of ischium
3. Fleshy body of semitendinosus
4. Insertion into inner tibia
5. Origin of biceps femoris, long head from tuberosity of ischium
6. Femur bone
7. Fleshy body of biceps femoris, long head
8. Insertion into head of fibula and outer tibia
9. Fibula
10. Tibia
11. Fleshy body of semimembranosus
12. Origin of semimembranosus from ischial tuberosity
13. Linea aspera
14. Origin from linea aspera
15. Fleshy body of biceps femoris, short head
16. Insertion into head of fibula and outer tibia

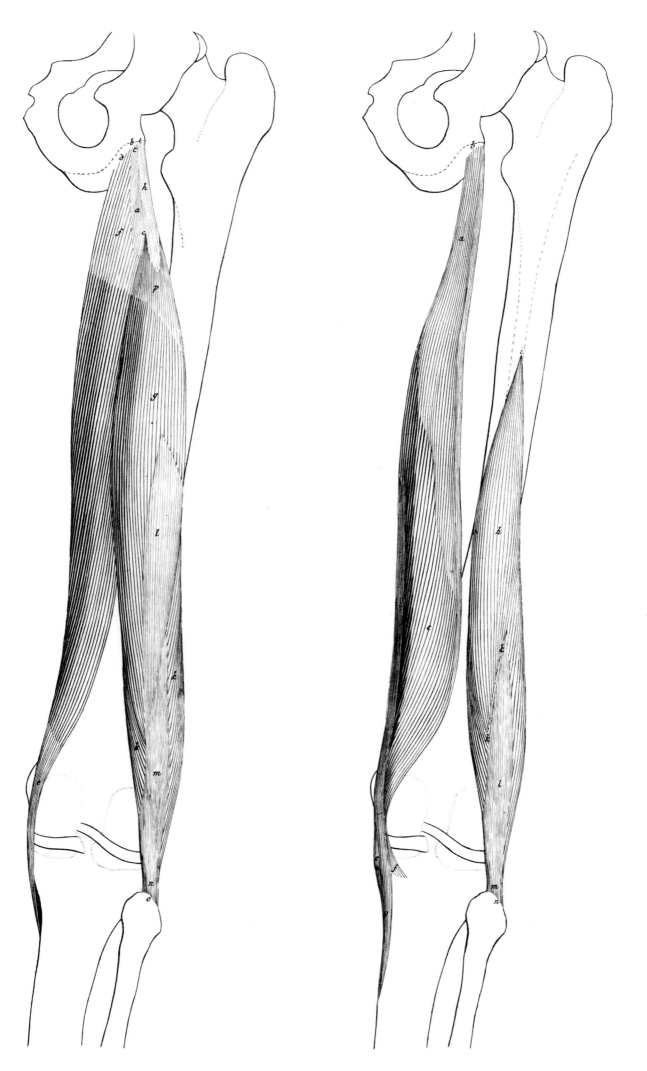

THE KNEE AND LOWER LEG

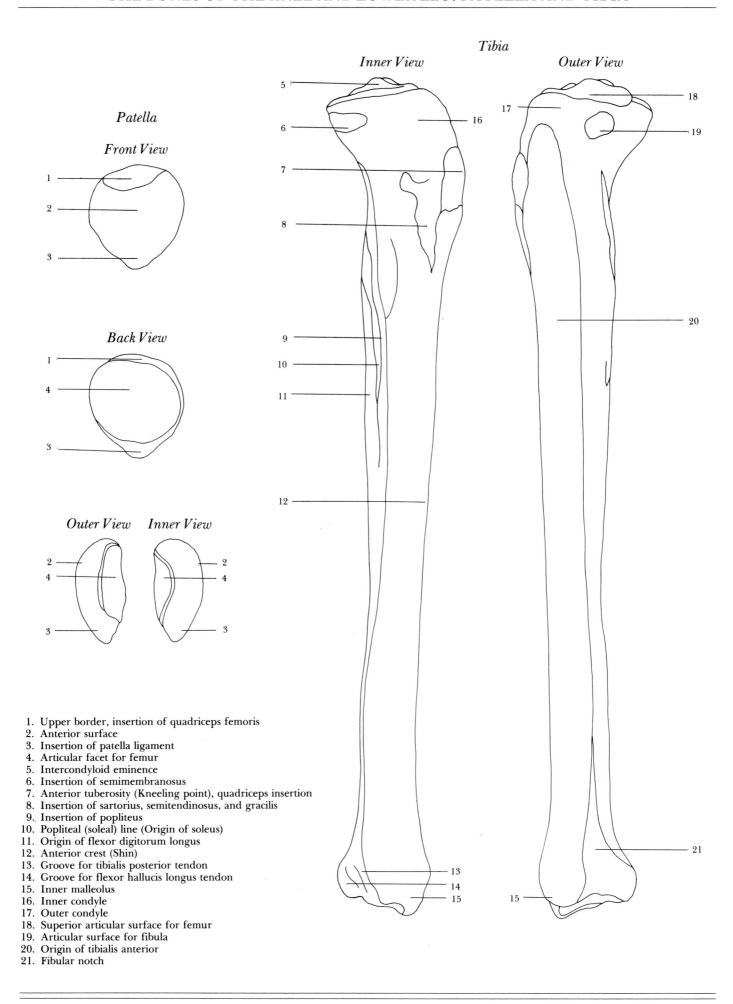

Tibia

Inner View *Outer View*

Patella

Front View

Back View

Outer View *Inner View*

1. Upper border, insertion of quadriceps femoris
2. Anterior surface
3. Insertion of patella ligament
4. Articular facet for femur
5. Intercondyloid eminence
6. Insertion of semimembranosus
7. Anterior tuberosity (Kneeling point), quadriceps insertion
8. Insertion of sartorius, semitendinosus, and gracilis
9. Insertion of popliteus
10. Popliteal (soleal) line (Origin of soleus)
11. Origin of flexor digitorum longus
12. Anterior crest (Shin)
13. Groove for tibialis posterior tendon
14. Groove for flexor hallucis longus tendon
15. Inner malleolus
16. Inner condyle
17. Outer condyle
18. Superior articular surface for femur
19. Articular surface for fibula
20. Origin of tibialis anterior
21. Fibular notch

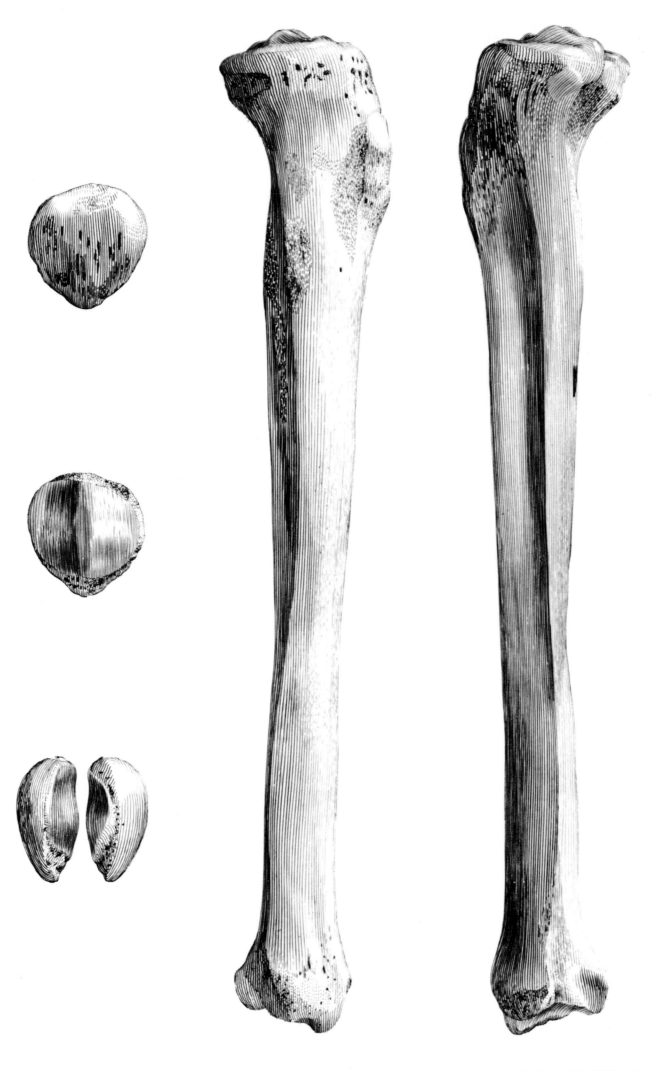

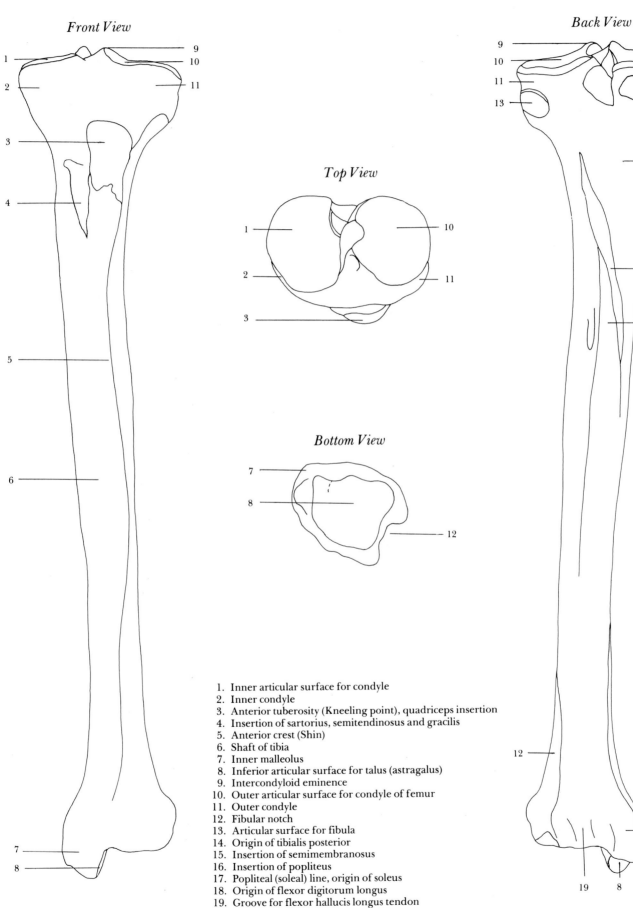

Front View

Back View

Top View

Bottom View

1. Inner articular surface for condyle
2. Inner condyle
3. Anterior tuberosity (Kneeling point), quadriceps insertion
4. Insertion of sartorius, semitendinosus and gracilis
5. Anterior crest (Shin)
6. Shaft of tibia
7. Inner malleolus
8. Inferior articular surface for talus (astragalus)
9. Intercondyloid eminence
10. Outer articular surface for condyle of femur
11. Outer condyle
12. Fibular notch
13. Articular surface for fibula
14. Origin of tibialis posterior
15. Insertion of semimembranosus
16. Insertion of popliteus
17. Popliteal (soleal) line, origin of soleus
18. Origin of flexor digitorum longus
19. Groove for flexor hallucis longus tendon
20. Groove for tibialis posterior tendon

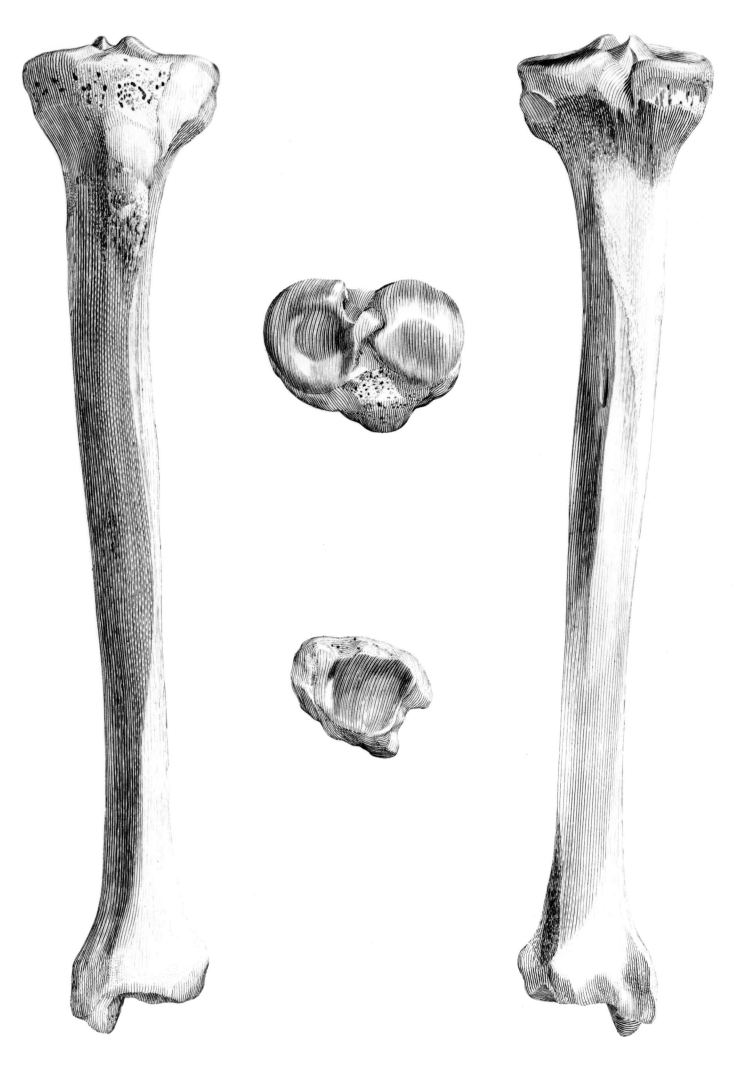

Front View *Back View* *Inner View* *Outer View*

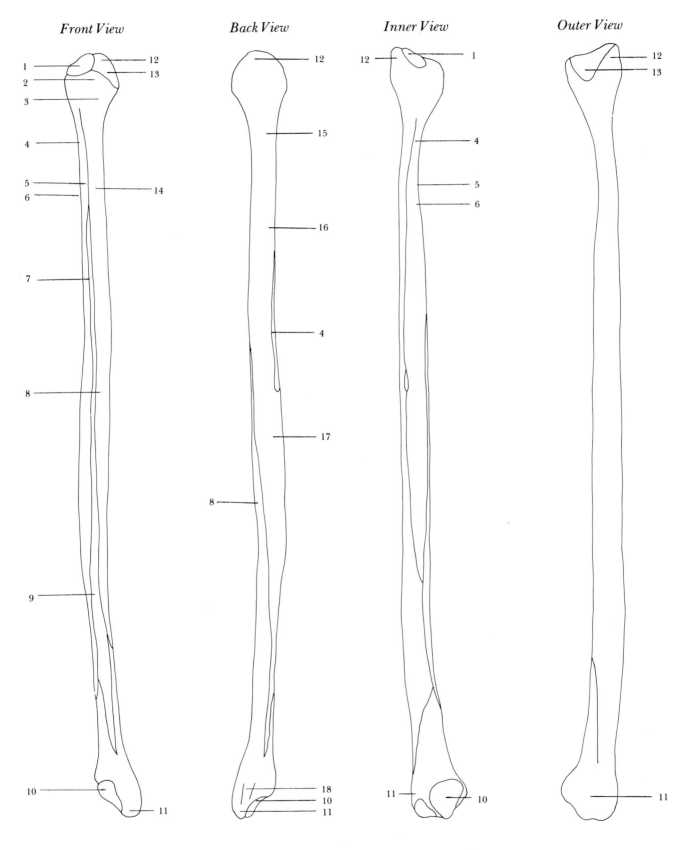

1. Articular surface for tibia
2. Head
3. Neck
4. Origin of tibialis posterior
5. Medial crest
6. Interosseous border
7. Origin of extensor digitorum longus
8. Origin of peroneus brevis
9. Origin of peroneus tertius
10. Articular surface for talus
11. Outer malleolus
12. Styloid process
13. Insertion of biceps femoris
14. Origin of peroneus longus
15. Origin of soleus
16. Origin of peroneus longus
17. Origin of flexor hallucis longus
18. Groove for peroneus brevis and longus

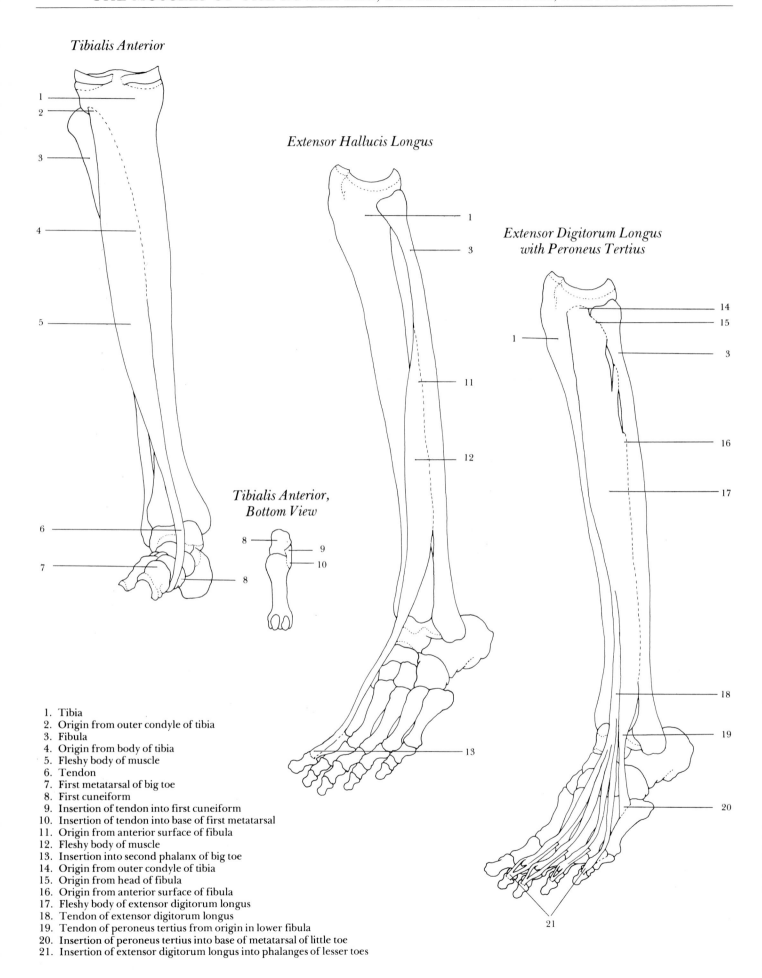

Tibialis Anterior

Extensor Hallucis Longus

*Extensor Digitorum Longus
with Peroneus Tertius*

*Tibialis Anterior,
Bottom View*

1. Tibia
2. Origin from outer condyle of tibia
3. Fibula
4. Origin from body of tibia
5. Fleshy body of muscle
6. Tendon
7. First metatarsal of big toe
8. First cuneiform
9. Insertion of tendon into first cuneiform
10. Insertion of tendon into base of first metatarsal
11. Origin from anterior surface of fibula
12. Fleshy body of muscle
13. Insertion into second phalanx of big toe
14. Origin from outer condyle of tibia
15. Origin from head of fibula
16. Origin from anterior surface of fibula
17. Fleshy body of extensor digitorum longus
18. Tendon of extensor digitorum longus
19. Tendon of peroneus tertius from origin in lower fibula
20. Insertion of peroneus tertius into base of metatarsal of little toe
21. Insertion of extensor digitorum longus into phalanges of lesser toes

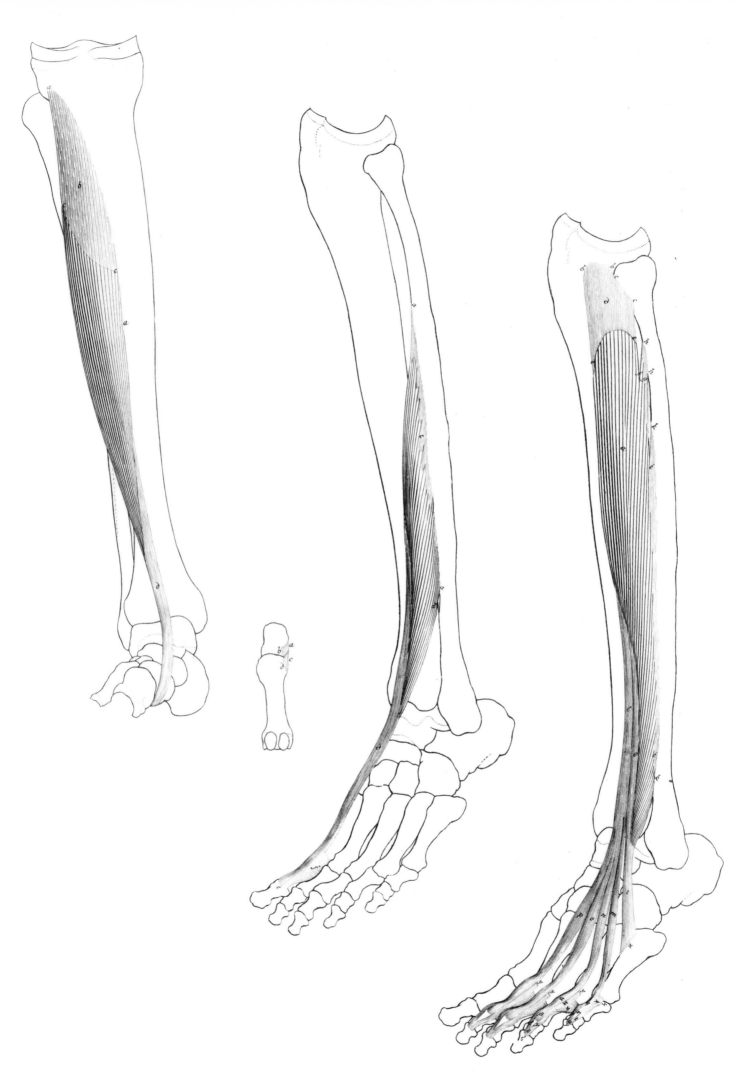

Popliteus *Soleus* *Gastrocnemius* *Plantaris*

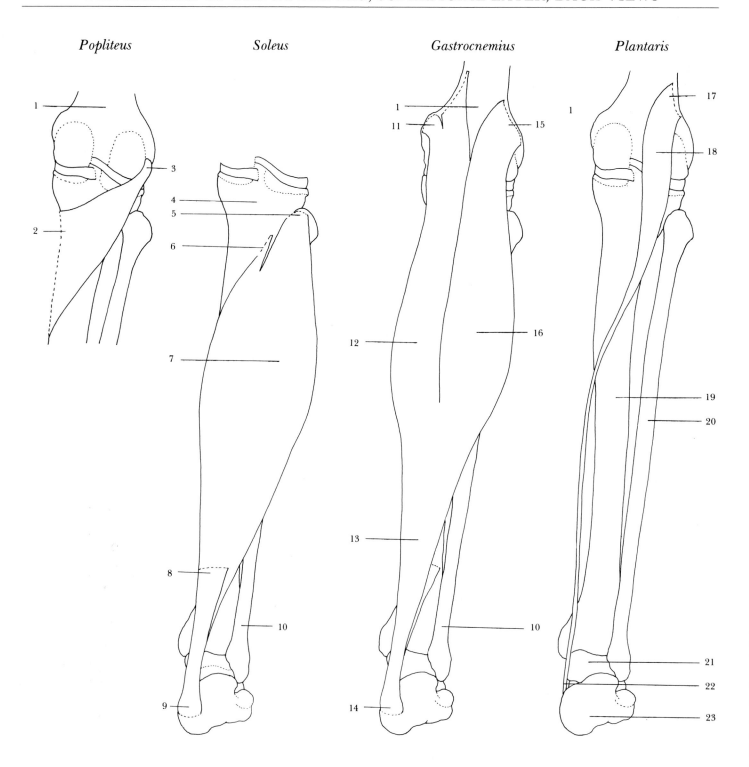

1. Popliteal surface of femur
2. Insertion into tibia
3. Origin from femur
4. Tibia, back view
5. Origin from head of fibula
6. Origin from tibia
7. Fleshy body of muscle
8. Gastrocnemius (Achilles) tendon, cut off
9. Insertion of soleus into calcaneus
10. Fibula
11. Origin of inner head from condyle of femur
12. Inner (medial) head

13. Tendo calcaneus (Achilles tendon)
14. Insertion into calcaneus
15. Origin of outer head from condyle of femur
16. Outer (lateral) head
17. Origin from femur
18. Fleshy body of muscle
19. Shaft of tibia
20. Shaft of fibula
21. Talus (Astragalus)
22. Insertion into calcaneus
23. Calcaneus (Heel bone)

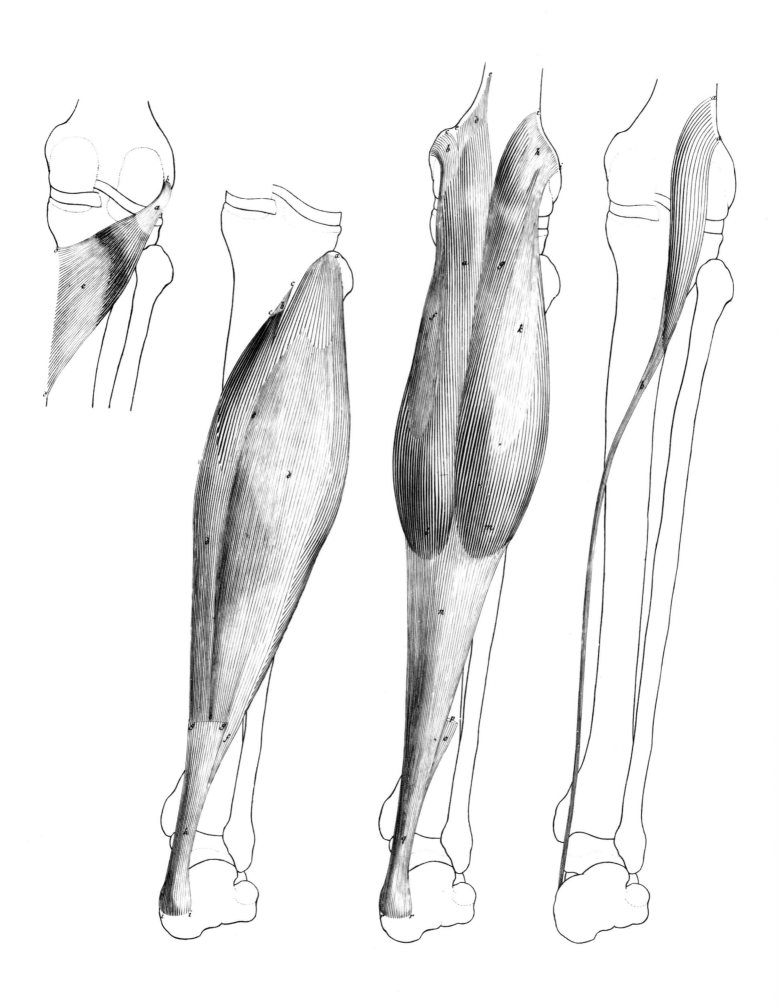

1. Origin from popliteal line of tibia
2. Origin from inner fibula
3. Tendon of insertion to navicular
4. Inner malleolus of tibia
5. Talus (Astragalus)
6. Navicular (Scaphoid)
7. Insertion into navicular
8. Insertion into first cuneiform
9. Calcaneus (Heel bone)
10. Fibrous expansion to calcaneus
11. Fibrous expansion to cuboid
12. Tendon, cut off
13. Fibrous expansion
14. Metatarsal of big toe

Back View

Inner View

Bottom View

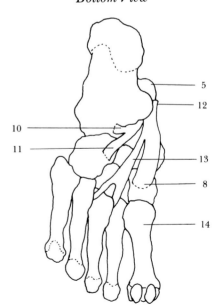

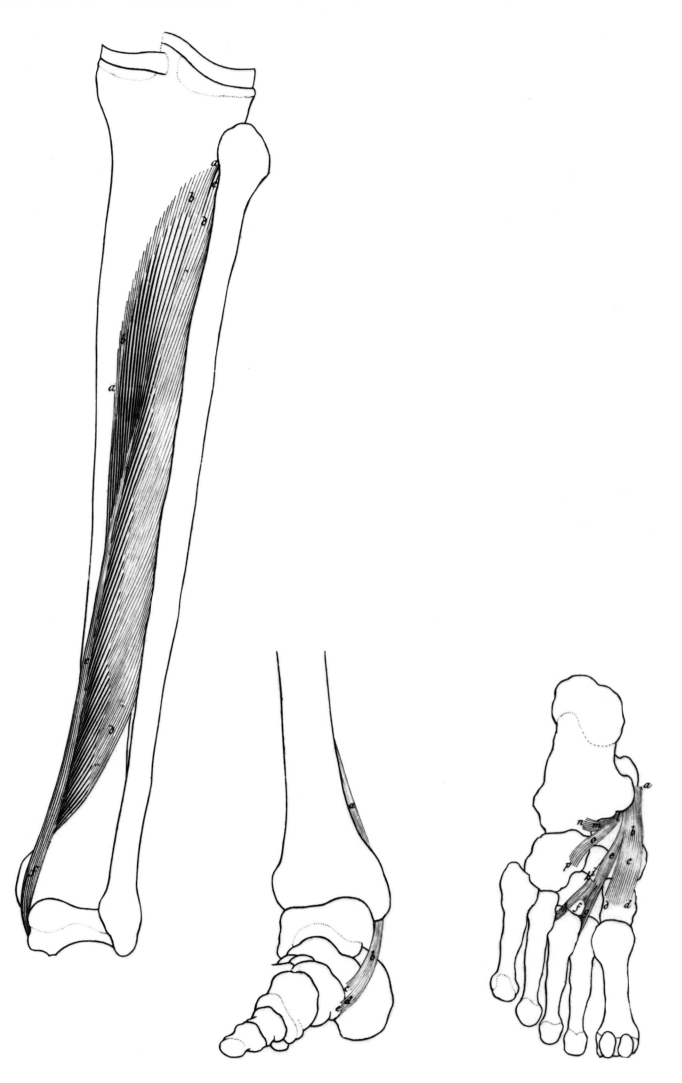

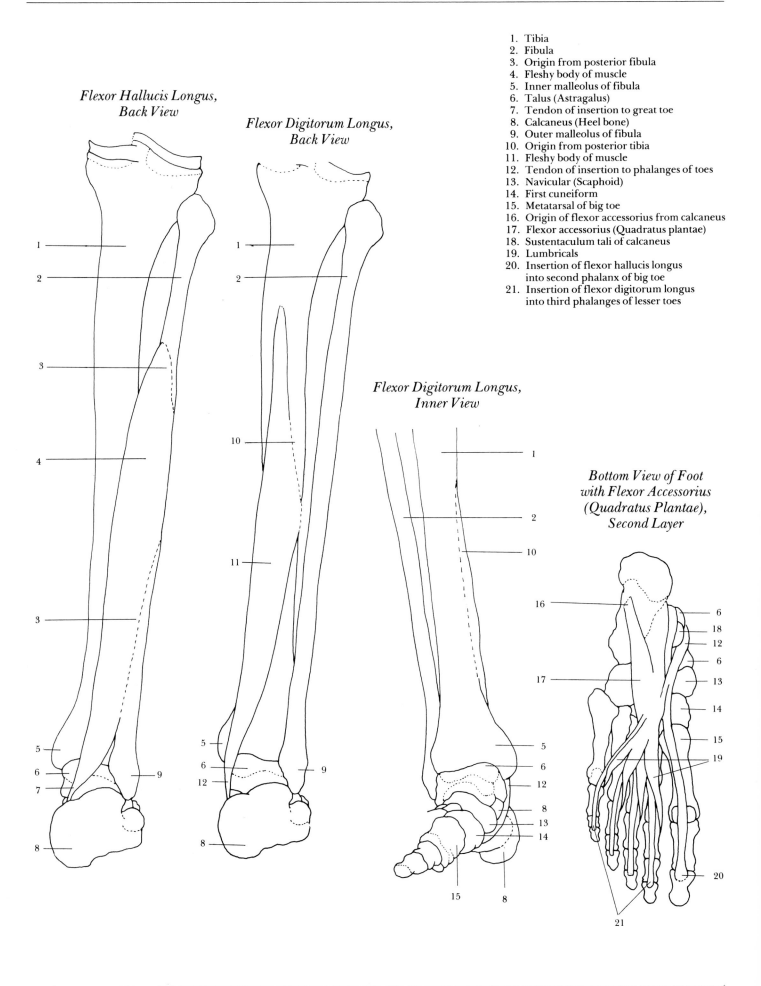

1. Tibia
2. Fibula
3. Origin from posterior fibula
4. Fleshy body of muscle
5. Inner malleolus of fibula
6. Talus (Astragalus)
7. Tendon of insertion to great toe
8. Calcaneus (Heel bone)
9. Outer malleolus of fibula
10. Origin from posterior tibia
11. Fleshy body of muscle
12. Tendon of insertion to phalanges of toes
13. Navicular (Scaphoid)
14. First cuneiform
15. Metatarsal of big toe
16. Origin of flexor accessorius from calcaneus
17. Flexor accessorius (Quadratus plantae)
18. Sustentaculum tali of calcaneus
19. Lumbricals
20. Insertion of flexor hallucis longus into second phalanx of big toe
21. Insertion of flexor digitorum longus into third phalanges of lesser toes

Flexor Hallucis Longus, Back View

Flexor Digitorum Longus, Back View

Flexor Digitorum Longus, Inner View

Bottom View of Foot with Flexor Accessorius (Quadratus Plantae), Second Layer

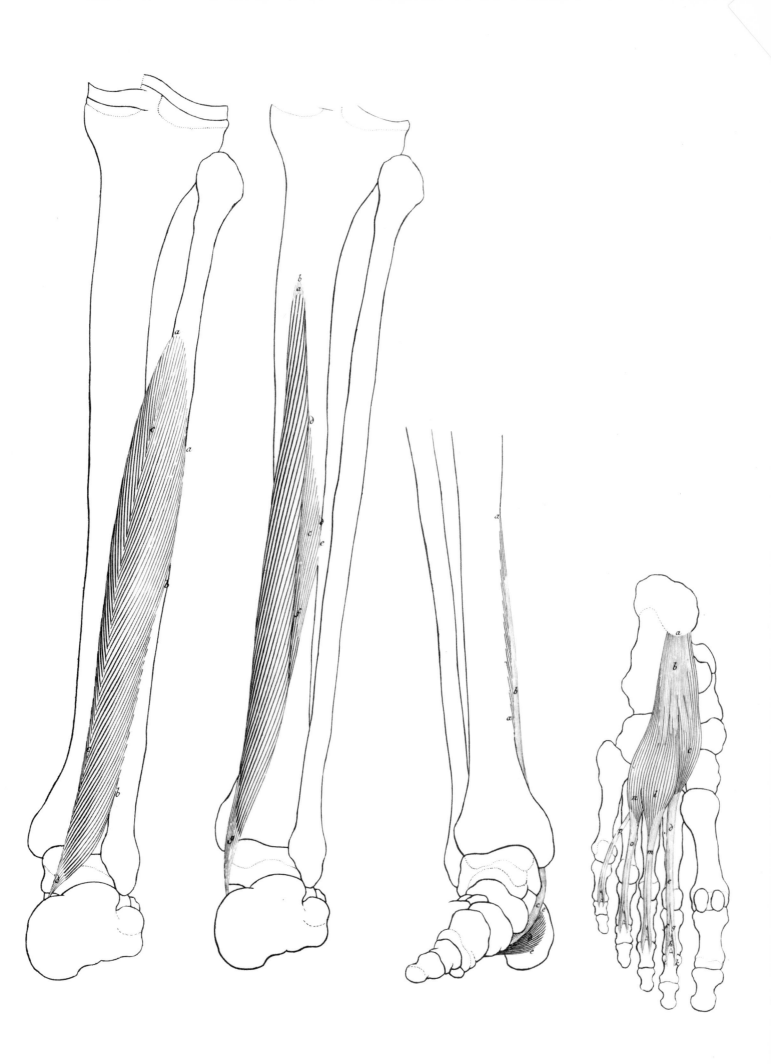

1. Tibia
2. Origin from fibula
3. Talus (Astragalus)
4. Calcaneus (Heel bone)
5. Peroneal tubercle of calcaneus
6. Cuboid
7. Insertion into metatarsal of little toe
8. Origin from fibula
9. Tendon of insertion to big toe
10. Insertion into first cuneiform
11. Insertion into base of metatarsal of big toe

Peroneus Brevis, Outer View

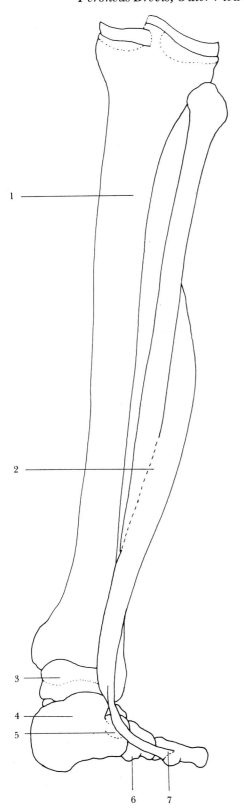

Peroneus Longus, Outer View

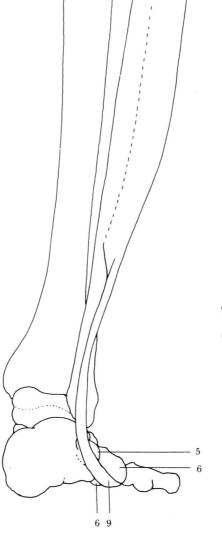

Peroneus Longus, Bottom View

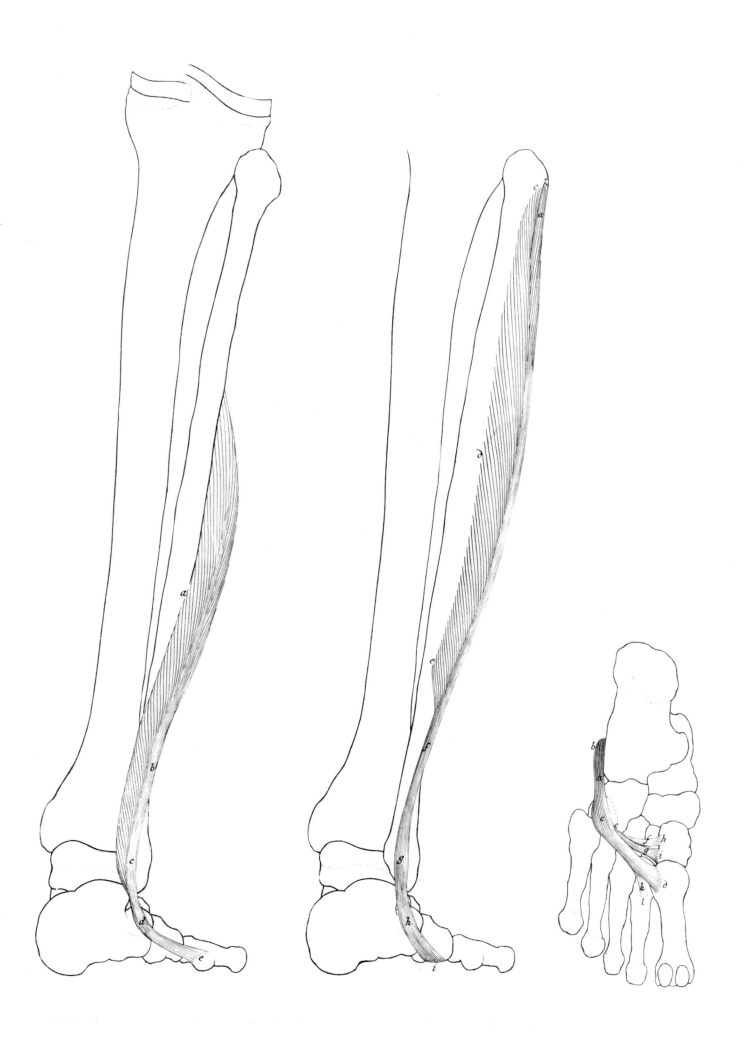

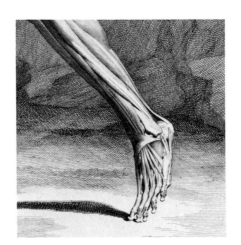

THE FOOT

Front View

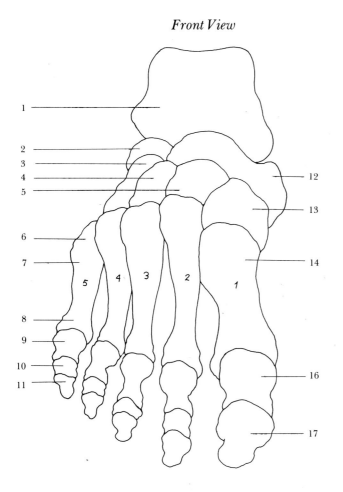

Top View

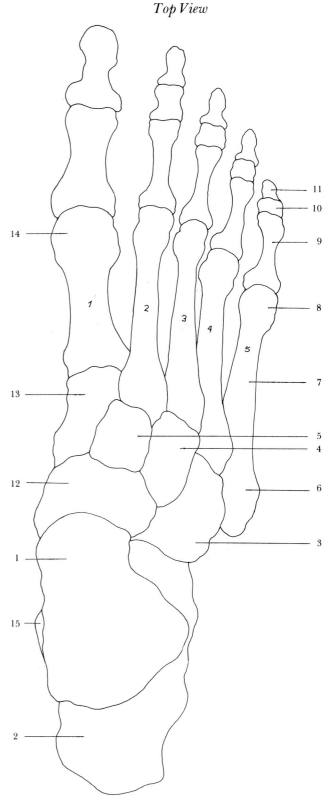

1. Talus (Astragalus)
2. Calcaneus (Heel bone)
3. Cuboid
4. Third cuneiform
5. Second cuneiform
6. Base of metatarsal
7. Fifth metatarsal
8. Head of metatarsal
9. First phalanx of little toe
10. Second phalanx of little toe
11. Third phalanx of little toe
12. Navicular (Scaphoid)
13. First cuneiform
14. First metacarpal of big toe
15. Sustentaculum tali of calcaneus
16. Proximal (first) phalanx of big toe
17. Distal (second) phalanx of big toe

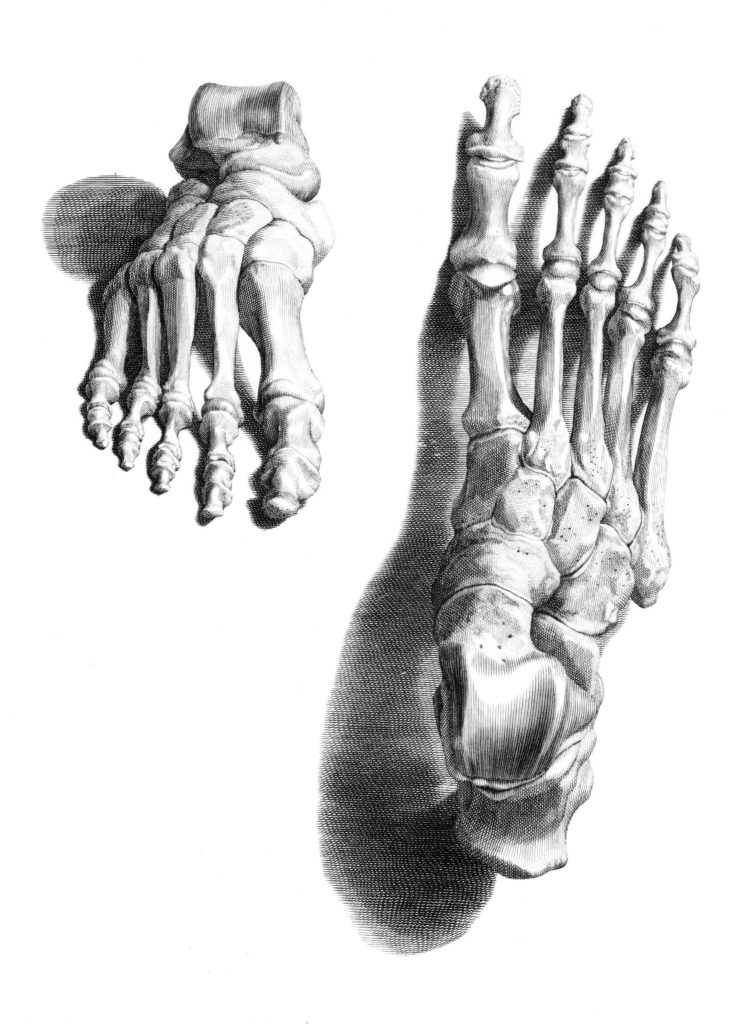

Inner View

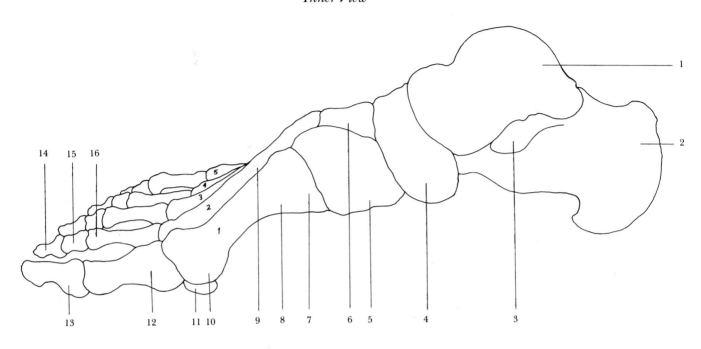

Outer View

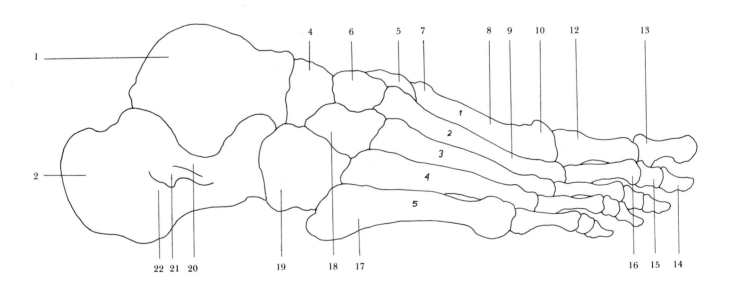

1. Talus (Astragalus)
2. Calcaneus (Heel bone)
3. Sustentaculum tali of calcaneus
4. Navicular (Scaphoid)
5. First cuneiform
6. Second cuneiform
7. Base of metatarsal
8. First metatarsal
9. Second metatarsal
10. Head of metatarsal
11. Sesamoid bone
12. Proximal (first) phalanx of big (great) toe
13. Distal (second) phalanx
14. Third phalanx of second toe
15. Second phalanx
16. First phalanx
17. Fifth metatarsal
18. Third cuneiform
19. Cuboid
20. Superior groove for peroneus brevis
21. Peroneal tubercle (Cuboid tuberosity)
22. Inferior groove for peroneus longus

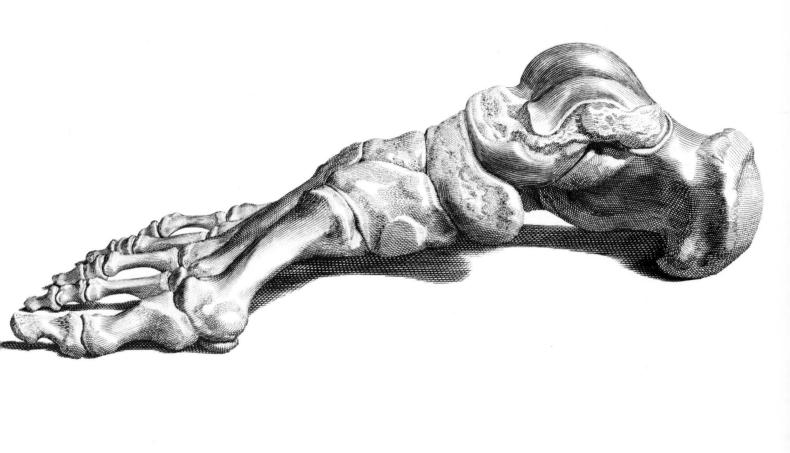

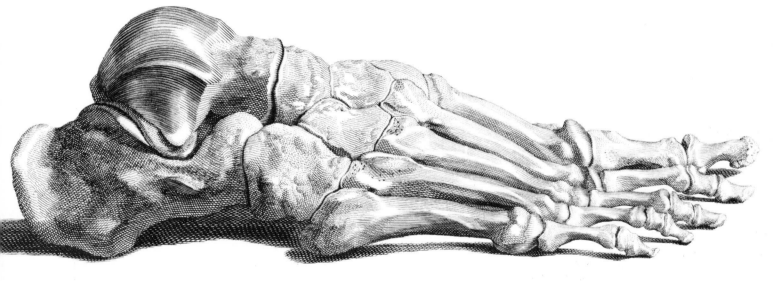

Abductor Digiti Minimi,
Superficial Layer,
Bottom View

Flexor Digitorum Brevis,
Superficial Layer,
Bottom View

Flexor Digiti Minimi Brevis,
Deep Layer,
Bottom View

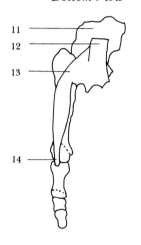

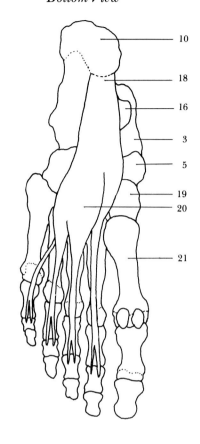

Extensor Digitorum Brevis,
Top View

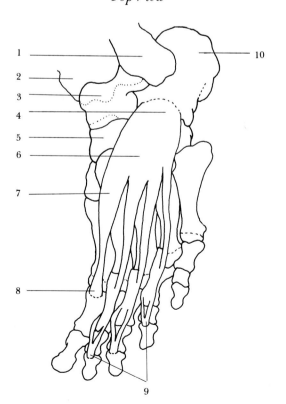

1. Lateral malleolus of fibula
2. Tibia
3. Talus
4. Origin from calcaneus
5. Navicular (Scaphoid)
6. Fleshy body of extensor digitorum brevis
7. Portion of extensor digitorum brevis
 (also called Extensor hallucis brevis)
8. Insertion into first phalanx of big toe
9. Insertion with extensor digitorum longus into phalanges
10. Calcaneus
11. Cuboid
12. Origin from sheath of peroneus longus tendon
13. Origin from base of metatarsal of little toe
14. Insertion into base of first phalanx of little toe
15. Origin from calcaneus
16. Sustentaculum tali of calcaneus
17. Insertion into first phalanx of little toe
18. Origin in calcaneus
19. First cuneiform
20. Fleshy body of muscle
21. First metatarsal
22. Insertion into second phalanx of lesser toes

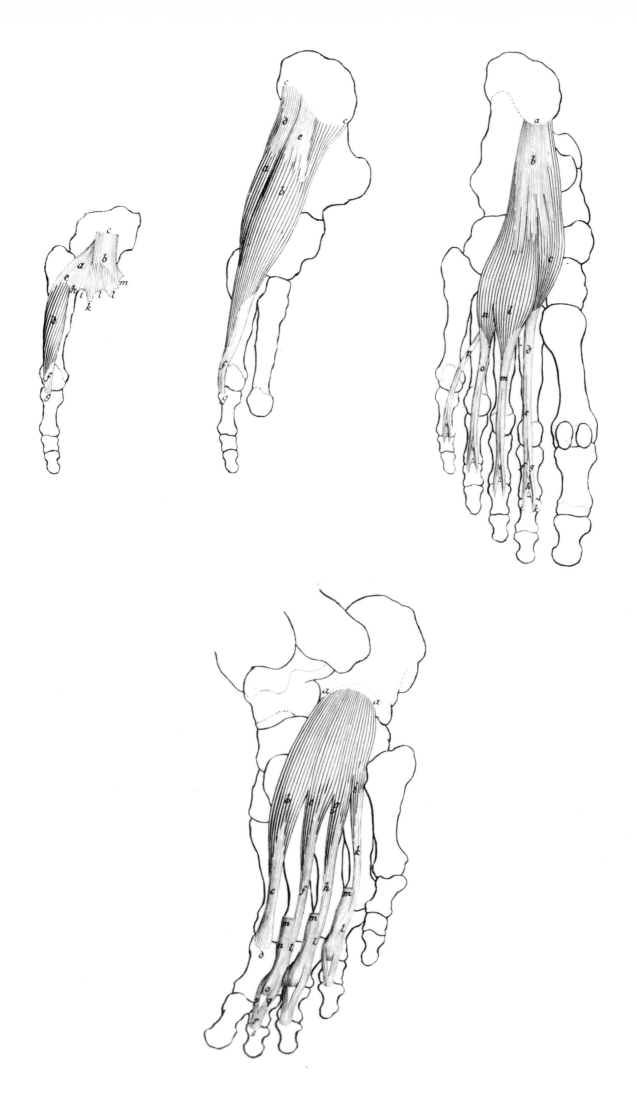

Adductor Hallucis, Deep Layer,
Bottom View

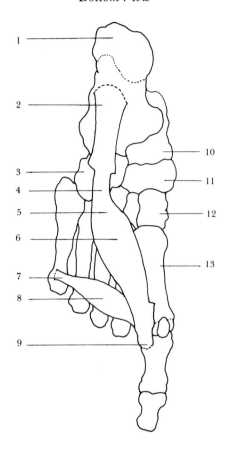

Abductor Hallucis
with Flexor Hallucis Brevis,
Deep Layer, Bottom View

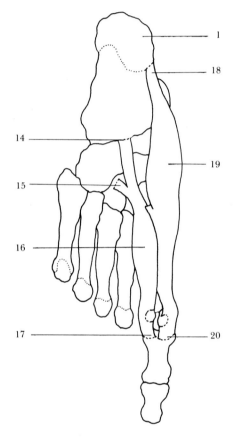

Abductor Hallucis
with Flexor Hallucis Brevis,
Deep Layer, Inner View

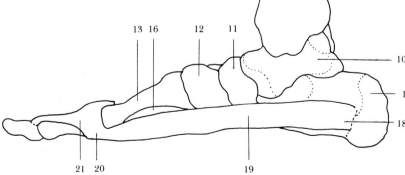

1. Calcaneus (Heel bone)
2. Long plantar ligament
3. Cuboid
4. Origin of oblique head from sheath of peroneus longus tendon
5. Origin of oblique head from second, third, and fourth metatarsal
6. Fleshy body of oblique head
7. Origin of transverse head from deep transverse ligaments
8. Fleshy body of transverse head
9. Insertion of both heads into proximal phalanx of big toe
10. Talus (Astragalus)
11. Navicular (Scaphoid)
12. First cuneiform
13. First metatarsal
14. Origin of flexor hallucis brevis from cuboid
15. Origin of flexor hallucis brevis from third cuneiform
16. Fleshy body of flexor hallucis brevis
17. Insertion of flexor hallucis brevis into base
 of first phalanx of big toe
18. Origin of abductor hallucis from calcaneus
19. Fleshy body of abductor hallucis
20. Insertion of abductor hallucis into base
 of first phalanx of big toe
21. Abductor aponeurosis

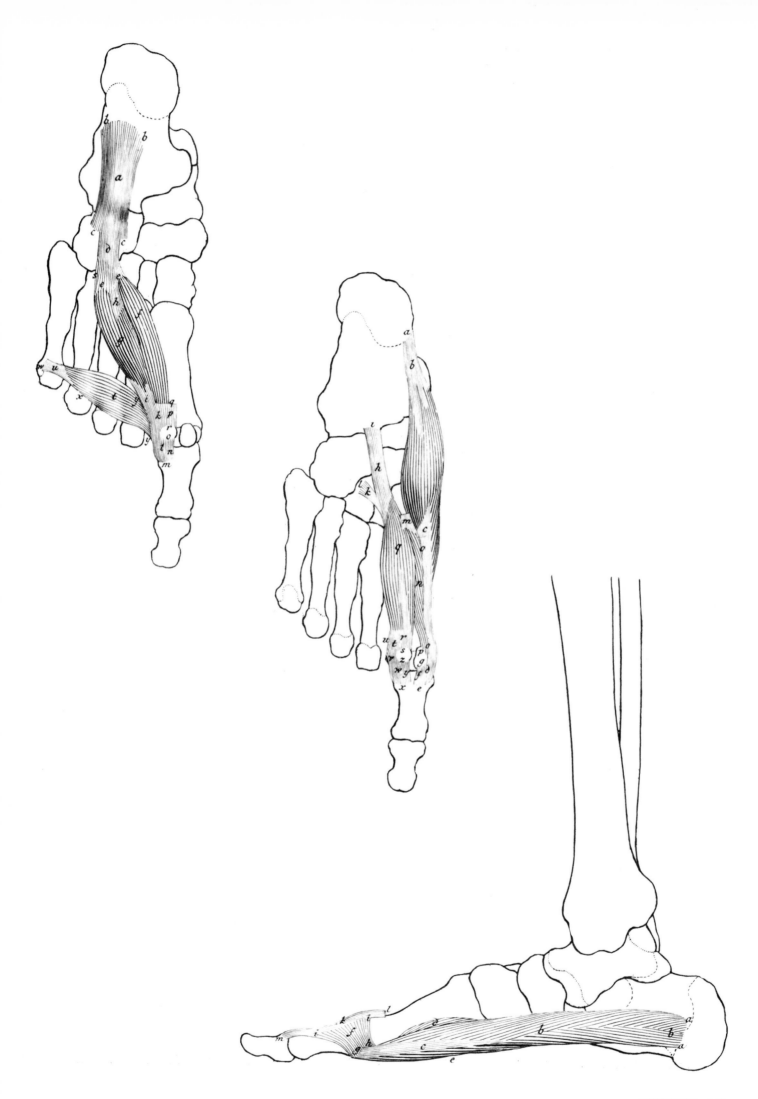

THE SHOULDER GIRDLE

Top View

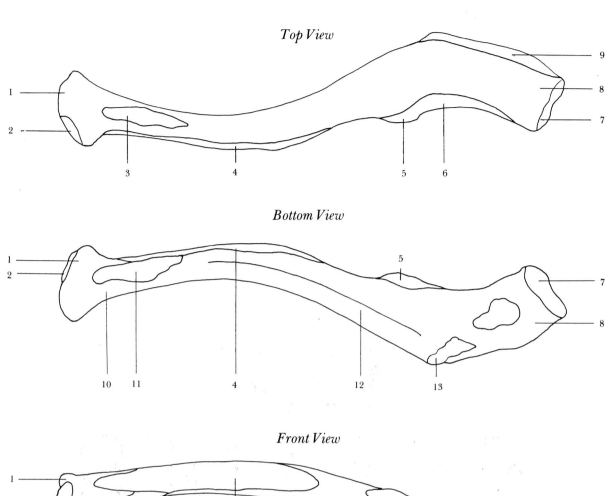

Bottom View

Front View

Back View

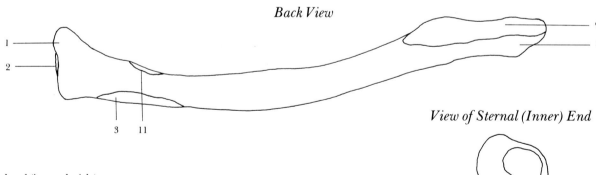

View of Sternal (Inner) End

1. Sternal end (inner clavicle)
2. Articular surface for manubrium of sternum
3. Origin of sternocleidomastoideus
4. Origin of pectoralis major
5. Deltoid tubercle
6. Origin of deltoid
7. Articular surface for acromion process of scapula
8. Acromial end (outer clavicle)
9. Insertion of trapezius
10. Origin of sternohyoid
11. Costal tuberosity
12. Subclavian groove
13. Conoid tubercle

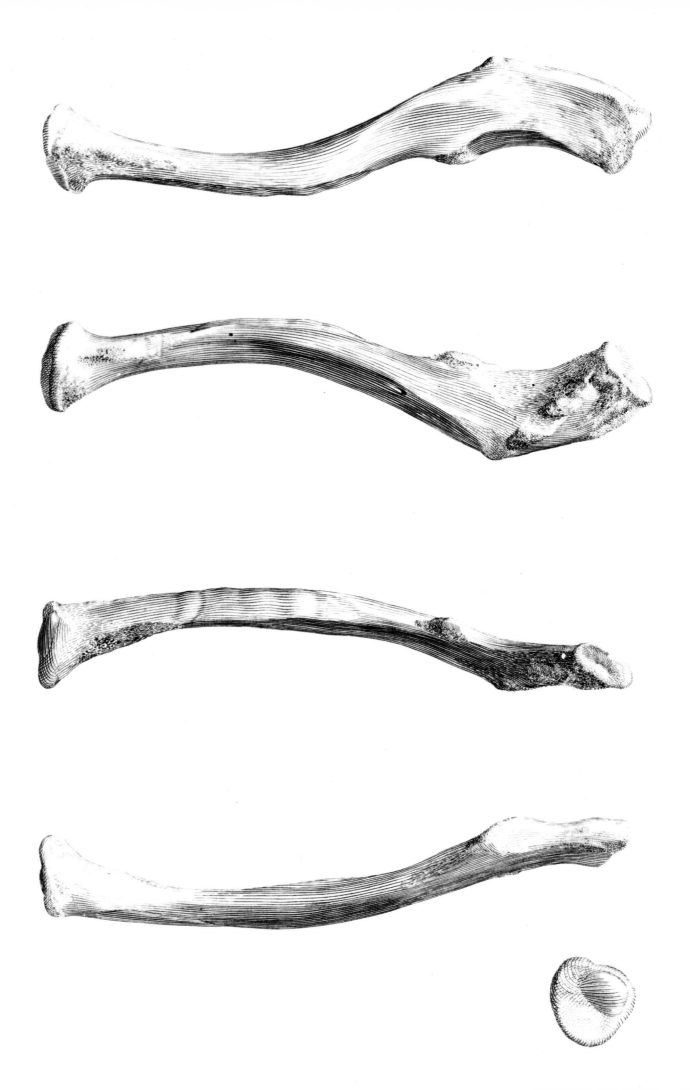

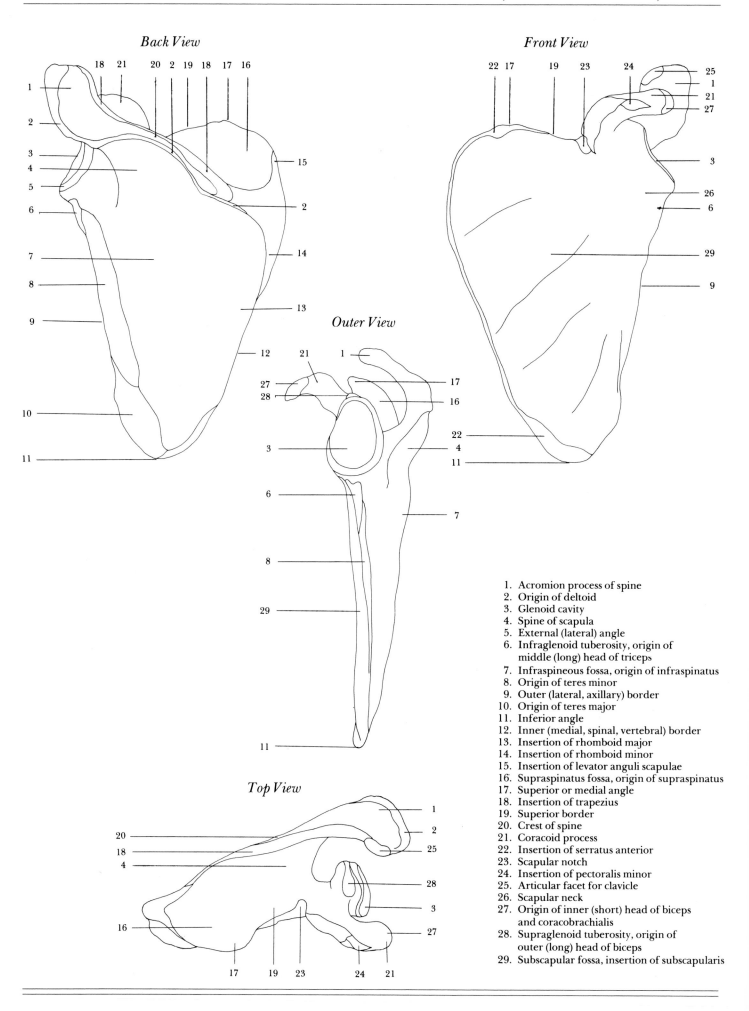

Back View

Front View

Outer View

Top View

1. Acromion process of spine
2. Origin of deltoid
3. Glenoid cavity
4. Spine of scapula
5. External (lateral) angle
6. Infraglenoid tuberosity, origin of middle (long) head of triceps
7. Infraspineous fossa, origin of infraspinatus
8. Origin of teres minor
9. Outer (lateral, axillary) border
10. Origin of teres major
11. Inferior angle
12. Inner (medial, spinal, vertebral) border
13. Insertion of rhomboid major
14. Insertion of rhomboid minor
15. Insertion of levator anguli scapulae
16. Supraspinatus fossa, origin of supraspinatus
17. Superior or medial angle
18. Insertion of trapezius
19. Superior border
20. Crest of spine
21. Coracoid process
22. Insertion of serratus anterior
23. Scapular notch
24. Insertion of pectoralis minor
25. Articular facet for clavicle
26. Scapular neck
27. Origin of inner (short) head of biceps and coracobrachialis
28. Supraglenoid tuberosity, origin of outer (long) head of biceps
29. Subscapular fossa, insertion of subscapularis

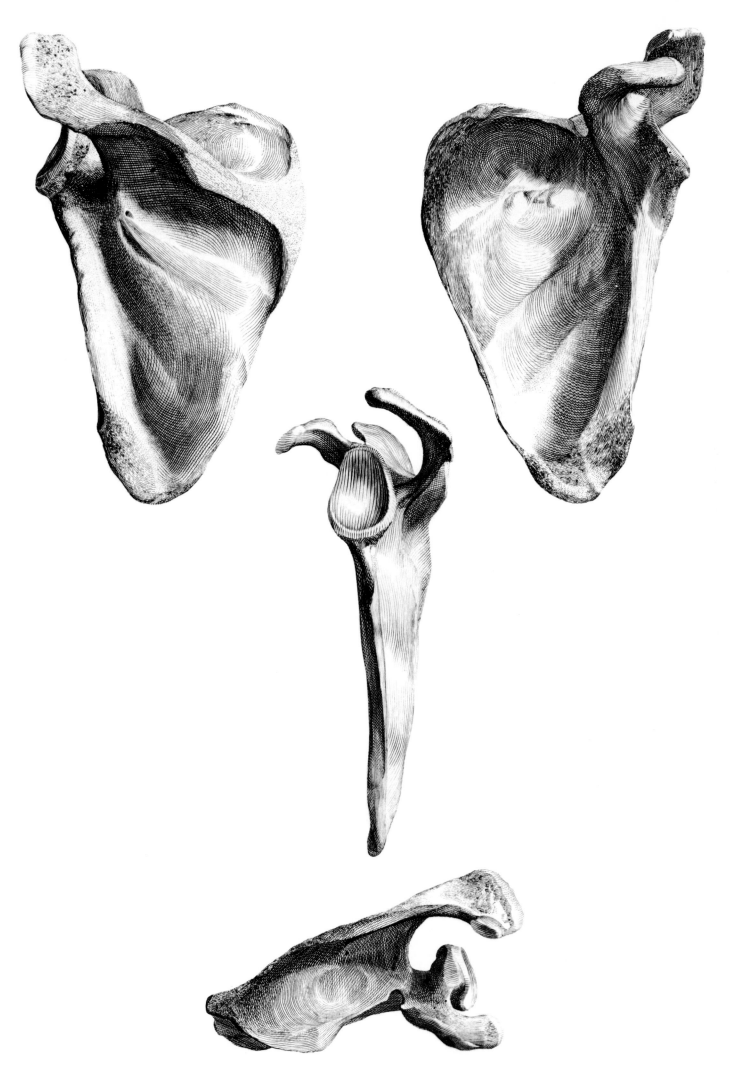

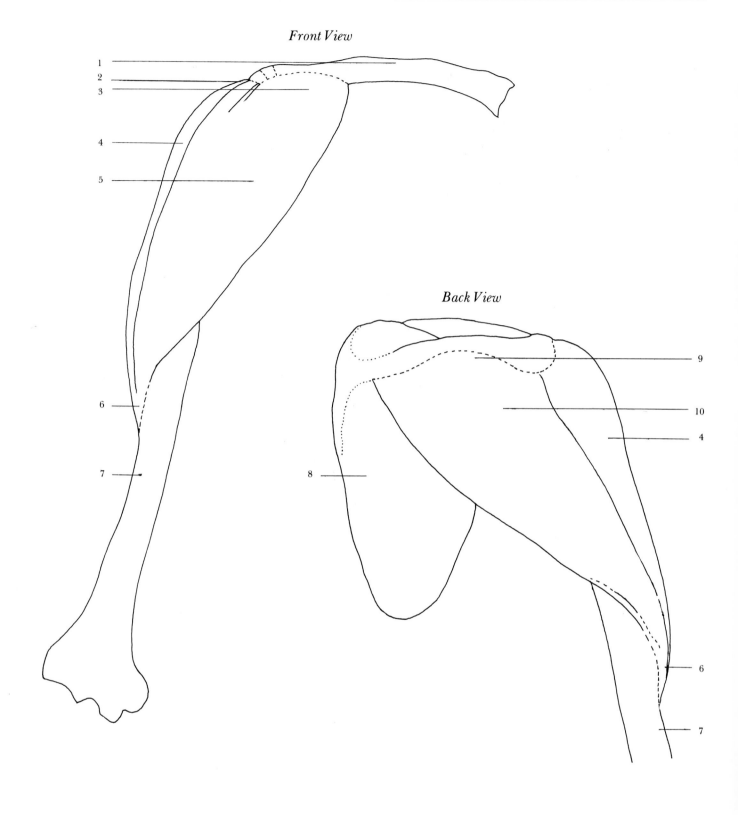

Front View

Back View

1. Clavicle
2. Origin of middle portion from acromion process of scapula
3. Origin of front portion from outer third of clavicle
4. Middle (acromial) portion
5. Front (clavicular) portion
6. Common insertion into deltoid tuberosity
7. Humerus
8. Infraspinous fossa of scapula
9. Origin of back portion from spine of scapula
10. Back (scapular) portion

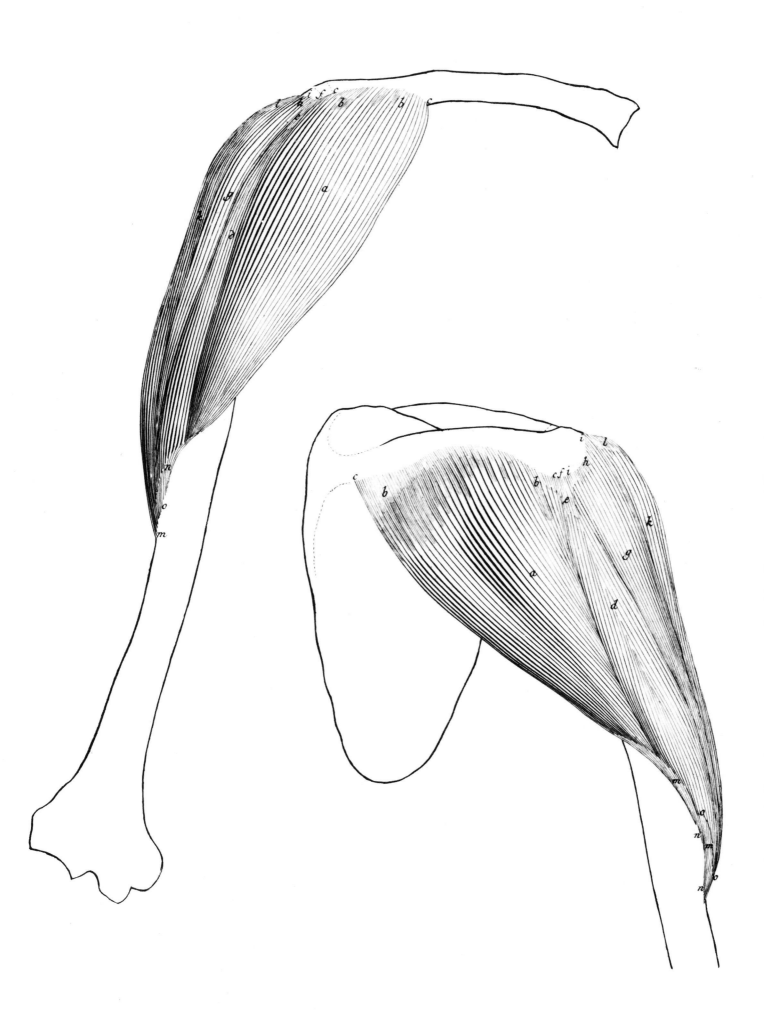

Pectoralis Major, Front View

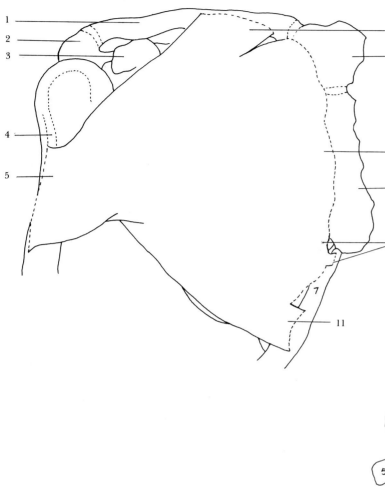

Serratus Anterior, Front View

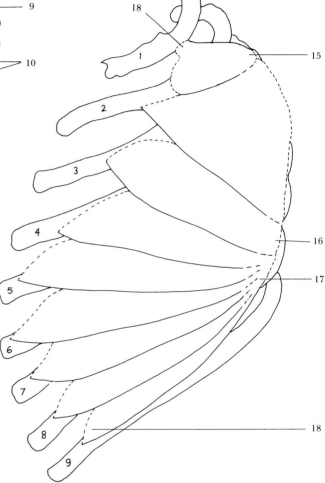

Pectoralis Minor, Front View

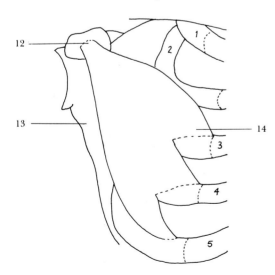

1. Clavicle
2. Acromion process of scapula
3. Coronoid process of scapula
4. Intertubercular (bicipital) groove of humerus
5. Insertion into outer border of intertubercular groove
6. Origin of clavicular portion from inner two thirds of clavicle
7. Manubrium of sternum
8. Origin of sternal portion from entire length of sternum
9. Gladiolus (body) of sternum
10. Origin from cartilages of upper ribs
11. Origin of abdominal portion from aponeurosis of external oblique
12. Insertion into coracoid process of scapula
13. Outer border of scapula
14. Origin from third, fourth, and fifth ribs
15. Insertion of upper portion into superior angle of scapula
16. Insertion of middle portion into inner border of scapula
17. Insertion of lower portion into inferior angle of scapula
18. Origin from first nine ribs

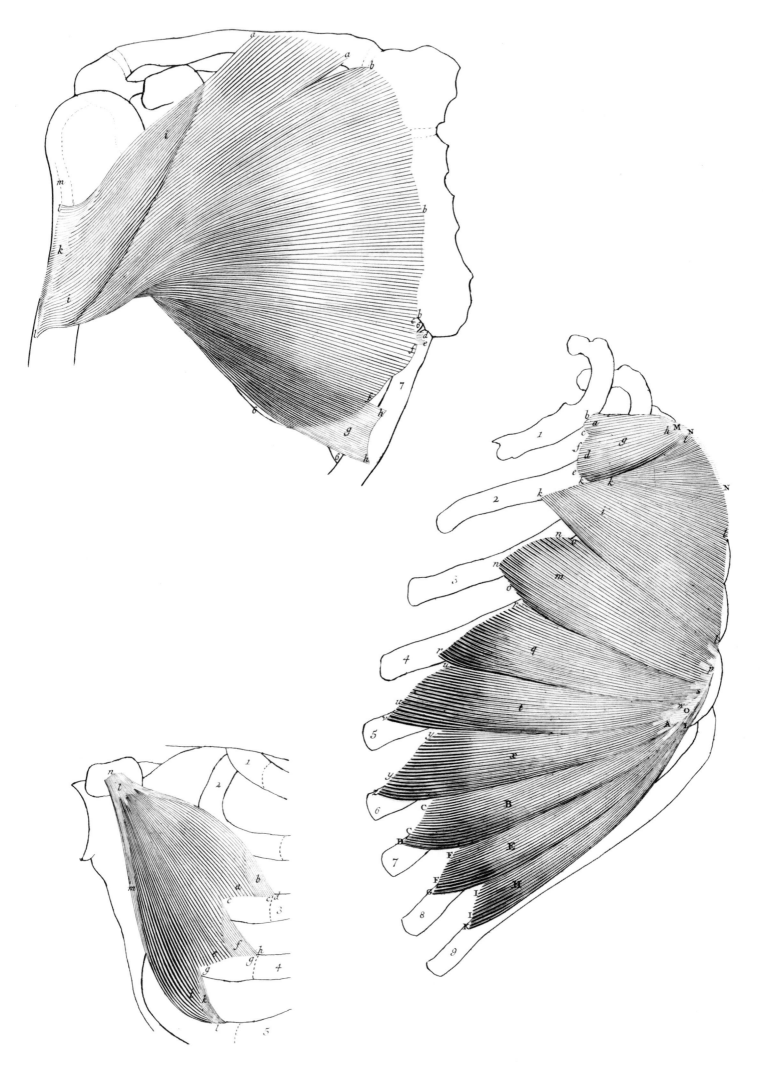

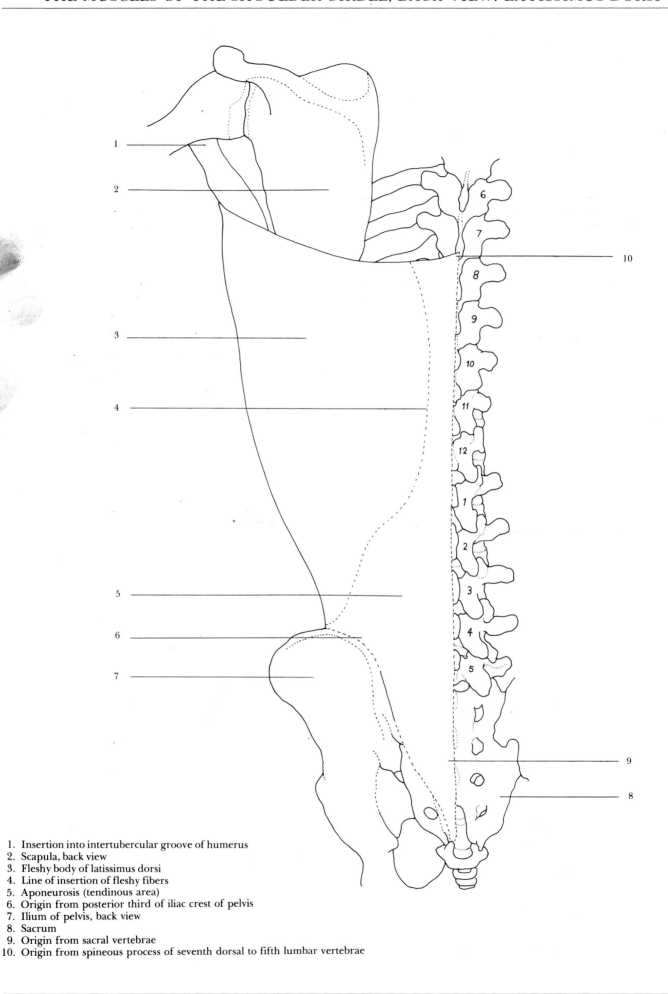

1. Insertion into intertubercular groove of humerus
2. Scapula, back view
3. Fleshy body of latissimus dorsi
4. Line of insertion of fleshy fibers
5. Aponeurosis (tendinous area)
6. Origin from posterior third of iliac crest of pelvis
7. Ilium of pelvis, back view
8. Sacrum
9. Origin from sacral vertebrae
10. Origin from spineous process of seventh dorsal to fifth lumbar vertebrae

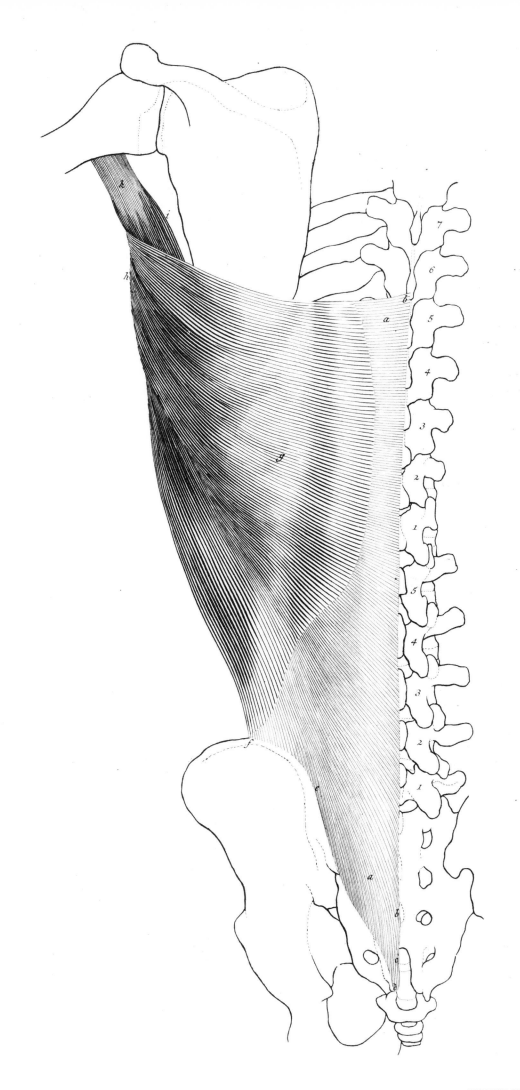

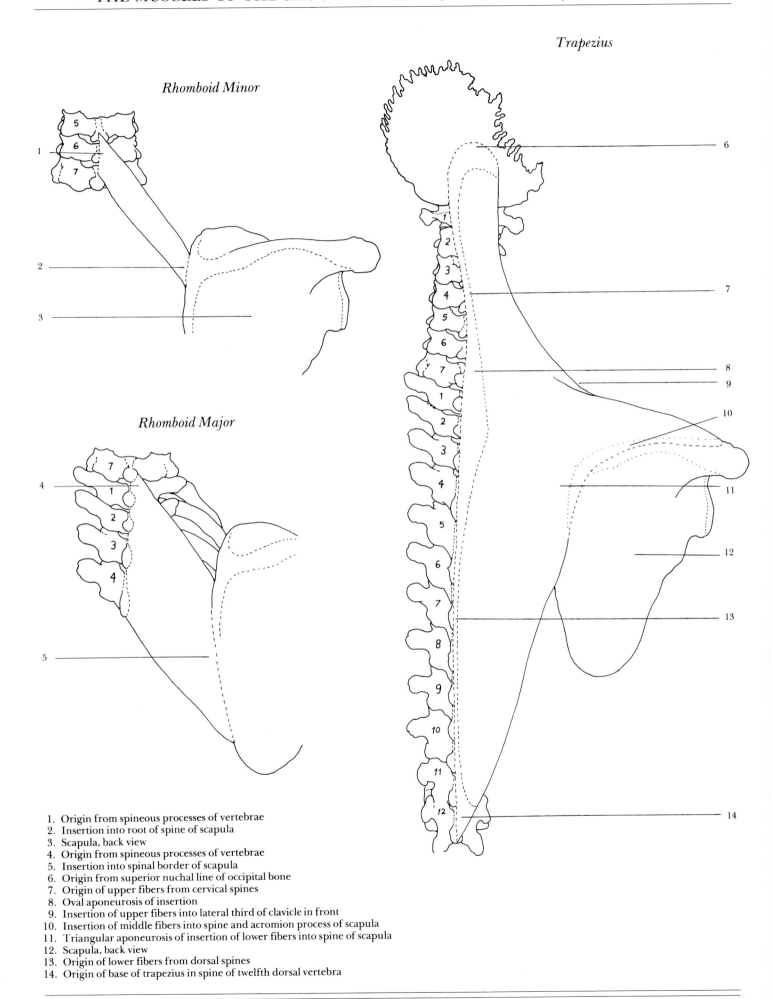

Rhomboid Minor

Rhomboid Major

Trapezius

1. Origin from spineous processes of vertebrae
2. Insertion into root of spine of scapula
3. Scapula, back view
4. Origin from spineous processes of vertebrae
5. Insertion into spinal border of scapula
6. Origin from superior nuchal line of occipital bone
7. Origin of upper fibers from cervical spines
8. Oval aponeurosis of insertion
9. Insertion of upper fibers into lateral third of clavicle in front
10. Insertion of middle fibers into spine and acromion process of scapula
11. Triangular aponeurosis of insertion of lower fibers into spine of scapula
12. Scapula, back view
13. Origin of lower fibers from dorsal spines
14. Origin of base of trapezius in spine of twelfth dorsal vertebra

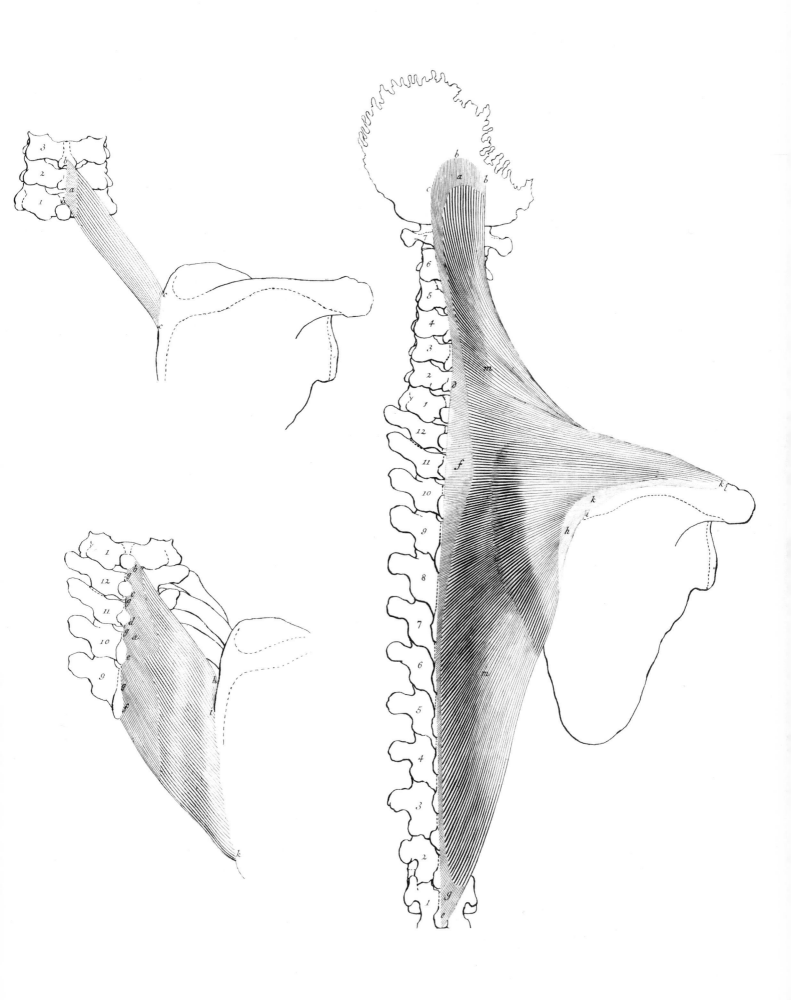

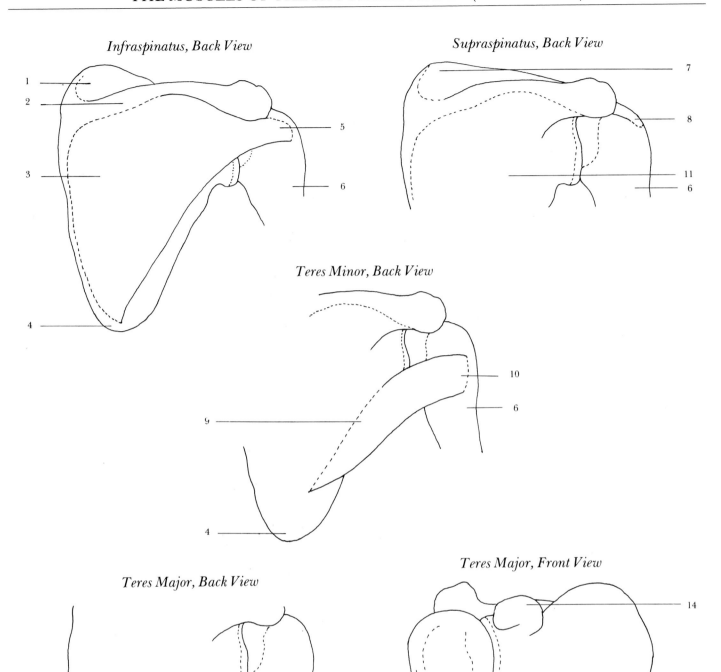

Infraspinatus, Back View

Supraspinatus, Back View

Teres Minor, Back View

Teres Major, Back View

Teres Major, Front View

1. Superior angle of scapula
2. Spine of scapula
3. Origin from infraspineous fossa of scapula
4. Inferior angle of scapula
5. Insertion into greater tubercle of humerus
6. Humerus
7. Origin from supraspinatous fossa of scapula
8. Insertion into greater tubercle of humerus

9. Origin from outer border of scapula
10. Insertion into greater tubercle of humerus
11. Infraspineous fossa of scapula
12. Origin from dorsal surface of inferior angle
13. Insertion into intertubercular groove of humerus
14. Coracoid process
15. Subscapular fossa
16. Intertubercular (bicipital) groove of humerus

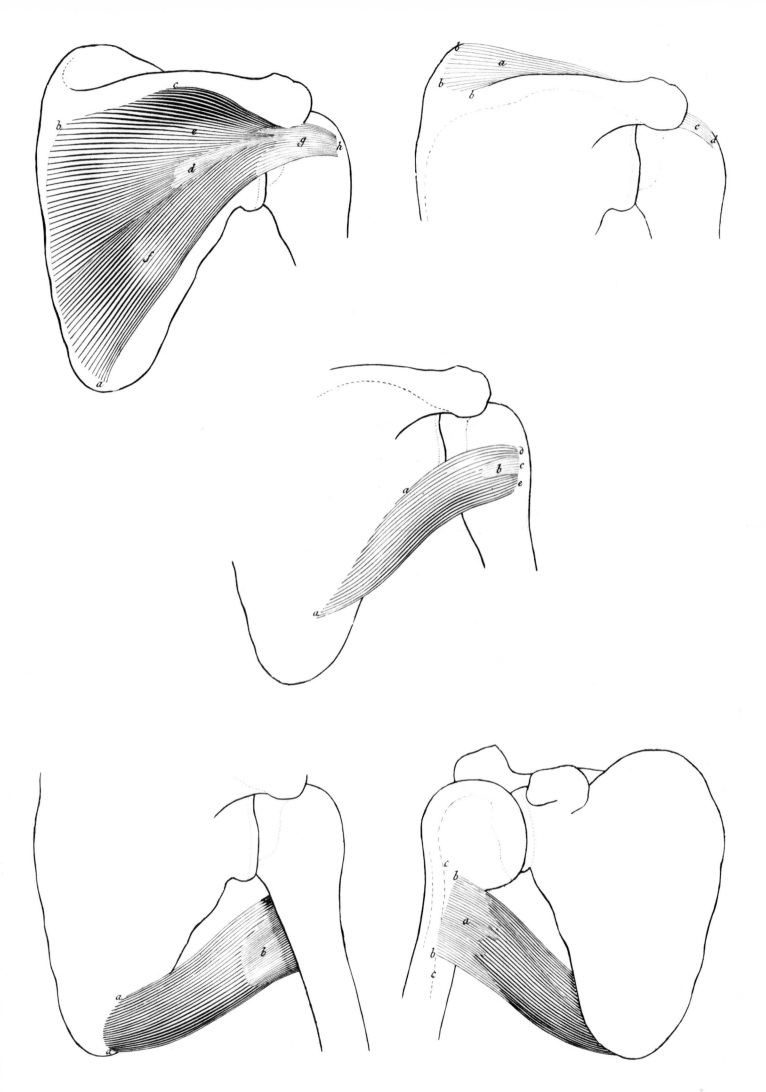

THE ARM

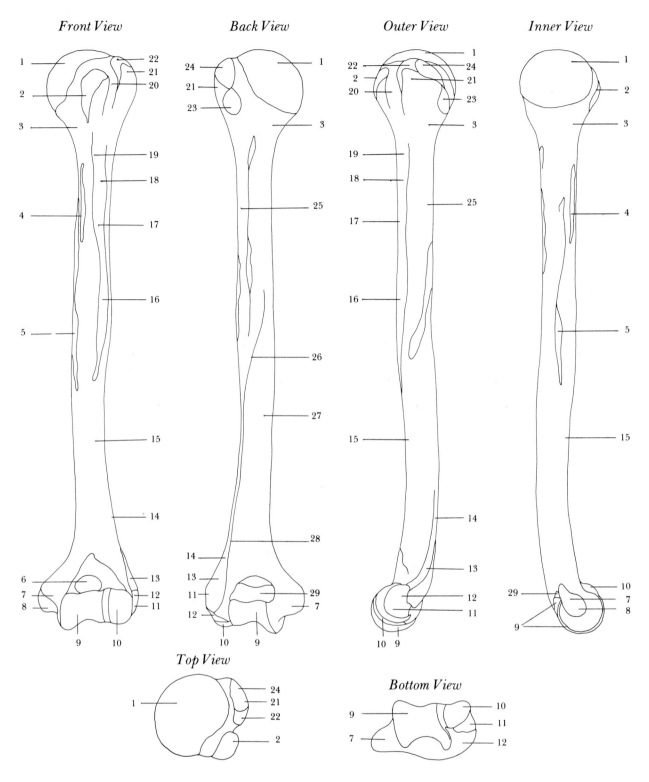

Front View *Back View* *Outer View* *Inner View*

Top View

Bottom View

1. Head (articular surface)
2. Lesser tuberosity
3. Surgical neck
4. Insertion of teres major
5. Insertion of coracobrachialis
6. Coronoid fossa (depression)
7. Inner epicondyle
8. Common origin of flexors
9. Trochlea, articulates with ulna
10. Capitulum, articulates with radius
11. Outer epicondyle
12. Common origin of extensors
13. Origin of extensor carpi radialis longus
14. Origin of supinator longus (Brachioradialis)
15. Internal supracondylar ridge, origin of brachialis

16. Deltoid tuberosity, insertion of deltoid
17. Intertubercular (bicipital) groove
18. Insertion of pectoralis major
19. Insertion of latissimus dorsi
20. Upper intertubercular groove, holds long tendon of biceps
21. Greater tuberosity
22. Insertion of supraspinatus
23. Insertion of teres minor
24. Insertion of infraspinatus
25. Origin of outer head of triceps
26. Radial groove
27. Origin of inner head of triceps
28. External supracondylar ridge
29. Olecranon fossa

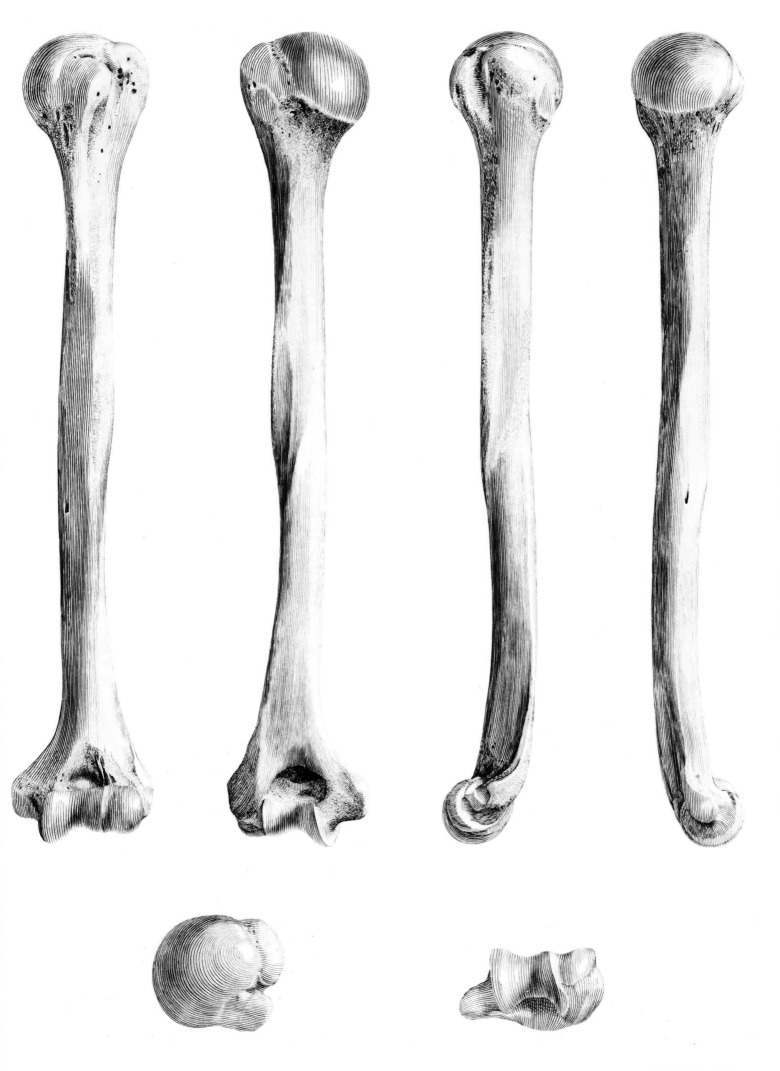

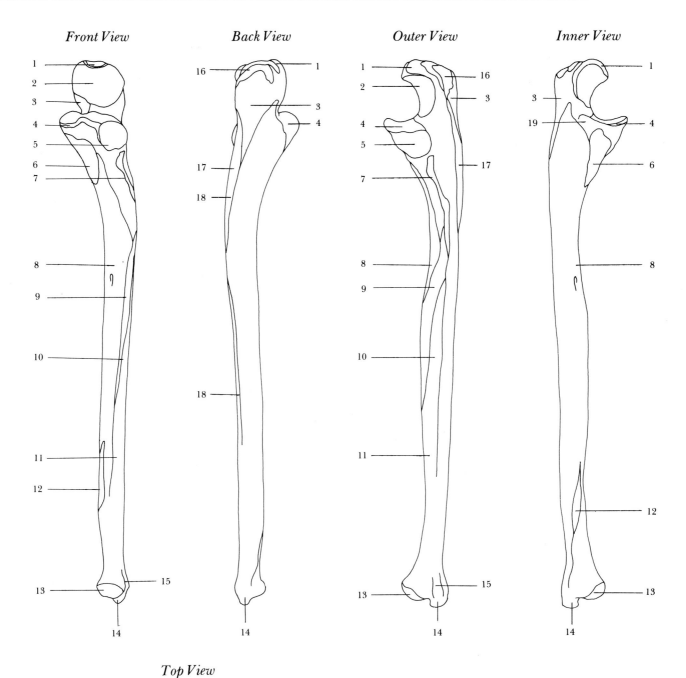

Front View

Back View

Outer View

Inner View

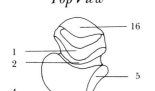

Top View

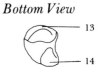

Bottom View

1. Tip of olecranon (Elbow)
2. Trochlear (semilunar) notch (Greater sigmoid cavity) for humerus
3. Body of olecranon (Elbow)
4. Coronoid process
5. Radical notch for head of radius
6. Ulnar tuberosity, insertion of brachialis
7. Supinator fossa, origin of supinator brevis
8. Origin of flexor digitorum profundus
9. Origin of abductor pollicis longus
10. Origin of extensor pollicis longus

11. Origin of extensor indicis
12. Origin of pronator quadratus
13. Head, articulates with radius
14. Styloid process
15. Groove for extensor carpi ulnaris tendon
16. Insertion of common tendon of triceps
17. Insertion of anconeus
18. Crest (posterior margin)
19. Tubercle for insertion of flexor digitorum superficialis

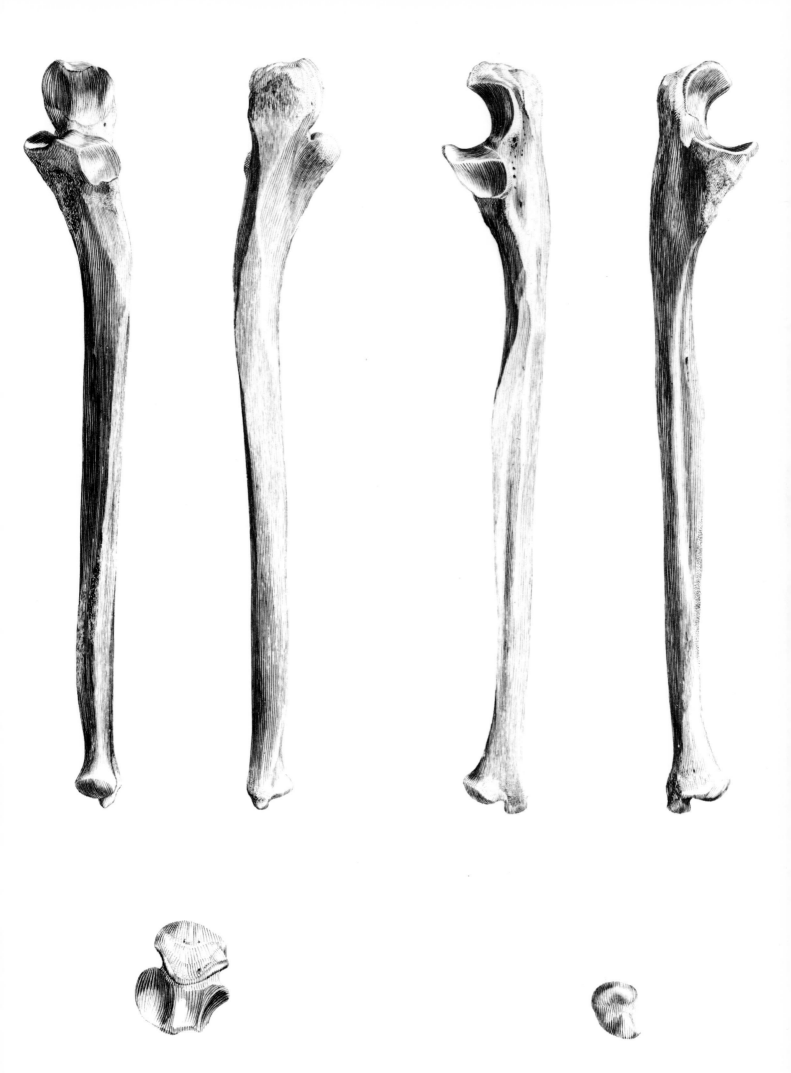

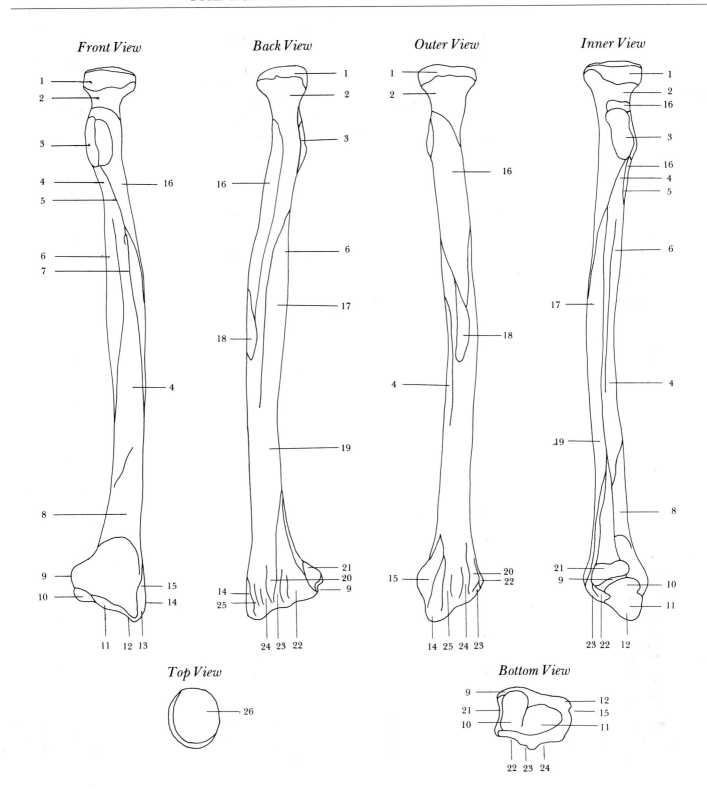

Front View

Back View

Outer View

Inner View

Top View

Bottom View

1. Head, articulates with radial notch of ulna
2. Neck
3. Radial (bicipital) tuberosity, insertion of biceps
4. Origin of flexor pollicis longus
5. Oblique line
6. Interosseous margin
7. Origin of flexor digitorum superficialis
8. Insertion of pronator quadratus
9. Inner (ulnar) side
10. Articular surface for lunate of carpus
11. Articular surface for scaphoid of carpus
12. Styloid process
13. Insertion of supinator longus
14. Outer (radial, thumb) side

15. Groove for abductor pollicis longus
 and extensor pollicis brevis tendons
16. Insertion of supinator brevis
17. Origin of abductor pollicis longus
18. Insertion of pronator teres
19. Origin of extensor pollicis brevis
20. Lister's tubercle
21. Ulnar notch (Sigmoid cavity) for head of ulna
22. Groove for extensor digitorum and extensor indicis tendons
23. Groove for extensor pollicis longus tendon
24. Groove for extensor carpi radialis brevis tendon
25. Groove for extensor carpi radialis longus tendon
26. Articular surface for capitulum of humerus

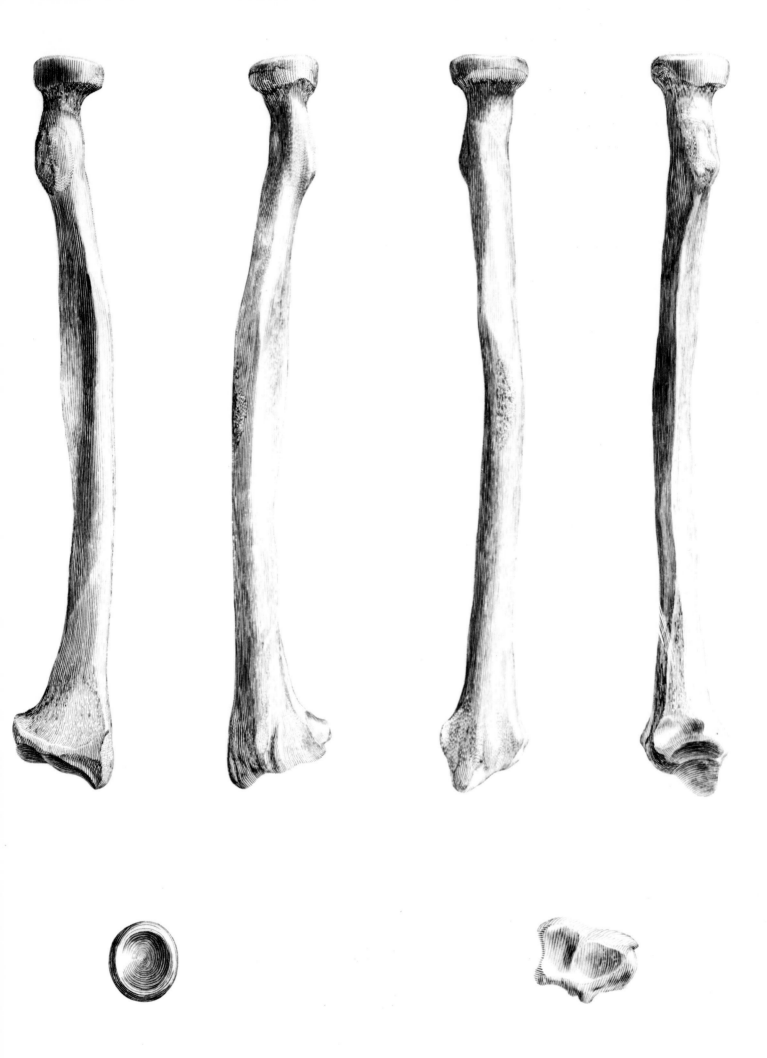

Coracobrachialis

Brachialis

Biceps Brachii

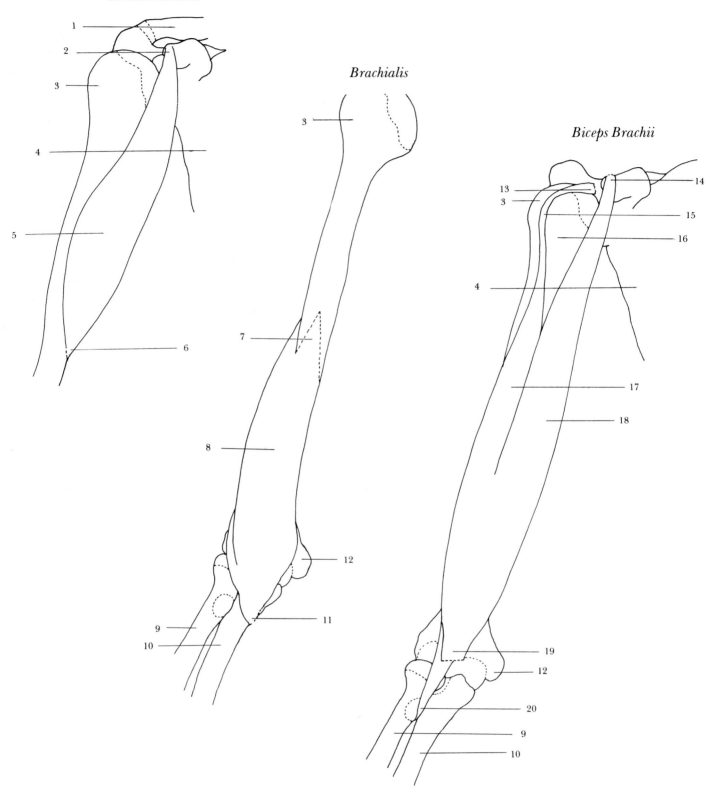

1. Clavicle
2. Origin from coracoid process of scapula
3. Greater tuberosity of humerus
4. Front of scapula
5. Fleshy body of muscle
6. Insertion into humerus
7. Origin from humerus
8. Fleshy body of muscle
9. Radius
10. Ulna

11. Insertion into ulna
12. Inner epicondyle
13. Origin of long head from supraglenoid tuberosity
14. Origin of short head from coracoid process of scapula
15. Tendon of long head of biceps in intertubercular groove of humerus
16. Lesser tuberosity
17. Fleshy body of outer (long) head
18. Fleshy body of inner (short) head
19. Bicipital aponeurosis to fascia of forearm
20. Insertion into radial tuberosity

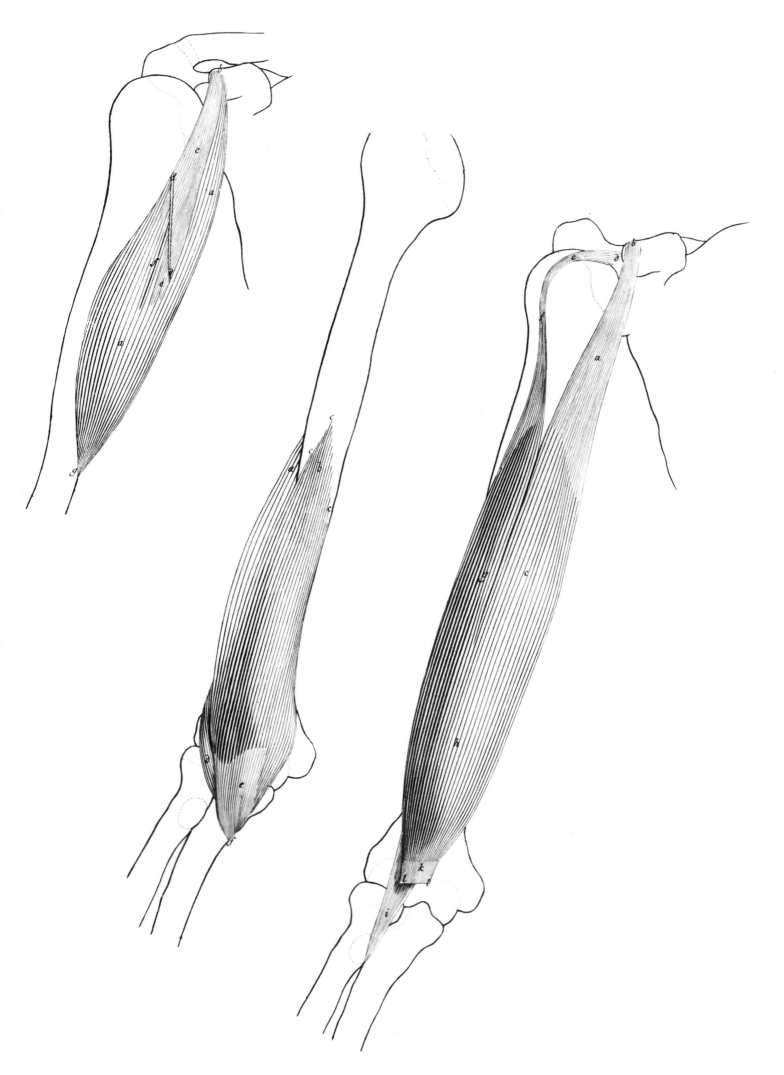

*Outer, Middle,
and Inner Heads*

Inner Head

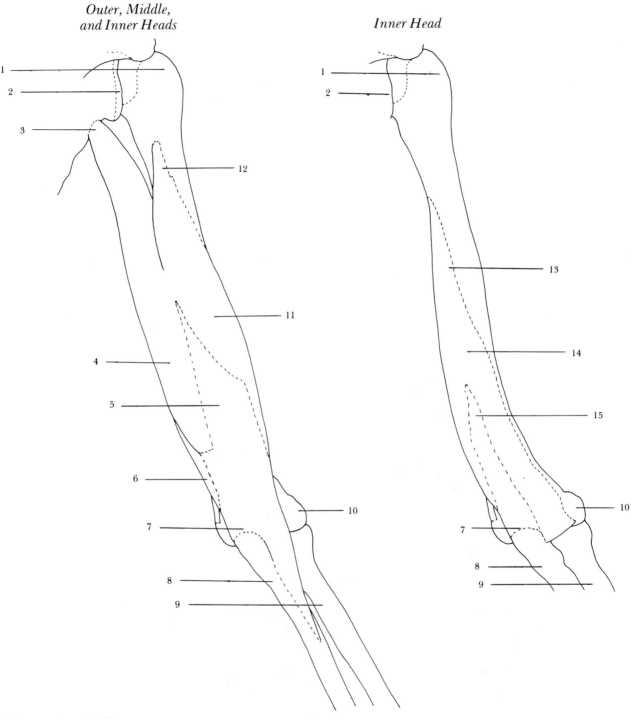

1. Greater tuberosity of humerus
2. Lip of glenoid cavity of scapula
3. Origin of middle (scapular or long) head
 from infraglenoid tuberosity
4. Fleshy body of middle (scapular or long) head
5. Common tendon of insertion
6. Lower body of inner (short humeral) head
7. Insertion of common head into olecranon of ulna
8. Ulna
9. Radius
10. Outer epicondyle
11. Fleshy body of outer (long humeral) head
12. Origin of outer head from humerus
13. Origin of inner (short humeral) head from humerus
14. Upper body of inner head
15. Middle and outer heads, cut off
16. Common tendon, cut off

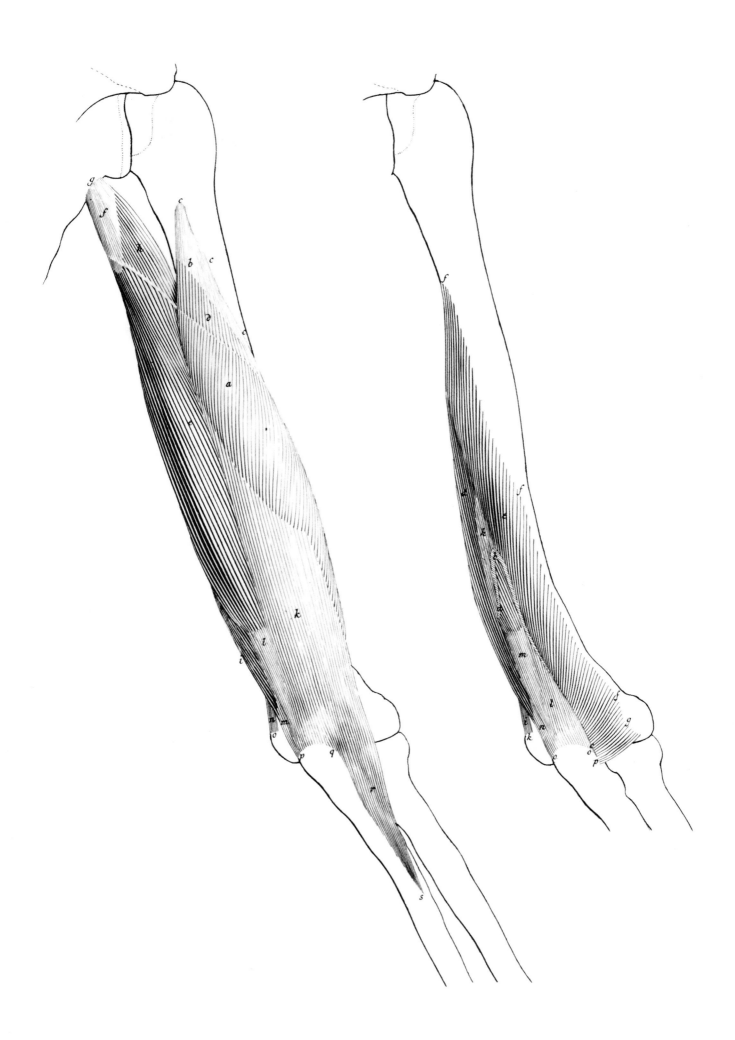

Supinator Brevis

Pronator Teres

Pronator Quadratus

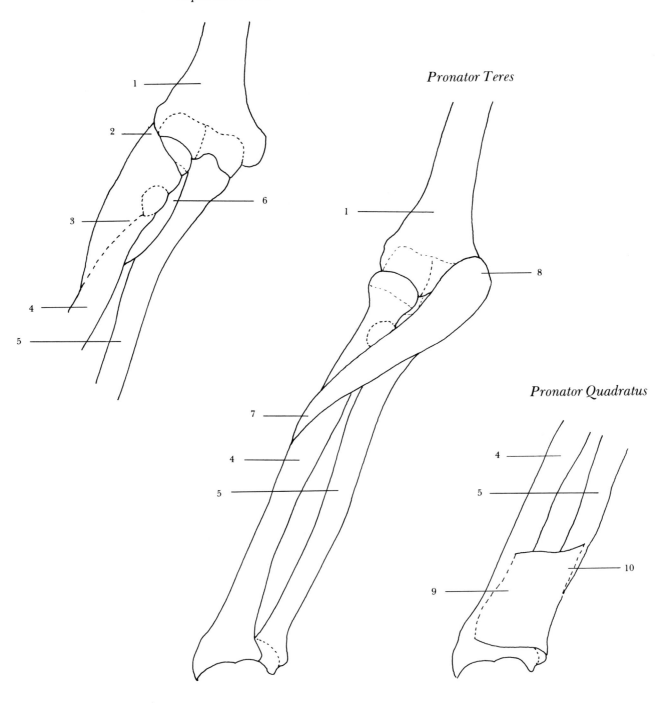

1. Humerus
2. Origin from outer epicondyle of humerus
3. Insertion into superior third of radius above oblique line
4. Radius
5. Ulna
6. Origin of deep portion from ulna
7. Insertion into radius
8. Origin from medial epicondyle of humerus and coronoid process of ulna
9. Insertion into radius
10. Origin from ulna

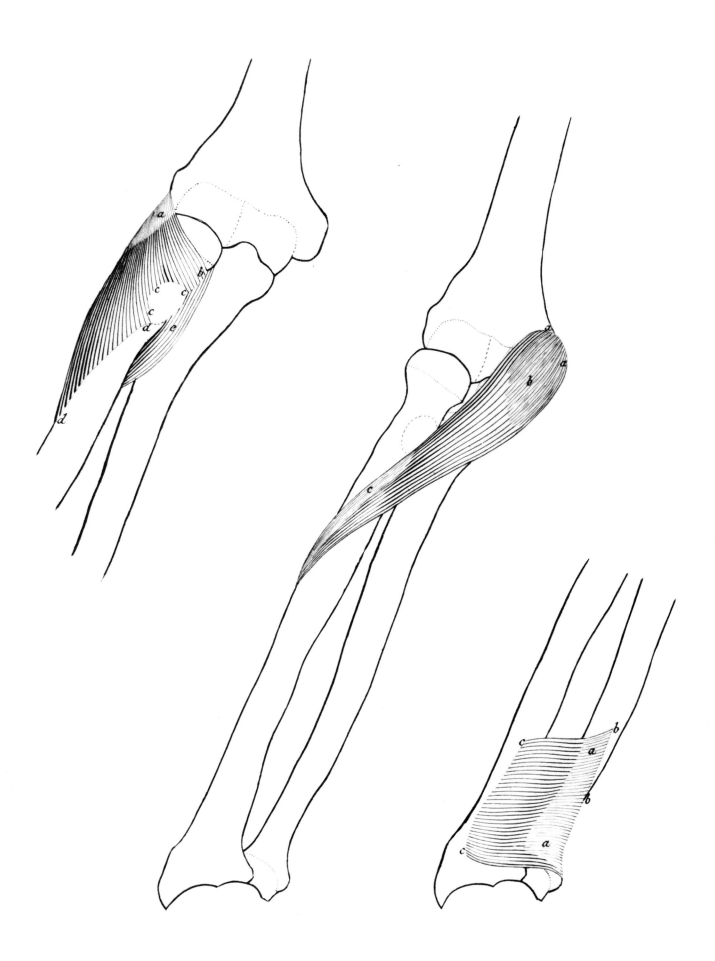

Brachioradialis
(Supinator Longus)

1. Origin from external supercondylar ridge of humerus
2. Fleshy body of muscle
3. Tendon
4. Insertion into styloid process of radius
5. Origin from outer humerus
6. Fleshy body of muscle
7. Tendon
8. Insertion into base of second metacarpal
9. Humerus
10. Origin from outer epicondyle
11. Radius
12. Ulna
13. Fleshy body of muscle
14. Tendon
15. Insertion into base of third metacarpal

Extensor Carpi Radialis Longus

Extensor Carpi
Radialis Brevis

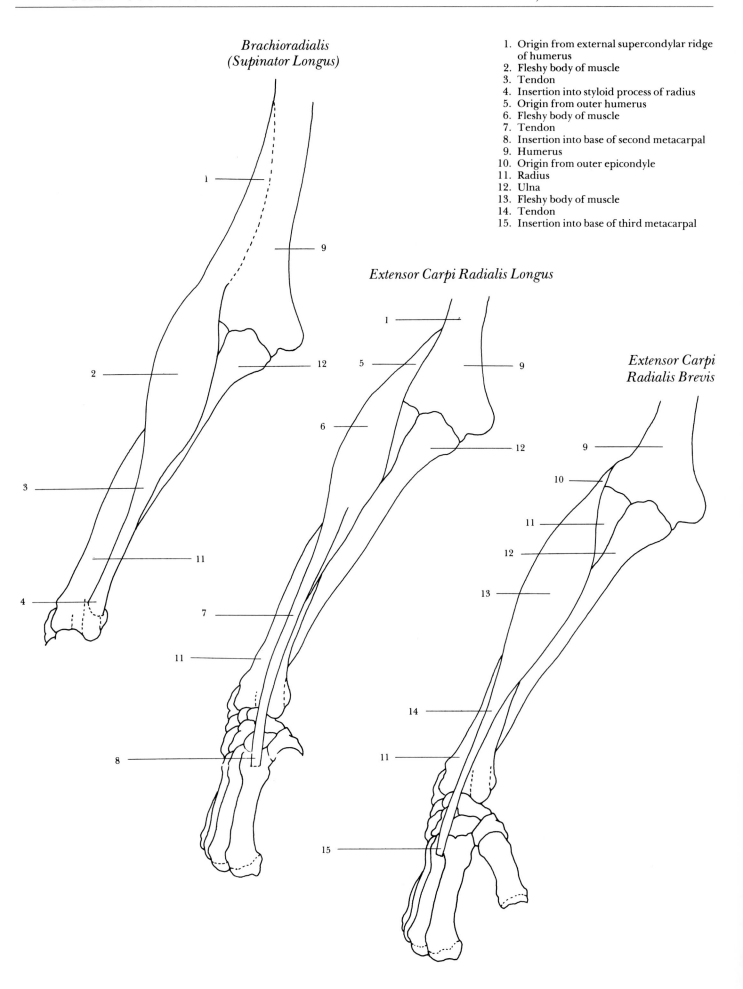

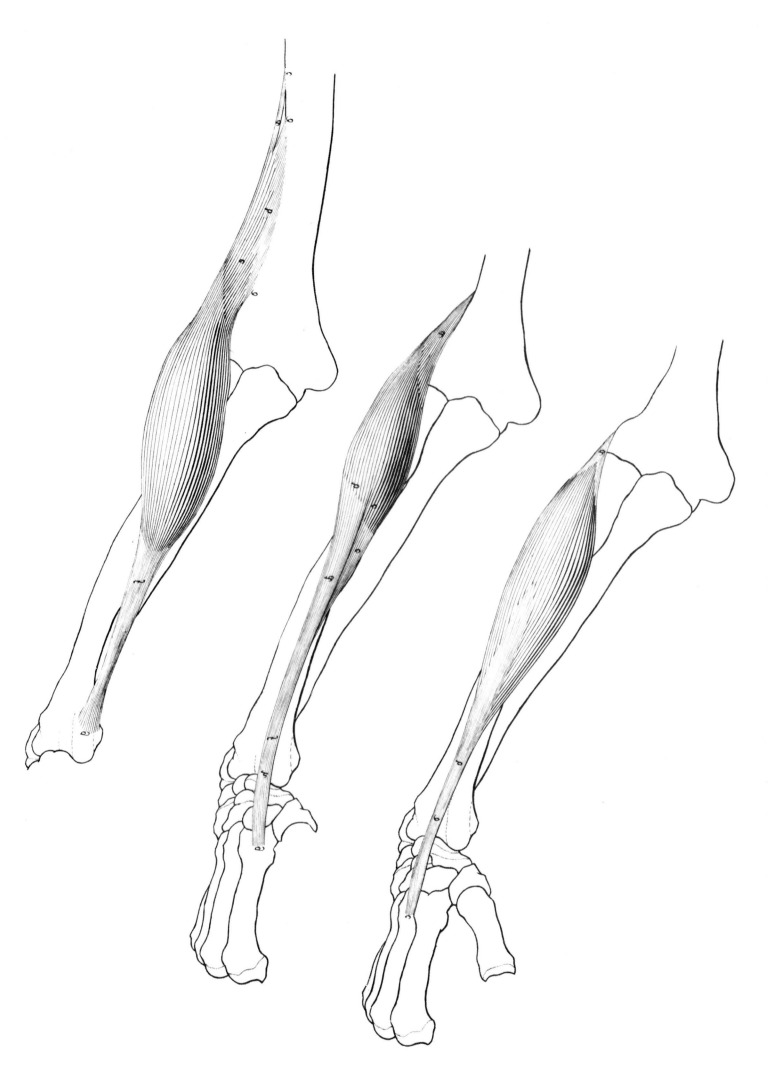

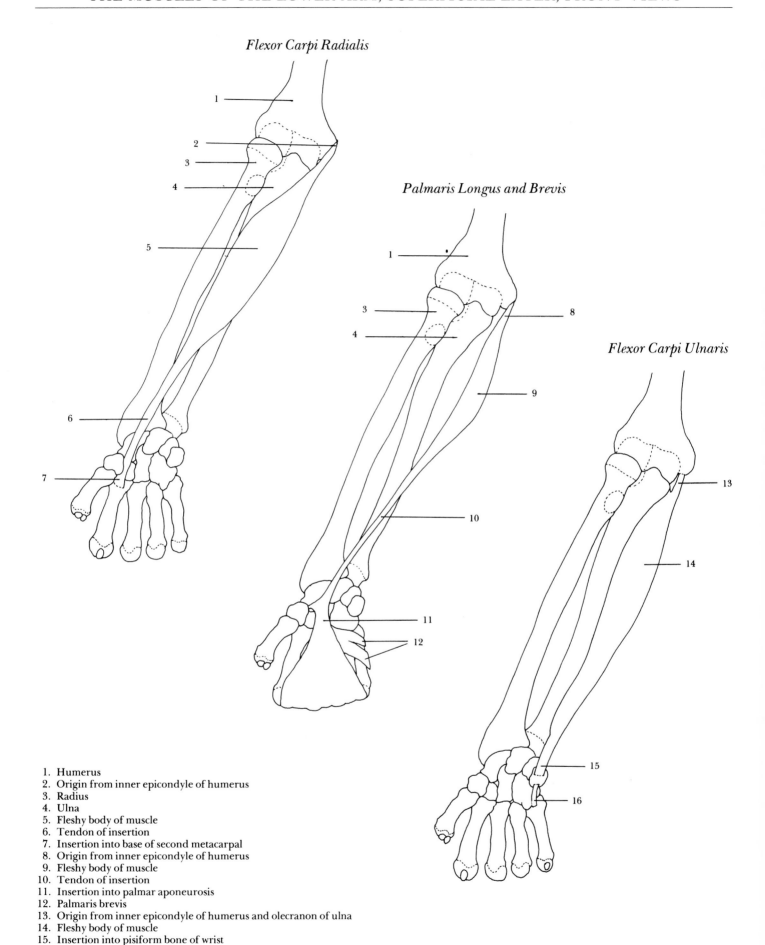

Flexor Carpi Radialis

Palmaris Longus and Brevis

Flexor Carpi Ulnaris

1. Humerus
2. Origin from inner epicondyle of humerus
3. Radius
4. Ulna
5. Fleshy body of muscle
6. Tendon of insertion
7. Insertion into base of second metacarpal
8. Origin from inner epicondyle of humerus
9. Fleshy body of muscle
10. Tendon of insertion
11. Insertion into palmar aponeurosis
12. Palmaris brevis
13. Origin from inner epicondyle of humerus and olecranon of ulna
14. Fleshy body of muscle
15. Insertion into pisiform bone of wrist
16. Ligaments of insertion into hamate and fifth metacarpal

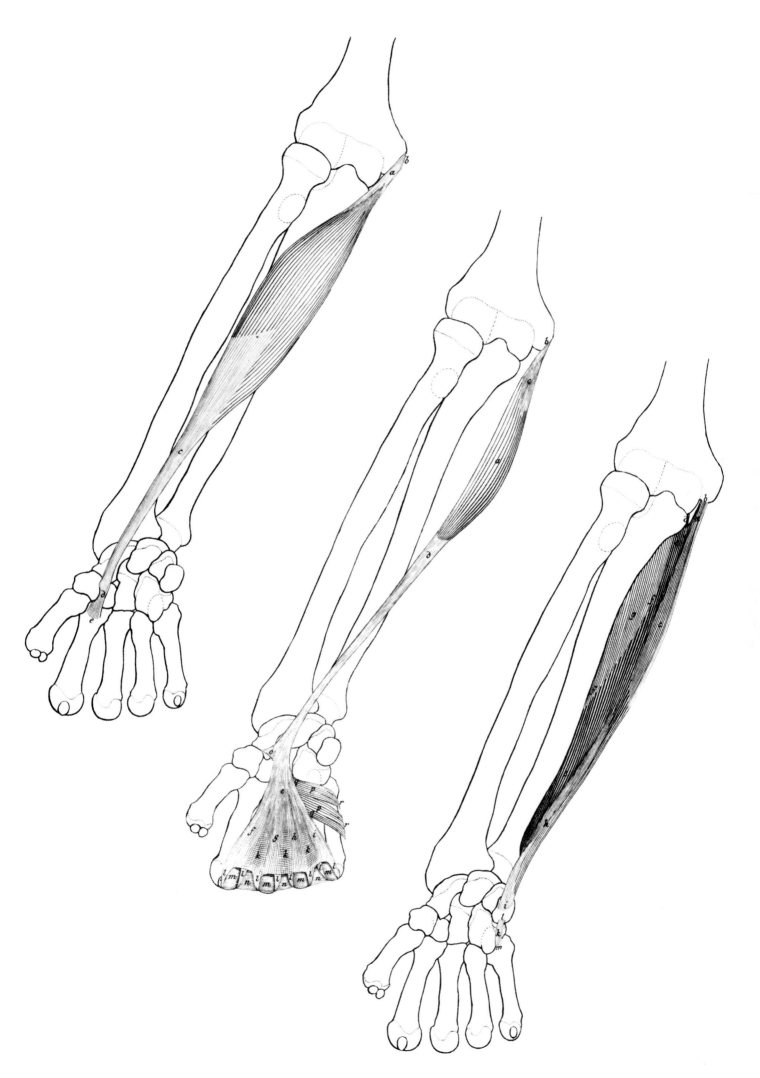

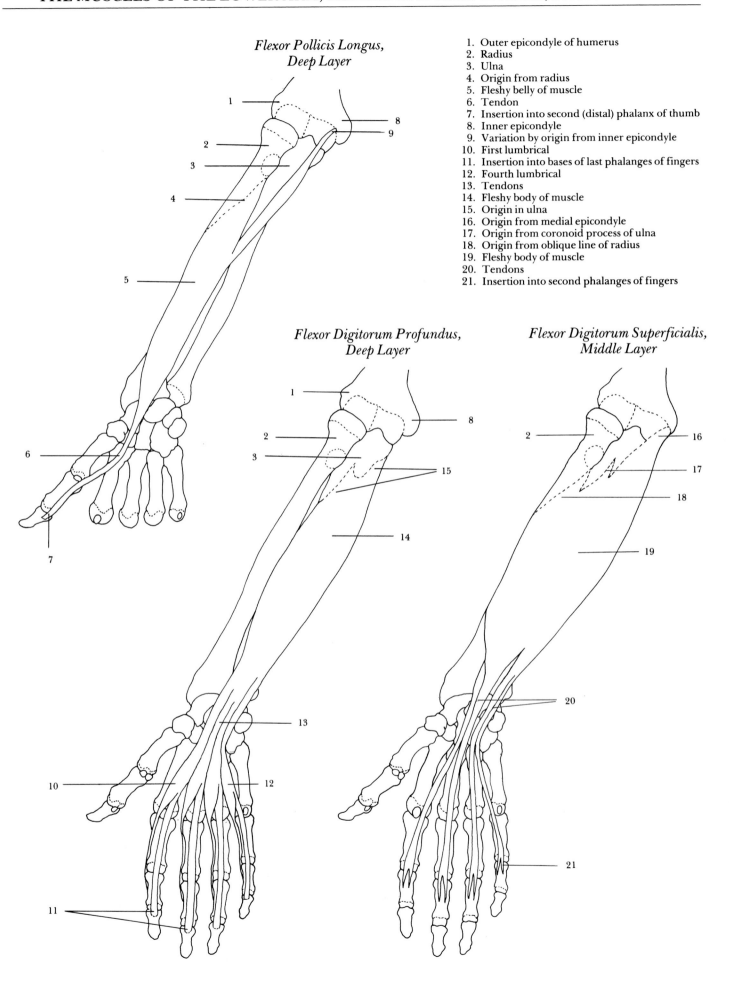

Flexor Pollicis Longus,
Deep Layer

Flexor Digitorum Profundus,
Deep Layer

Flexor Digitorum Superficialis,
Middle Layer

1. Outer epicondyle of humerus
2. Radius
3. Ulna
4. Origin from radius
5. Fleshy belly of muscle
6. Tendon
7. Insertion into second (distal) phalanx of thumb
8. Inner epicondyle
9. Variation by origin from inner epicondyle
10. First lumbrical
11. Insertion into bases of last phalanges of fingers
12. Fourth lumbrical
13. Tendons
14. Fleshy body of muscle
15. Origin in ulna
16. Origin from medial epicondyle
17. Origin from coronoid process of ulna
18. Origin from oblique line of radius
19. Fleshy body of muscle
20. Tendons
21. Insertion into second phalanges of fingers

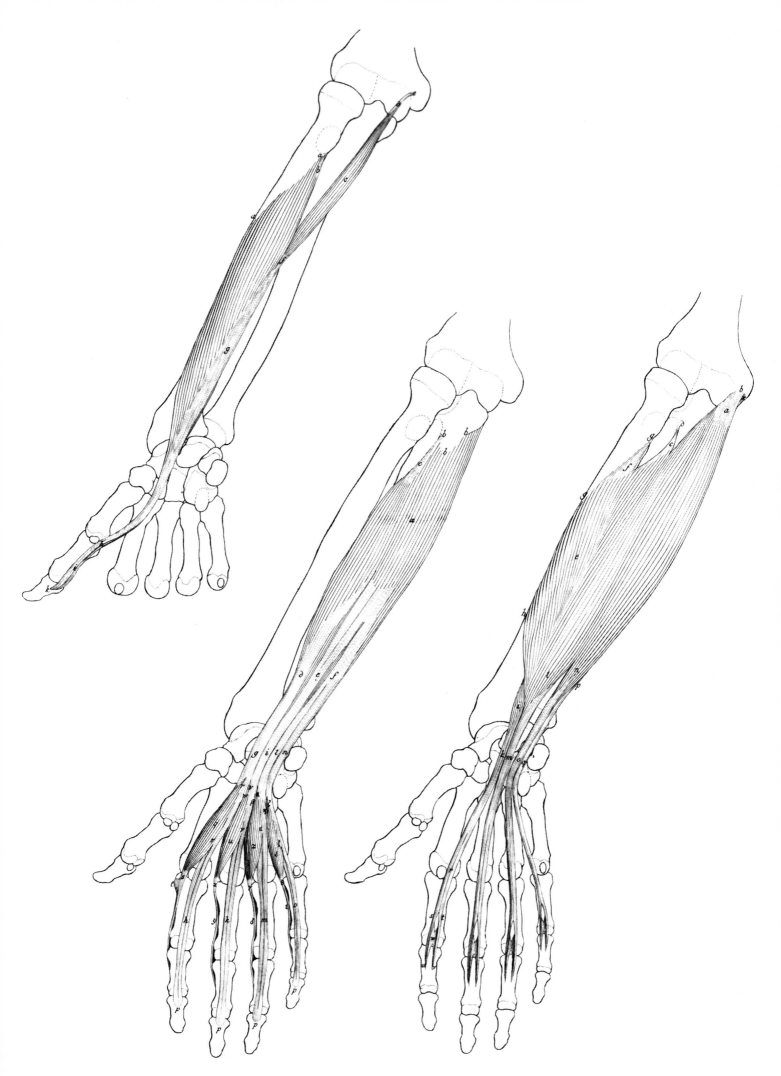

1. Humerus
2. Inner epicondyle of humerus
3. Tendon
4. Ulna
5. Aponeurotic origin in ulna
6. Fleshy body of muscle
7. Radius
8. Insertion into head of fifth metacarpal
9. Origin from outer epicondyle of humerus
10. Origin from inner epicondyle of humerus
11. Origin from olecranon and crest of ulna
12. Fleshy body of muscle
13. Lister's tubercle
14. Insertion into pisiform and fifth metacarpal
15. Origin from outer epicondyle of humerus
16. Fleshy body of muscle
17. Tendon
18. Insertion into base of third metacarpal
19. Origin from outer humerus
20. Fleshy body of muscle
21. Tendon
22. Insertion into base of second metacarpal
23. Origin from lateral epicondyle of humerus
24. Insertion into outer olecranon and back of ulna

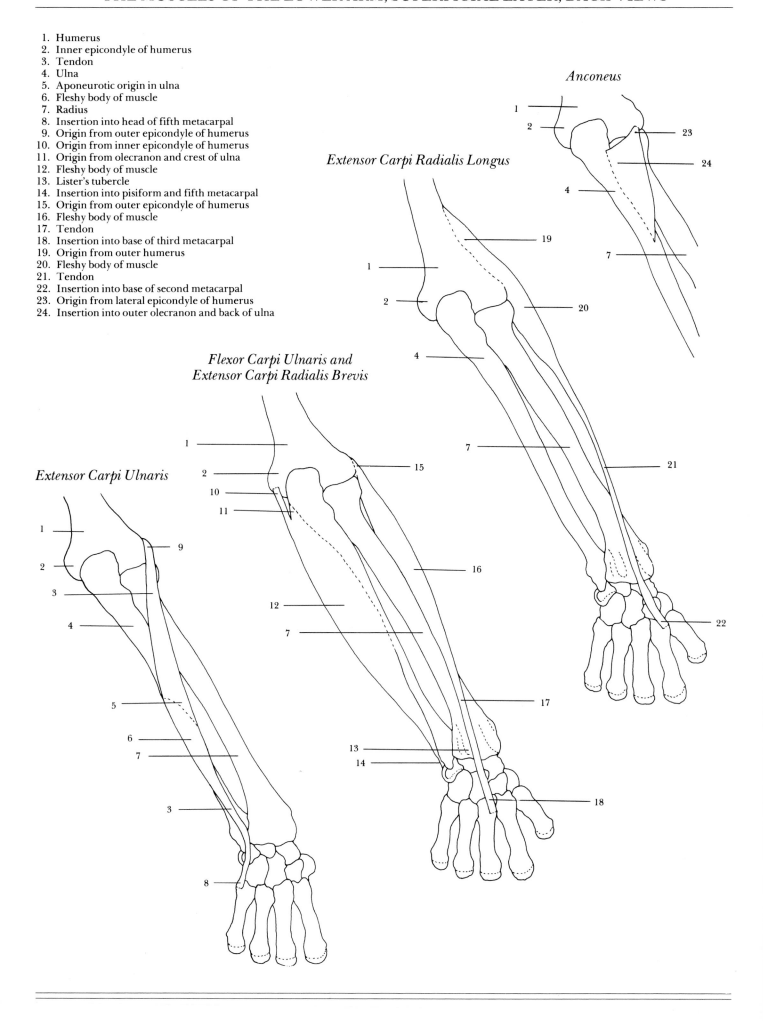

Anconeus

Extensor Carpi Radialis Longus

*Flexor Carpi Ulnaris and
Extensor Carpi Radialis Brevis*

Extensor Carpi Ulnaris

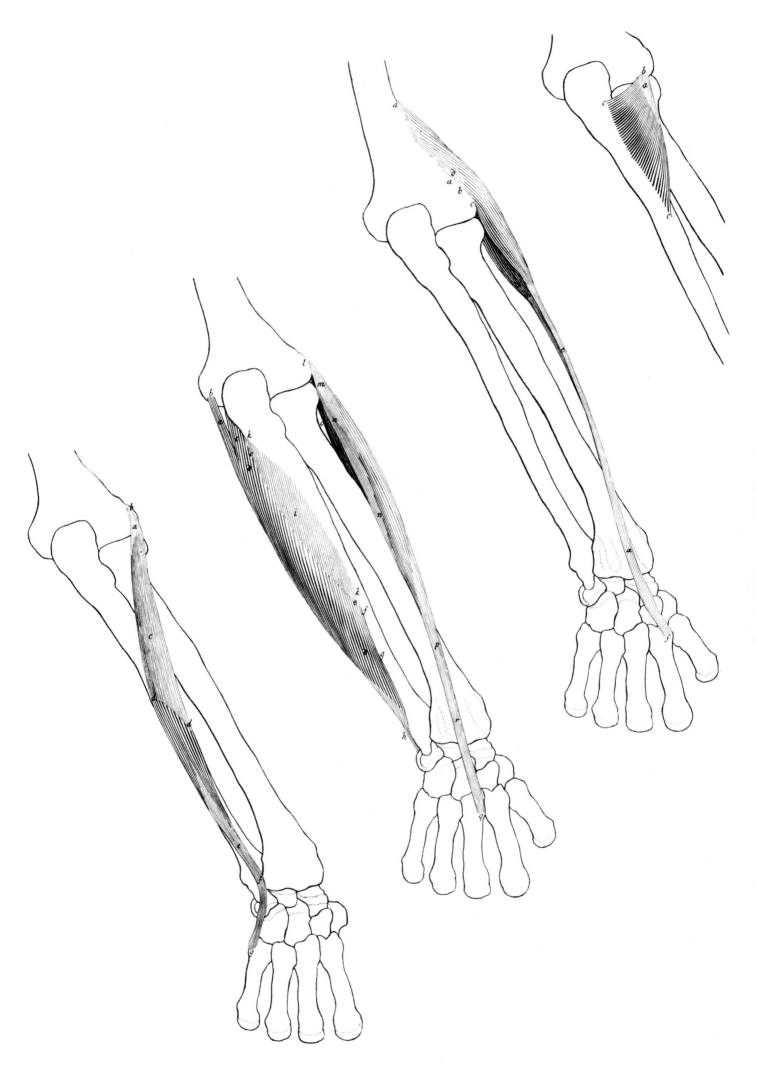

Extensor Indicis

Extensor Digitorum and
Extensor Digiti Minimi

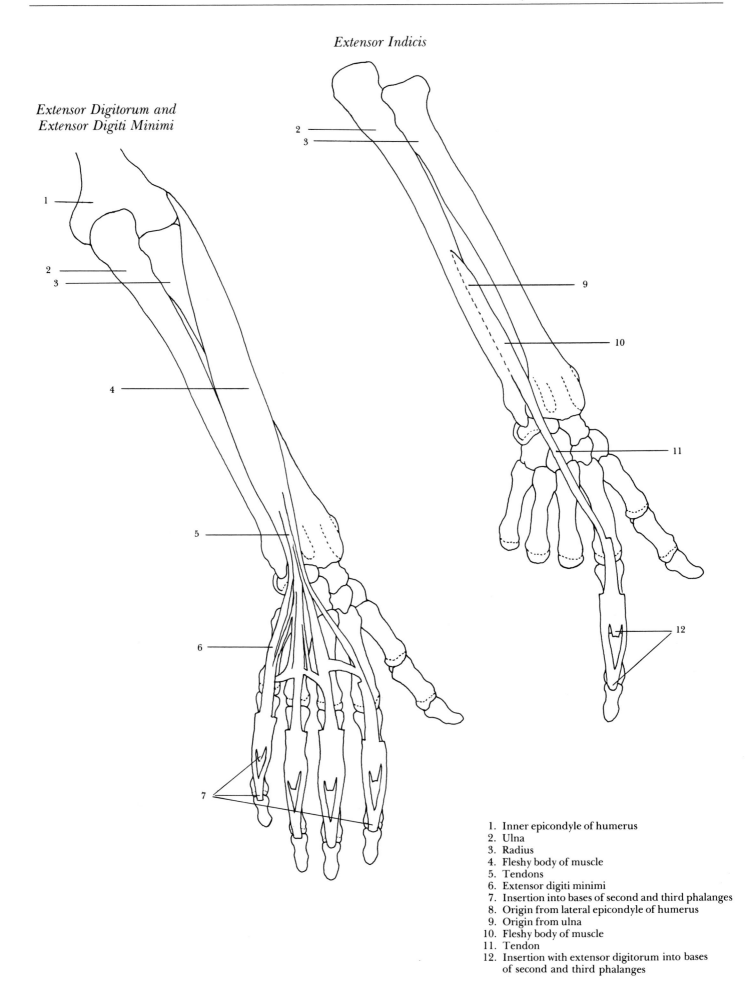

1. Inner epicondyle of humerus
2. Ulna
3. Radius
4. Fleshy body of muscle
5. Tendons
6. Extensor digiti minimi
7. Insertion into bases of second and third phalanges
8. Origin from lateral epicondyle of humerus
9. Origin from ulna
10. Fleshy body of muscle
11. Tendon
12. Insertion with extensor digitorum into bases
 of second and third phalanges

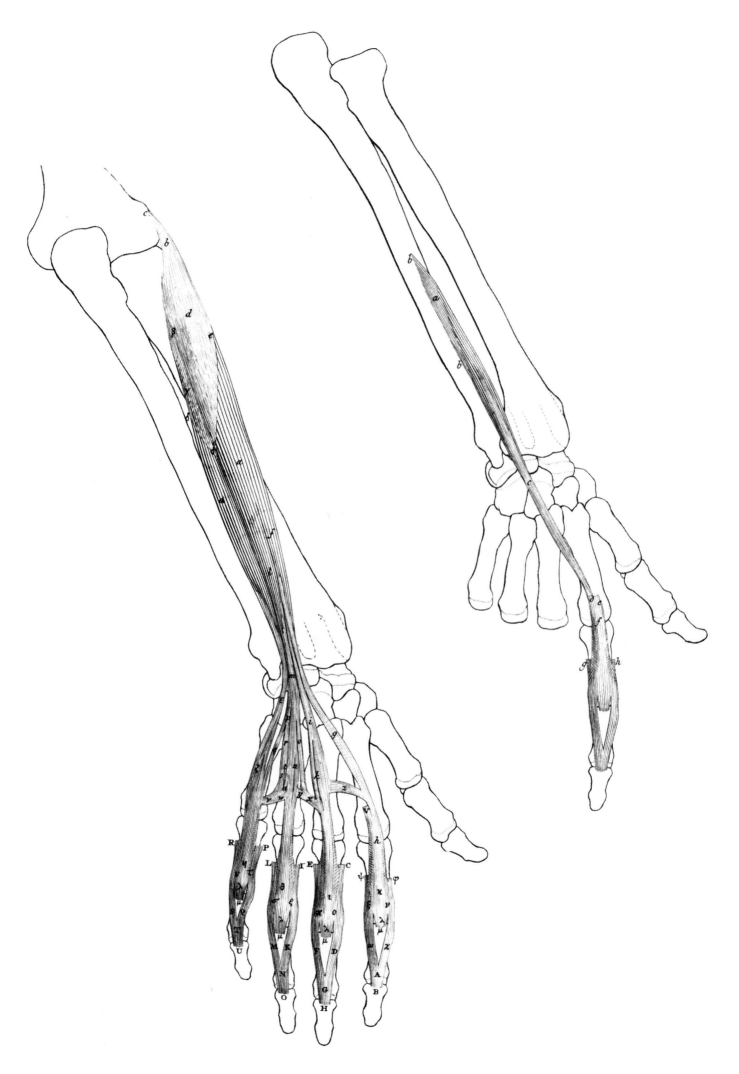

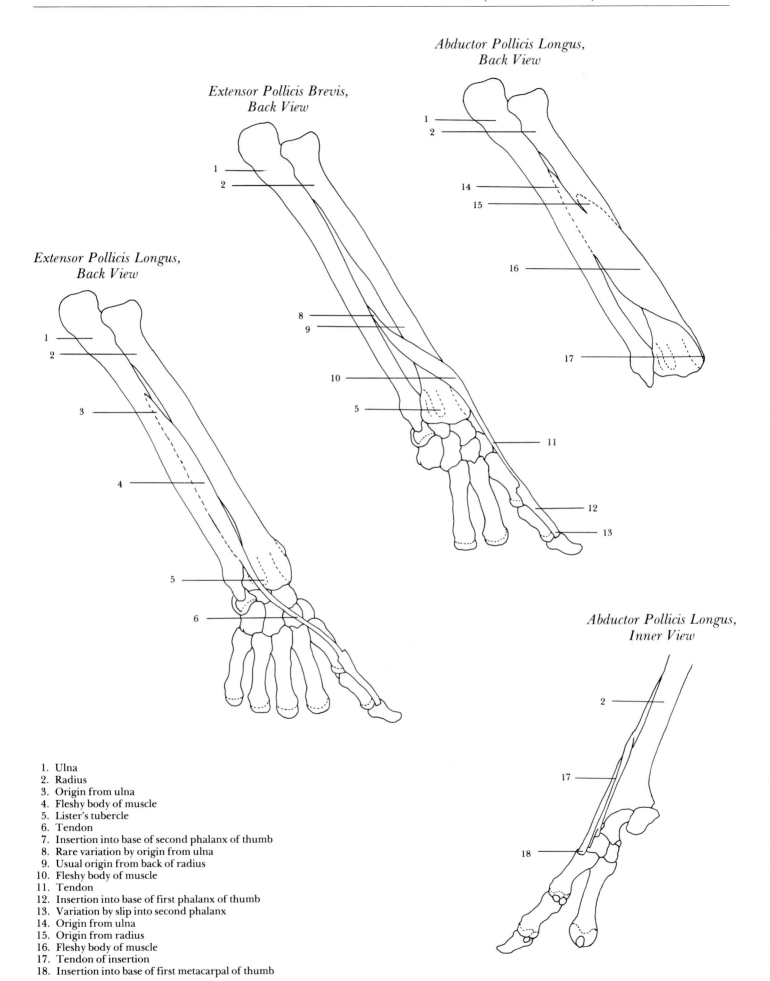

Abductor Pollicis Longus,
Back View

Extensor Pollicis Brevis,
Back View

Extensor Pollicis Longus,
Back View

Abductor Pollicis Longus,
Inner View

1. Ulna
2. Radius
3. Origin from ulna
4. Fleshy body of muscle
5. Lister's tubercle
6. Tendon
7. Insertion into base of second phalanx of thumb
8. Rare variation by origin from ulna
9. Usual origin from back of radius
10. Fleshy body of muscle
11. Tendon
12. Insertion into base of first phalanx of thumb
13. Variation by slip into second phalanx
14. Origin from ulna
15. Origin from radius
16. Fleshy body of muscle
17. Tendon of insertion
18. Insertion into base of first metacarpal of thumb

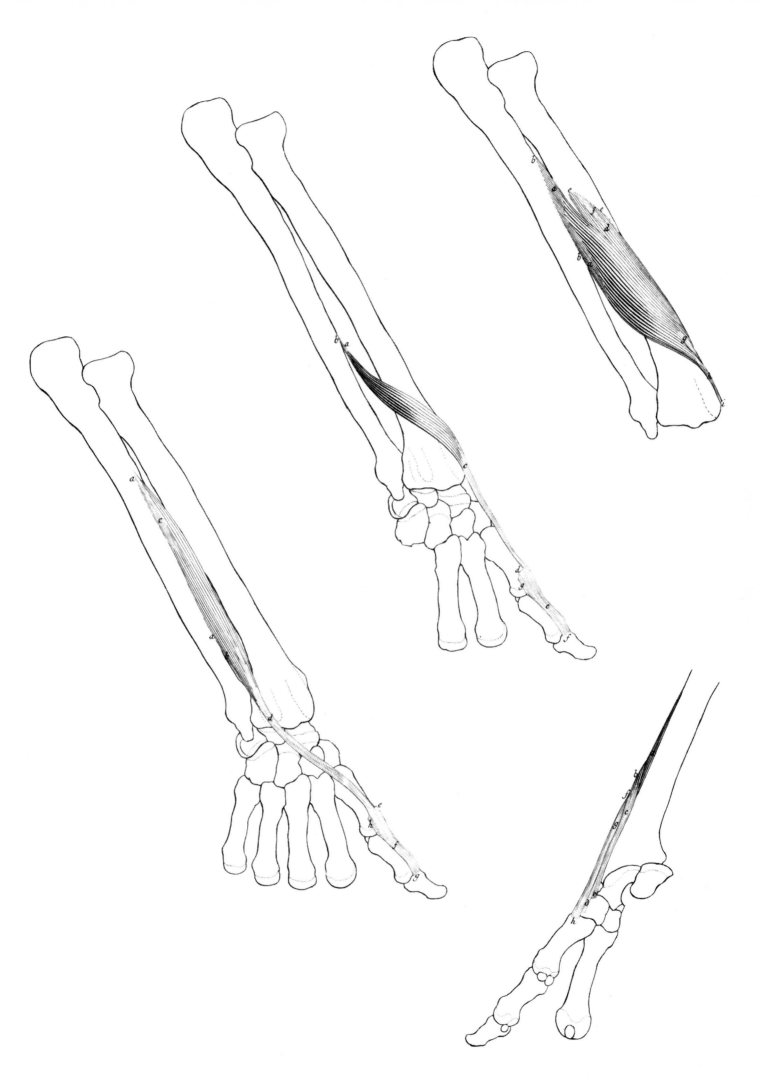

THE HAND

Metacarpals, Back View

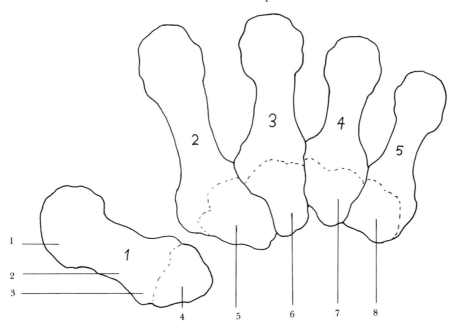

Carpals (Wrist Bones), Distal Row, Back View

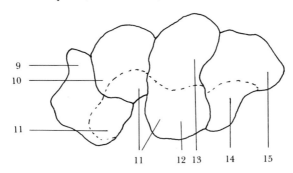

Carpals, Proximal Row, Back View

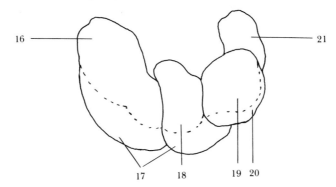

1. Head (Capitulum)
2. Shaft
3. Base
4. Articular surface for trapezium
5. Articular surface for trapezium, trapezoid, and capitate
6. Articular surface for capitate
7. Articular surface for capitate and hamate
8. Articular surface for hamate
9. Trapezium (Greater multangular)
10. Trapeziod (Lesser multangular)
11. Articular surface for scaphoid

12. Articular surface for lunate
13. Capitate
14. Articular surface for triangular
15. Hamate (Cuneiform, unciform)
16. Navicular (Scaphoid)
17. Articulates with radius
18. Lunate (Semilunar)
19. Triangular (Cuneiform, triquetrial)
20. Articulates with ulna by articular disk
21. Pisiform

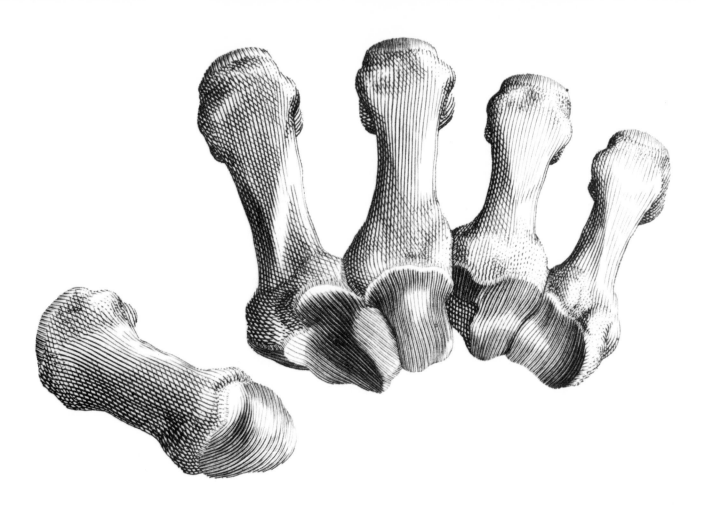

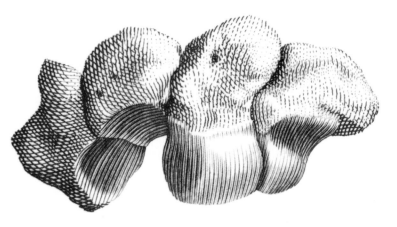

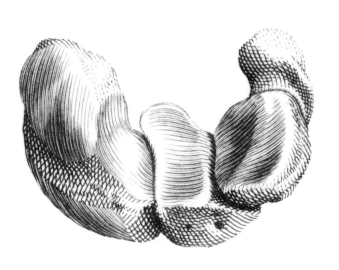

The Middle Finger,
Back View

The Middle Finger,
Inner View

Distal (Third) Phalanx

Distal (Third) Phalanx

The Thumb,
Outer View

Distal (Second) Phalanx

Middle (Second) Phalanx

Middle (Second) Phalanx

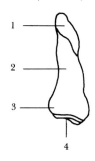

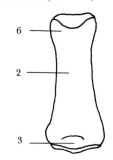

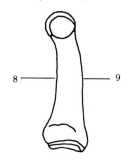

Proximal (First) Phalanx

Proximal (First) Phalanx

Proximal (First) Phalanx

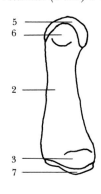

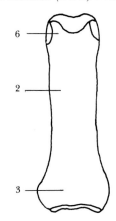

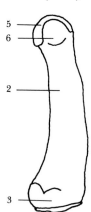

1. Ungual tuberosity
2. Shaft
3. Base
4. Articular surface for first phalanx
5. Condyle of trochlea
6. Head
7. Articular surface for first metacarpal
8. Concave
9. Convex

Flexor Digiti Minimi Brevis,
Little Finger

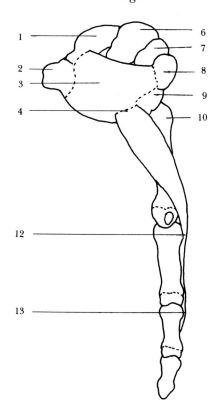

Opponens Digiti Minimi
(Adductor Digiti Minimi),
Little Finger

Abductor Digiti Minimi,
Little Finger

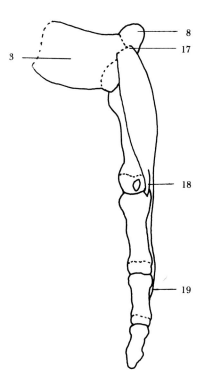

Abductor Indicis
(First Dorsal Interossei),
Index Finger

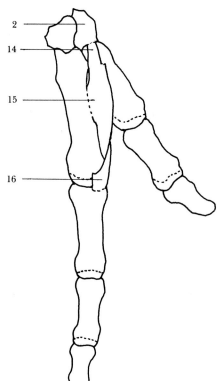

1. Navicular (Scaphoid)
2. Trapezium (Greater multangular)
3. Annular ligament (Flexor retinaculum)
4. Origin from hook of hamate and annular ligament
5. Insertion into fifth metacarpal
6. Lunate
7. Triangular
8. Pisiform
9. Hamate
10. Fifth metacarpal (little finger)
11. Origin from hook of hamate and annular ligament
12. Insertion into base of first phalanx
13. Variation by joining abductor digiti minimi
14. Origin of outer portion from first metacarpal (thumb)
15. Origin of inner portion from second metacarpal (index finger)
16. Insertion into base of first phalanx of index finger
17. Origin from pisiform
18. Insertion into base of first phalanx
19. Tendon joins aponeurosis of extensor digiti minimi
 and inserts into second and third phalanx

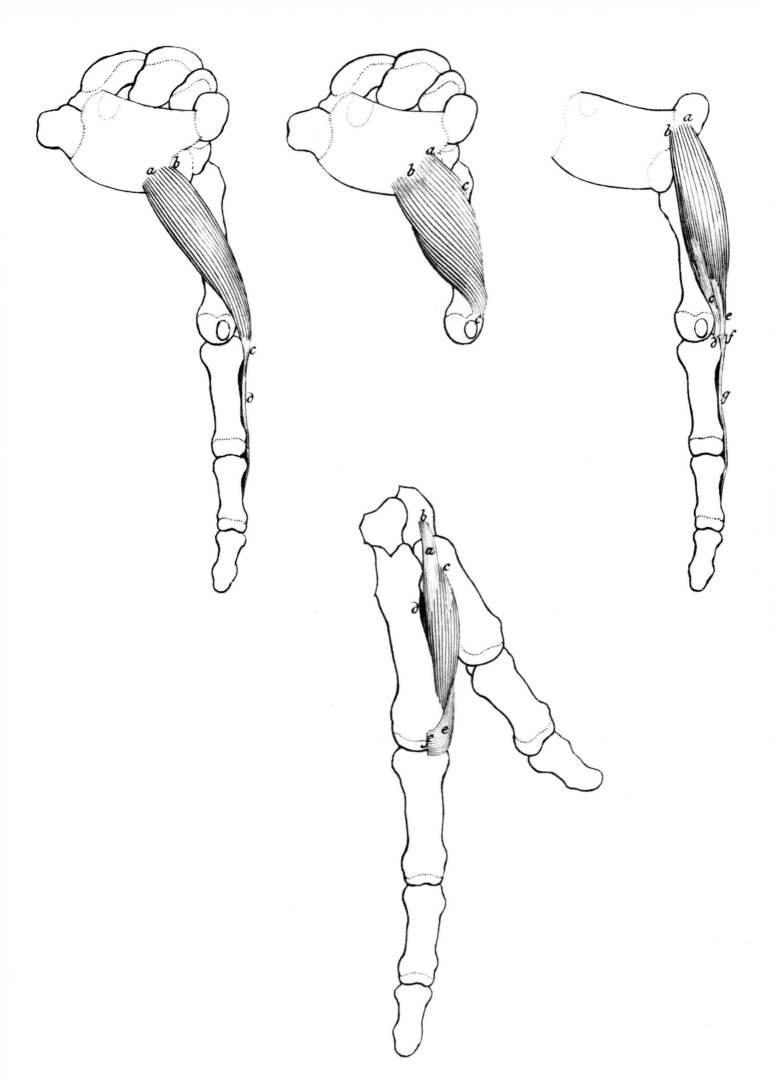

Abductor Pollicis Brevis

*Flexor Pollicis Brevis
and Adductor Pollicis,
Oblique Portion*

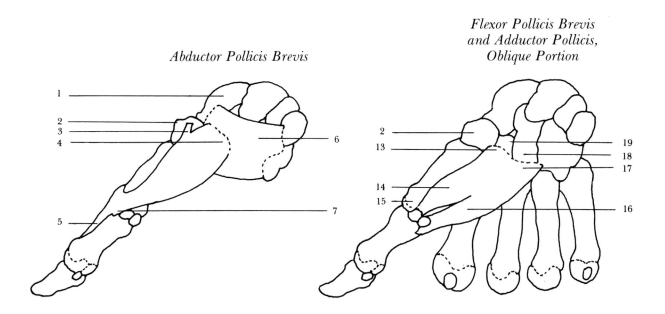

Opponens Pollicis

*Adductor Pollicis,
Transverse Portion*

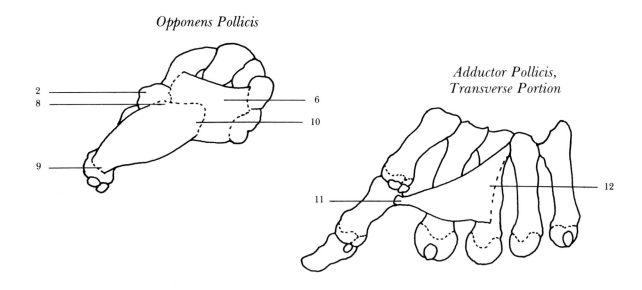

1. Navicular (Scaphoid)
2. Trapezium
3. Origin from trapezium
4. Origin from navicular and annular ligament
5. Insertion into tendon of extensor pollicis longus
6. Annular ligament (Flexor retinaculum)
7. Insertion into base of first phalanx
8. Origin from trapezium
9. Insertion into first metacarpal
10. Origin in annular ligament
11. Insertion into base of first phalanx

12. Origin from third metacarpal (middle finger)
13. Origin of outer portion of flexor pollicis brevis
 from trapezium and annular ligament
14. Fleshy body of flexor pollicis brevis
15. Insertion into base of first phalanx of thumb
16. Fleshy body of oblique portion of adductor pollicis
 over deep portion of flexor pollicis brevis
17. Origin of oblique portion of adductor pollicis
 from capitate and bases of second and third metacarpals
18. Capitate
19. Trapezoid

Palmar (Volar) Interossei, Front View

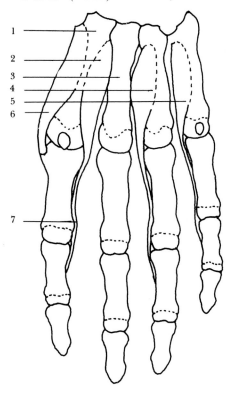

Palmar (Volar) Interossei, Back View

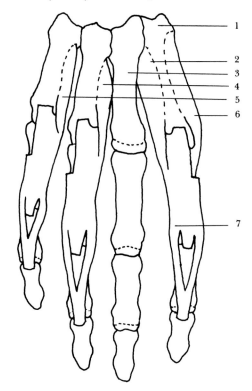

Dorsal Interossei, Front View

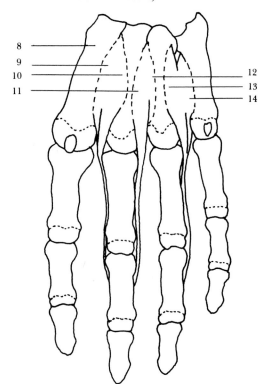

Dorsal Interossei, Back View

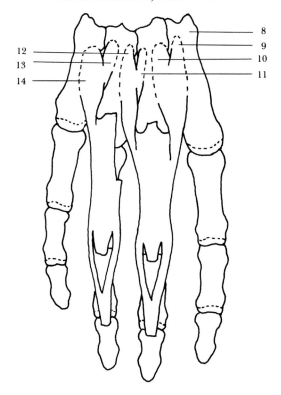

1. Second metacarpal
2. Origin of first interossei from side of second metacarpal
3. Third metacarpal
4. Origin of second interossei from side of fourth metacarpal
5. Origin of third interossei from side of fifth metacarpal
6. Abductor indicis (First dorsal interossei)
7. Insertion of first palmar interossei into first phalanx and common extensor tendon

8. Second metacarpal
9. Origin of second dorsal interossei from second metacarpal
10. Origin of second dorsal interossei from third metacarpal
11. Origin of third dorsal interossei from third metacarpal
12. Origin of third dorsal interossei from fourth metacarpal
13. Origin of fourth dorsal interossei from fourth metacarpal
14. Origin of fourth dorsal interossei from fifth metacarpal

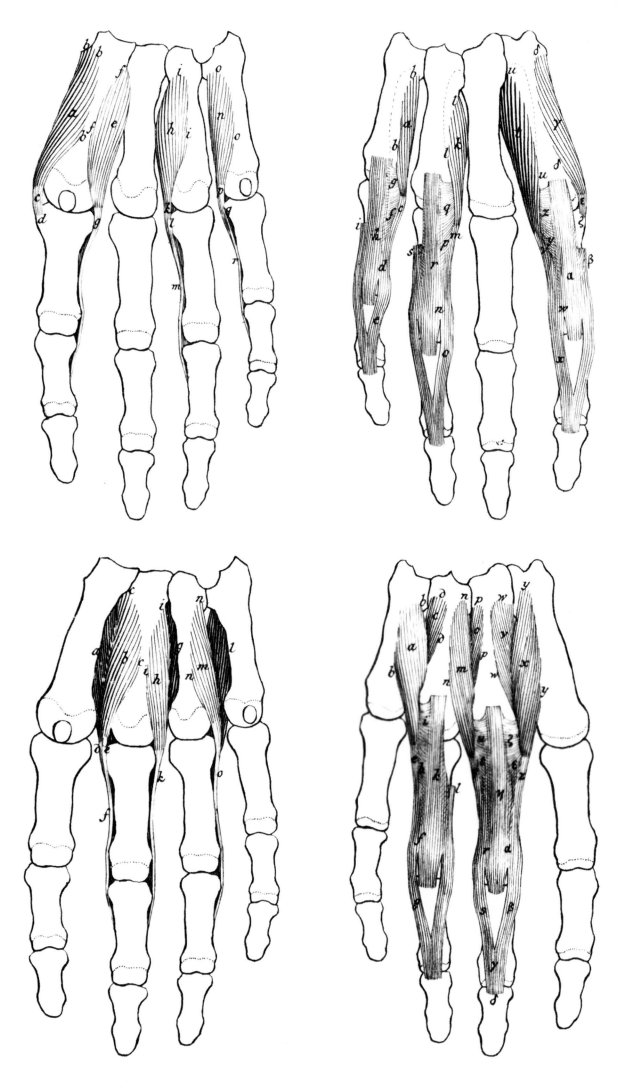

Greater trochanter of femur,
106–108; 28–32, 42, 46, 50
Groin, 34, 92

Hamate, 194, 198
Hamstring group, 120
Hand
 bones of, 196; 30–32
 short (intrinsic) muscles of, 198, 202
 long (extrinsic) muscles of,
 180–190
Head, bones of, 54–58; 28–32
Head, muscles of, 60–66; 34–44
Head of fibula, 128; 34
Helix, 60
Heel bone (calcaneus), 142–144
High point of pelvis, 100–104
Humerus bone, 168

Iliac crest, 100–104; 28, 36
Iliac tubercle of pelvis (wide point),
 100–104; 28–32
Iliacus, 112; 34, 40, 44, 48–50, 106
Iliocostalis cervicis, 96; 46
Iliocostalis dorsi, 96; 42, 46
Iliocostalis luborum, 96; 46
Iliopectineal line, 100–102; 114
Ilium of pelvis, 100–104; 28–32, 50,
 92
Incisive fossa, 54
Inferior angle of scapula, 154
Inferior maxillary (mandible),
 54–58, 62–64
Inferior ramus of pubis, 104; 100
Infraglenoid tuberosity, 154
Infraorbital margin of skull, 54
Infraspinatus, 164; 36–38, 42, 154,
 168
Infraspineous group, 164
Infraspineous fossa of scapula, 154
Inguinal ligament, 92; 34
Inlet, 100–102
Intercondyloid eminence of tibia,
 124–126
Intercondyloid notch of femur, 106
Intercostal spaces of rib cage, 84; 88
Intermaxillary suture (alveolar point),
 54
Internal oblique, 92; 40
 aponeurosis of, 44
Internal supracondylar ridge of
 humerus, 168
Interossei
 dorsal, of foot, 48
 dorsal and volar, of hand, 202
Interosseous border of fibula,
 124–128
Interosseous margin of radius, 172

Intertrochanteric crest of femur, 106
Intertrochanteric line of femur, 106
Intertubercular groove of humerus,
 168; 158, 164
Intervertebral disks, articular surface
 for, 76–80
Intrinsic (short) muscles of hand, 198;
 202
Ischial spine, 102–104
Ischial tuberosity, 102–104; 50, 120
Ischium, 100–104; 28, 32
 ramus of, 102–104
 spine of, 102–104

Jaw
 bones of, 54, 58
 muscles of, 64
Jugular notch of sternum, 90; 84

Knee, bones of, 124; 28–32
Kneecap (patella), 124; 28, 32
Kneeling point (anterior tuberosity),
 124–126; 40

Lamboid suture, 56–58
Latissimus dorsi, 160; 34–38, 104,
 164
Lesser multangular bone of hand, 194
Lesser sciatic notch, 104, 102
Lesser trochanter of femur, 106–108
Lesser tuberosity of humerus, 168;
 174
Levator anguli oris (caninus), 62
Levator labii superioris, 62
Levator labii superioris alaque nasi, 62
Levator menti (mentalis), 62
Levator scapulae, 72; 38–42, 154
Levatores costarum (elevators of ribs),
 50
Ligament
 annular of hand, 198–200
 anterior annular of foot, 34
 of patella, 38–40
 Poupart's (inguinal), 34
Linen alba, 92; 34, 44
Linea aspera, 106–108, 114, 120
Linea transversae, 92; 94
Line of angle of ribs, 86; 30
Lines
 arcuate (iliopectineal) line, 102
 inferior nuchal line, 56
 linea alba, 92, 44
 linea transversae of rectus
 abdominus, 92; 94
 line of angle of ribs, 86; 30
 line of groin, 34, 92
 nuchal (superior curved line), 56
 oblique line of lower jaw, 58; 54

oblique line of radius, 172
spiral line of femur, 108
superior curved (nuchal) line, 56
temporal line, 54–56
where rib meets cartilage, 84;
 28–32, 88
Lips
 muscles of, 60–62
 red margin of, 62
Lister's tubercle, 172; 186, 190
Lobule of ear, 60
Loins (lower back), muscles of, 36, 42,
 96
Longissimus capitis, 72; 46
Longissimus cervicis, 96; 46
Longissimus dorsi, 96; 42, 46
Lower leg, bones of, 128; 126
Lumbar vertebrae, 80; 28–32
Lumbricals of foot, 136; 44
Lunate bone of hand, 194; 198

Malar (zygomatic, cheek bone), 54;
 58, 32, 64
Malleolus of fibula, 128; 28
Malleolus of tibia, 124–126
Mandible (inferior maxillary), 54, 58
Mandible, ramus of, 54, 58
Mandibular notch, 58
Manubrium of sternum, 90; 66, 84,
 88
Masseter, 64; 34, 40–42
Mastoid process, 56–58
Maxilla (superior maxillary), 54, 58
Mentalis (levator menti), 62; 44
Mental process of mandible, 54
Mental protuberance, 54, 58
Menton, 54; 58
Metacarpals of hand, 194; 28–32
Metatarsals of foot, 142; 28–32, 144
Middle scaleni, 72; 50
Mouth, exterior forms of, 62
Multifidus, 50
Muscles
 of abdominal wall, front and side,
 92–94; 34, 40, 44, 48
 of arm (lower)
 front view, 182–184
 back view, 186–190
 of arm (upper)
 front view, 174
 back view, 176
 of axilla (armpit), 158–160, 164,
 174
 of back, 96; 160–162
 of breast, 158
 of buttock, 110
 of chest, 158
 of chewing, 64

Scalenus anterior, 72
Scalenus medius, 72
Scalenus posterior, 72
Scaphoid bone
 of hand, 194
 of foot, 142–144
Scapula, 154
Sciatic notch, 102–104
Semilunar bone of hand, 194
Semilunar line of abdomen, 92
Semilunar notch of ulna, 170
Semimembranosus, 120
Semispinalis capitis (complexus), 68
Semispinalis cervicis, 50
Semispinalis dorsi, 50
Semitendinosus, 120
Serratus anterior, 158; 34, 38–42,
 154
Serratus posterior inferior, 42
Serratus posterior superior, 42
Sesamoid bone of foot, 144
Shoulder girdle, muscles of,
 158–162
Shin bone (tibia), 124–126
Sigmoid cavity of radius, 172
Skull, bones of, 54–58
Soleus, 132; 34, 38–42, 124–128
Spinalis dorsi, 96; 42, 46
Spine of ischium, 102–104
Spine of scapula, 154; 32, 42, 50, 164
Spineous process
 of sacrum, 82
 of vertebrae, 76–80
Spiral line of femur, 106
Splenius capitis, 70; 36–38, 42–44
Splenius cervicis, 38, 42
Squama of temporal bone, 66
Squamosal suture of temporal bone,
 58
Sternal angle, 90
Sternocleidomastoid, 70; 34–40, 152
Sternohyoid, 66, 152
Sternothyroid, 44
Sternum, 90; 28, 84, 88
Stylohyoid, 66
Styloid process
 of fibula, 128
 of radius, 172
 of temporal bone, 56, 58
 of ulna, 170; 30, 42, 46
Subclavian groove, 152
Subscapular fossa, 154
Subscapularis, 40, 44–50, 154
Superciliary eminence, 54; 28
Superior curved (nuchal) line, 56
Superior extensor retinaculum
 (annular ligament), 36
Superior maxillary, 54, 58

Supinator brevis, 178; 40–50,
 170–172
Supinator fossa of ulna, 170
Supinator group, 180
Supinator longus, 180; 168, 172
Supraglenoid tuberosity, 154; 174
Supraspinatus, 164; 42, 154, 168
Supraspinatus fossa of scapula, 154
Suprasternal notch of sternum, 90;
 84
Surgical neck of femur, 106–108
Surgical neck of humerus, 168
Sustentaculum tali of calcaneus,
 142–144; 136
Suture
 coronal, 54–58
 frontonasal, 54
 intermaxillary, 54
 lamboidal, 56; 58
 nasomaxillary, 54
 sagittal, 56
 squamosal, 58
 zygomaxillary, 54
Symphysis of mandible, 54
Symphysis pubis, 100

Tailor's muscle (sartorius), 116
Talus bone of foot, 144
Tarsals, 142–144; 28–32
Temporal bone, 58; 28, 54–56
Temporal fossa, 54
Temporalis, 38–42, 64
Temporal line, 54–56
Tendinous expansion of external
 oblique, 92
Tendinous lines of rectus abdominus,
 92; 40, 94
Tendo calcaneus, 132
Tensor fasciae latae, 116; 34–40, 104
Teres major, 164; 36–46, 154, 168
Teres minor, 164; 36–38, 42, 154,
 168
Thighbone, 106–108
Thigh, muscles of, 114–120
Thoracic arch, 84
Thoracic (dorsal) vertebrae, 78
Thorax (chest), 84–88
Thumb, 194–196; 200
Thyrohyoid, 44
Tibia, 124–126
Tibialis anterior, 130; 34, 38
Tibialis posterior, 134
Toes, 142–144
Tragus, 60
Transverse ligaments of the foot, 148
Transverse process of vertebrae,
 76–80
Transverse ridge of sacrum, 82

Transversus abdominus
 (transversalis), 44–46
Trapezium, 194
Trapezius, 162; 34–38, 152–154
Trapezoid, 194
Triangular, 198
Triangular aponeurosis of trapezius,
 162
Triceps brachii, 176
Triquetrial, 194
Trochlea of humerus, 168
Trochlear notch of ulna, 170
Tubercle of ischium, 120

Ulna, 170; 30–32
Ulnar notch of radius, 172
Umbilicus (navel), 92; 34
Unciform, 194
Ungual tuberosity, 196

Vastus externus (lateralis), 118;
 34–36, 42, 106
Vastus intermedius (crureus), 118; 40
Vastus internus (medialis), 118;
 34–40
Ventral (spinal) border of scapula,
 154
Vertebrae, 76–80; 28–32
Vertebrae
 atlas (first cervical), 76; 30–32
 axis (second cervical), 76; 30–32
 cervical, 76; 28, 32
 dorsal (thoracic), 78; 28–32, 86
 lumbar, 80; 28–32
Vertebral (ventral, spinal) border of
 scapula, 154
Vertebral column, 76–80; 28–32
Vertebral foramen, 78–80
Vertebra prominens, 78; 30–32, 38
Volar interossei
 of foot, 48
 of hand, 202
Vomer (nasal septum), 54

Wide point of pelvis, 100–104
Wing of nose, 60
Wrist bones, 194; 28–32

Xiphoid process, 90; 84

Zygomatic arch, 58; 66
Zygomatic bone, 54; 28, 32, 58
Zygomaticus major, 62; 34
Zygomaxillary suture, 54